Dancing Hearts

Dancing Hearts
Creative Arts with Books Kids Love

Martha Brady

fulcrum resources

Fulcrum Publishing
Golden, Colorado

For Matt and his dog

Library of Congress Cataloging-in-Publication Data

Brady, Martha.
Dancing hearts : creative arts with books kids love / Martha Brady.
p. cm.
ISBN 1-55591-947-2 (pbk.)
1. Arts—Study and teaching (Elementary)—United States.
2. Education, Elementary—Activity programs—United States.
3. Children—Books and reading. I. Title.
NX303.B73 1997
372.5'044—dc21 97-6050
 CIP

Printed in the United States of America

0 9 8 7 6 5 4 3 2 1

Fulcrum Publishing
350 Indiana Street, Suite 350
Golden, Colorado 80401-5093
(800) 992-2908 ♡ (303) 277-1623

Contents

Acknowledgments

Thanking people who assist anyone in the writing of a book is akin to thanking someone who has saved you from drowning. Nothing you do is adequate enough. So, to all those folks who threw me inner tubes while I was sinking, here are words of thanks that cannot, in the least, show my true appreciation of these efforts.

To Lori Miller, Pam Blackburn, Jennifer Fladd, Christy Swingle, Maria Salas, Jenny Leoni, Sue Cook, Nikki Nye, Patty Montgomery and Patty Wills, most of whom were former students of mine, thanks to you and your Gilbert Elementary kids for experiencing many of the activities in this book and validating that they work in the classroom in successful and very positive ways.

To Melissa Owens, Sarah Lee and Lyra Patten, my Northern Arizona University (NAU) interns, thanks for sharing some of these activities with the Sedona students you have been teaching and learning from this past year.

To my colleagues in the NAU/Sedona Partnership. Each day you define the best in education. I am very lucky.

Thanks also to that wonderful breed of human being, the writer of children's books, for continually asking all of us children and adults to slow down enough to enjoy the magic of words and pictures.

A profound thanks goes especially to Howard Gardner and also to David Lazear, both of whom have paved the way for a clearer understanding of the multiple intelligences and the impact those learning capacities have on our children, and especially the way we teach them.

And lastly to Suzanne, my editor, who said, "That sounds like a good idea—go for it."

Introduction

This book is written for a select group of educators. It is written for people with heart. It is written for persons who meet a good challenge head-on and see children as separate individuals. It is written for those who are willing to step up and step out. It is written for teachers and parents who see the value of arts as integral in the positive growth and development of all who wish to contribute to personal wholeness. It is written for everyone who dreams in color. I take it, it is written for you.

The crux of this book is very simple: the integration of children's literature and creative arts and the acknowledgment that kids use who and what they are to engage in the learning process in different ways.

Each chapter begins with a "Background" section that familiarizes the reader with the children's book that is showcased. We read books for all kinds of reasons, and this beginning section shows why I was drawn to the particular book and the personal impacts registered upon reading the selection. I believe your own personal impact is a critical element to share with your children when selecting children's books, as we truly wish for girls and boys to be aware of their own personal impact when they read a book.

The "Hook" activity, a starter experience that usually involves the entire class in a doing and listening format, comes next. It is a time to set the mood, show the value of the upcoming experiences, bring the boys and girls to a common place and, most importantly, awaken their interest in what is to follow. As with most new ideas, new curriculum, new content, what we as teachers do first, to present new material and how we value that new material sets up the tone for success or failure.

The following section of each chapter is the "Discussion" piece. This simply is a time for children to buy into the authenticity of the book, a time for kids to bring their own words, thoughts, ideas and feelings about the book or the "Hook" activity into play. It is a time for the teacher to validate the students' responses and input. It is usually also a preamble of the first reading of the book. So, getting to that point is like rehearsal for opening night. A lot of hard work and commitment to an idea.

Activities in music, drama, creative writing, movement, visual arts, media arts, poetry and other art forms follow.

Most of the activities can be adapted to any age, and most have been experienced by a wide range of grade levels. An example I use often is the watermelon teeth visual art activity found in the chapter, "One Watermelon Seed." When sharing that activity with sixth graders, I experienced real pleasure and excitement from those eleven-year-olds. They listened, connected poetry words with sensory awareness and showed, almost to a child, total delight when wearing the "teeth" for the first time. When I shared this activity with kindergartners, their reactions were almost identical. Listening skills were there. Tactile and sensory awareness was present. And when they wore the "teeth" for the first time, their faces registered the same delight. They, of course, either wanted to eat the teeth or take them home to show Mom and Dad. We provided plastic bags for the trip home. Who knows what the sixth graders did with their teeth.

Each activity includes a list of materials, which gives you a general idea of materials and supplies needed or suggested to assist in making the activity a successful experience. For new teachers, this section is useful in the pre-planning stages of an activity, which, in most cases, is a true key to management of the exercise. In other words, "have your stuff ready before you do it."

Deciding to include "Personal Learning Capacities" sections comes primarily from my belief that all kids learn differently and that if we as educators are mindfully aware of this throughout our hectic classroom schedules, then our chances of offering experiences and situations that lend to those differences is greatly enhanced.

Howard Gardner (*Frames of Mind*) has done the research for us, and David Lazear (*Seven Ways of Knowing*) has created user-friendly dialogue that helps us make sense of the verbal/linguistic, logical/mathematical, visual/spatial, bodily/kinesthetic, musical/rhythmic, interpersonal and intrapersonal intelligences and their applications in the classroom.

If we are in tune with what goes on in the classroom, it is quite easy to acknowledge that children simply do not grasp and understand at the same rate, in the same way, or by the same means. It is to our advantage, therefore, as teachers and parents, to learn as much as we can about the many capacities girls and boys have for understanding and learning.

Gardner's Theory of Multiple Intelligences includes the seven intelligences previously mentioned, which could be considered tools to assist and keep us on track in our efforts to understand the various ways children learn. It is also Gardner's belief that if, in fact, there are seven intelligences, then there must surely be more. This book, however, examines the applications of the intelligences with which we are most familiar: visual, linguistic, musical, kinesthetic, logical and the personal intelligences—intrapersonal and interpersonal.

Briefly and very simply stated, children who love all aspects of language and most often function in that realm are using their verbal/linguistic intelligence. Boys and girls who like to problem solve, who like order, who set priorities, who are, as David Lazear says, "scientific thinkers," are using their logical/mathematical intelligence. The visual/spatial intelligence is manifested in children who imagine or pretend. These are children who draw and appreciate color and design, children who must "see" to understand. Girls and boys who use their bodies to assist in understanding, whether it be drama, movement, math manipulatives or simply riding a bike, are functioning in their bodily/kinesthetic intelligence. The musical/rhythmic intelligence is activated by children who use music, tone, patterns or sounds and the like as forms of communication, emotional release or simple understanding of concepts and ideas. The interpersonal child knows about others and uses that intelligence in team situations. The interpersonal child empathizes extremely well and volunteers often. She hears all sides of problems and very often is a buffer for situations. Finally, children who are aware of and use their intrapersonal intelligence are, in fact, using all of their intelligences. For to be "tuned in to self," which is the mark of the intrapersonal boy or girl, all of the other intelligences must come into play. Children who function in their intrapersonal intelligence observe well. They are simply aware of feelings, of self and of where they fit in the scheme of things.

Because all children have the capacity for using all intelligences, our challenge as educators is to activate these capacities. This can and must be done. By bringing choices to students, by giving them ownership in how they learn, by offering challenging alternative teaching methods, by valuing process and by accepting children as individuals, this job, our job, though daunting, is quite doable.

My own personal reason for incorporating the intelligences into activities is purely selfish. As a teacher, I am in charge of creating an atmosphere in which learning can take place. If I could pick a blueprint for this to happen, I'd choose one that shows seven rooms (instead of one) for creating that atmosphere. To better phrase it, when it is time to build skills, create interest, introduce concepts, facilitate experiences, engage in meaningful dialogue, teach ... , I want all the help I can get. The intelligences give me a road map that will take me to every child's "house." The arts help me build the atmosphere when I get there.

Areas in which students can be evaluated are listed in the "Evaluation" component. This section attempts to draw attention to the three critical areas in which we want children to learn and grow: Knowledge, Skills and Dispositions. Too often, classroom teachers describe creative arts activities as "fun" or "fluff" and diminish the value these kinds of experiences have in overall student learning. Acknowledging the connection between the arts and learning is the first step in offering solid, engaging, thought-provoking stimuli in the classroom whereby students can, in fact, gain pertinent information, hone reading and writing skills and most importantly, create positive attitudes that will serve them well as they grow toward young adulthood.

There are three culminating activities that end every chapter. The "Community Activity" is simply that. An activity that engages the entire class in some way. The "Reflective Question or Journal Entry" requires students to think about certain things at a deeper, more intrapersonal level and are meant to be springboards for the classroom teacher and for students to think of their own personal questions.

The "Wrap-Up" is, well, the wrap-up to the chapter. An ending activity or discussion that merely puts the explored adventure into perspective and to rest. It quite often is a chance, also, to read the selected book one last time.

The "Related Books" and the "Related Music" bibliographies provide additional resources that may be used to enrich the activities, compare and contrast other literary or musical pieces or simply read or listen to.

Someone suggested to me once that I might pursue becoming a principal because I had so much boundless energy. I immediately asked if a root canal were an option instead. I guess what I am trying to say is that whoever we are—principal, kindergarten teacher, university professor, student, parent—we must answer two questions: Do we choose to make a difference in a child's life? How will we make that difference? The way I have chosen to make a difference is best expressed by Donald Graves, who said, "As you pass through life remember to let life pass through you." I think that is what this book is all about. Enjoy!

1
Alphabet City

by Stephen T. Johnson
(NEW YORK: VIKING, 1995)

Background

As a visual human being, I find myself observing life a lot. I love to watch people greet people as they get off airplanes. I like to sit at restaurants and watch as people come to their tables searching other tables for plates of food that might be exactly what they want to order. I enjoy watching people try on shoes at department stores. Oblivious to things around them and interested only in that perfect fit, they sashay back and forth in front of those small floor mirrors, eyeballing first the toe of the shoe then the heel. What a funny little ritual.

I also love detail and design. Even though I do not paint, nor draw, nor sculpt, I can see and appreciate the small intricate things that bring oohs and ahhs to life, like branches on a tree or rocks at the side of a creek. In the branches I see patterns, balance and architectural forms that are so difficult to duplicate. In the rocks I see how they gather, piled up, nestled close and in perfect alignment, waiting for a rock concert to begin.

Alphabet City, by Stephen T. Johnson is an intriguing wordless picture book that brings us a way to see things through a different set of lenses. The entire book is a compilation of wonderful little visual episodes in the form of interesting pictures, which create an alphabet of unbelievable beauty.

Books like this one serve such a grand purpose in the classroom. They help instill in children the value of things around them and also the mystery of what they see. And that, my friends, can do nothing but work in our favor as we try to offer those youngsters every opportunity to learn about who they are.

This beginning chapter is a shopping mall for alphabets. Take your children through each store of ideas. Let them browse, let them try on a few letters and give them time to see if anything fits. Then when it is all over, when the activities have been completed, when the discussions have ended, the next time it is cloudy, run outside and find a "T" in the sky. The next time it rains, trace the rivulet designs on the windows and see if the water forms into an "M." And the next time you walk to lunch, have your girls and boys find a shadow that forms a type of food.

Congratulations! You and Stephen T. Johnson have just given your kids a gift of a different kind of sight.

Hook
Materials

None.

Directions

For a simple hook to the activities that surround *Alphabet City*, ask your students to observe their clothing and find something on their shirts, trousers, shorts, socks, dresses or shoes that looks like a letter of the alphabet. Shoelaces might be in the shape of an "S"; the way leather pieces are sewn onto tennis shoes may look like a "D"; trouser pockets may have seams that resemble a "W."

When most of the kids have found letters of the alphabet on themselves or on one another, slowly "read" Stephen T. Johnson's *Alphabet City*.

Discussion

Talk about the letters that were found on clothing, then look around the room and try to find shapes of things in the immediate area that closely resemble each letter of the alphabet. Your students will have a great time looking for and discovering all those hidden letters.

Personal Learning Capacities

Students who show an interest in this kind of activity, which asks them to look for design, or color, or shape, are usually those students who have an awareness of their visual/spatial intelligence. That awareness also includes a sense of where things are in relation to other things. Therefore, finding letters of the alphabet in clothing is an excellent example of the visual/spatial intelligence at work.

abc

Activity 1 ◄ • • • • • • • • • •
Alphabet Books

Materials

Camera
Print film
Magnifying glasses
Beans
Rice
Tongue depressors
Tissue paper

Directions

There are many ways to create original alphabet books. The following ideas are just different enough to give your students a sense of adventure while creating something useful. When the books are completed, your kids may wish to give them as gifts to younger kids in kindergarten or first grade.

Print Film Alphabet Books

♡ Partner up your students, give them a camera with film and send them outside to take pictures of objects, creatures, shadows or people that begin with the letters of the alphabet or objects, creatures, shadows or people that are shaped like the letters of the alphabet. When the film is developed the students can bind the pictures as they see fit. Sample bindings might include

- Slipping each picture into a Zip-loc plastic bag and stapling the bags together.

- Pasting pictures on construction paper that has been cut into the shape of appropriate letters.

- Placing all the pictures on a large piece of poster board and decorating around each picture.

- Cutting out rectangular cardboard pieces and gluing pictures that have been photocopied onto the pieces, thus creating a deck of alphabet cards.

Magnifying Glass Alphabet Books

♡ Students will partner up or work alone. Using magnifying glasses, the students will look at very small objects, such as grass blades, imprints under rocks or merely somebody's hair, to find alphabet shapes. They can then write a narrative describing their discovery or draw what they see.

Alphabet Story

♡ Using *Alphabet City*, students will begin with the first picture in the book and write a story about that picture and each following picture, linking all the pictures together with some common thread so that in the end, a sensible story emerges.

Alphabet Buildings

♡ Students will look for buildings and parts of buildings that show shapes and forms that resemble the letters of the alphabet. They can either capture those on film or simply write about them.

Object Alphabet Book

♡ Students will use different objects such as beans, torn tissue paper, rice, wooden sticks, sand, etc., to create different letters of the alphabet on separate pages.

Personal Learning Capacities

Give your kids something to create and supplies with which to create, and you have some very happy visual/spatial students. With alphabet books you also encourage linguistic responses as well as bodily/kinesthetic and intrapersonal awareness. In addition, the mere mystery of looking for certain letters is a natural stimulus for most boys and girls and even those children who are not as strong in their visual, kinesthetic and intrapersonal intelligence will do well in this activity. Why? Because it is an interesting challenge.

Evaluation

Completion of task, correct spelling, correct vocabulary, teamwork, appropriate behavior, following directions, observation skills.

• • • • • • • • ► Activity 2
Alphabet Walks

Materials

None.

Directions

Take your kids outside and have them look for things that begin with each letter of the alphabet. The only thing they are asked to do is look. Here are some walks that might be of interest.

Open Alphabet Walk

♡ This works well for the younger students. Just walk around the school yard and try to spot anything that begins with an "A," then anything that begins with a "B," etc.

Junk Alphabet Walk

♡ Children will go outside and look at trash or junk items around the area and try to spot objects that begin with each letter of the alphabet.

Nature Alphabet Walk

♡ This one is similar to the Junk Walk. This time, however, students will look for objects in nature that begin with each letter of the alphabet.

Personal Learning Capacities

This is a kid-watcher activity. Stand back, be patient and see how your girls and boys attack the problem of finding letters of the alphabet. You should notice how some kids only need to "see" the letters. Some students, however, must not only see the letters but "feel" the letters as well. Some of your boys and girls will see and feel the letters then apply that experience in a personal way. All of those experiences become blueprints for you in your assessment of what intelligences they are using to be successful. This is an activity that truly shows how different we all are.

Evaluation

Appropriate behavior, following directions, staying on task, listening skills, observation skills.

Activity 3 ◀ · · · · · · · · ·
Alphabet Scavenger Rock Hunt

Materials
Cardboard box or paper sack, butcher paper, markers.

Directions

In this timed event, students will stay inside or go outside the classroom to find rocks that are shaped like the letters of the alphabet. They will bring the rocks back to the classroom and

1. Display the rocks.
2. Write a math story problem using the rocks.
3. Create a poem using the rocks.
4. Make an alphabet book using the rocks.
5. On large butcher paper, draw a general scene, such as a landscape, mountainscape, etc., on which to place the rocks in appropriate locations.

Personal Learning Capacities

This, too, is a very strong visual/spatial activity that will allow students to use that intelligence to do many creative things with the rocks, such as creating patterns from the rocks, painting scenes on the rocks, drawing pictures of the rocks, designing backgrounds for the rocks and placing those rocks in appropriate places.

Evaluation

Evidence of creativity, teamwork, completion of task, correct spelling, appropriate behavior, following directions, good word usage.

· · · · · · · · · ▶ Activity 4
Alphabet Creative Writing

Materials
None.

Directions

This activity has been around for ages but fits perfectly to coincide with *Alphabet City*. For starters, see how many kids can write a story or poem using as many letters of the alphabet as possible (in order). I would suggest letting the kids work in groups with this one. To make this event even a bit more intriguing, once the stories or poems have been written, ask your girls and boys to write the story again or make a copy of it, then cut the words into separate slips and place the slips of paper in a container. Other students will rearrange the cut out words in appropriate alphabetical order, thus enabling them to read the story or poem.

Personal Learning Capacities

This difficult activity requires some real thought, so your boys and girls must use as much of their logical/mathematical intelligence as possible. The exercise is a real brainer and does require concentration and stamina, two good skills that will work in your intrapersonal learners favor as well. The linguistic students will enjoy a chance to play with words, and this alone should keep them engaged until the activity is completed.

Evaluation
None.

Community Activity

As a natural conclusion to the alphabet activities, students will spend time learning about the American Sign Language. Each child will select a letter, learn how the hand is shaped to show that particular sign then create a hand mask constructed of Johnson and Johnson plaster bandages. Here is a simple way to accomplish these hand masks:

1. Students will pair up. One student will cover their hand with petroleum jelly. That student will then hold their hand in the shape of a particular sign.
2. Another student will cover that hand with wet strips of fast-drying Johnson and Johnson plaster bandages,

criss-crossing along the top of the hand, between the fingers, up toward the wrist.

3. When the hand mask is dry to the touch, it will be removed from the hand and placed in an area where it can totally dry out. This takes several days.

4. When the hand mask is dry, students will use fine grain sand paper and sand the hand mask until smooth.

5. Students will then paint the hand mask with tempera and decorate with sequins, glitter, etc.

6. All hand masks will be displayed (in the school library?).

Reflective Question or Journal Entry

"Think about different ways people communicate without speaking or writing."

Wrap-Up

Read *Alphabet City* once again and as a class have your girls and boys create their own symbolic alphabet. Designate several times during a week when they must use it to communicate in some way. Perhaps you can use the new alphabet to write directions on the chalkboard. You may even want the individuals in the class to attempt to write a short paragraph using the new alphabet. This should be an interesting assignment and one that brings home the importance of our alphabet to us in our daily lives.

Related Books

Anno, Mitsumasa. *Anno's Alphabet*. New York: Harper Trophy, 1975.

Anno, Mitsumasa and Masaichiro Anno. *Anno's Magical ABC*. New York: Philomel Books, 1980.

Feeney, Stephanie. Photographs by Hella Hanmid. *A Is for Aloha*. Honolulu: University of Hawaii Press, 1980.

Grifalconi, Ann. *The Village of Round and Square Houses*. Boston: Little, Brown and Co., 1993.

Grimes, Nikki. Illustrated by Pat Cummings. *C Is for City*. New York: Lothrop, Lee and Shepard Books, 1995.

Hoguet, Susan Ramsay. *I Unpacked My Grandmother's Trunk*. New York: E.P. Dutton, 1983.

Lobel, Arnold. Illustrated by Anita Lobel. *On Market Street*. New York: Greenwillow, 1981.

Matthiesen, Thomas. *ABC: An Alphabet Book*. New York: Grossett and Dunlap, 1966.

Mendoza, George. Illustrated by Kathleen Reidy. *Alphabet Sheep*. New York: Grossett and Dunlap, 1982.

Onyefulu, Ifloma. *A Is for Africa*. New York: E.P. Dutton, 1993.

Owens, Mary Beth. *A Caribou Alphabet*. Brunswick, ME: Dog Ear Press, 1988.

Pallota, Jerry. Illustrated by Leslie Evans. *The Spice Alphabet Book*. Watertown, MA: Charlesbridge, 1994.

———. Illustrated by Edgar Stewart. *The Bird Alphabet Book*. Boston: Quinlan Press, 1986.

———. Illustrated by Edgar Stewart. *The Underwater Alphabet Book*. Watertown, MA: Charlesbridge, 1991.

———. Illustrated by Frank Mazzolo Jr. *The Ocean Alphabet Book*. Boston: Quinlan Press, 1986.

———. Illustrated by Ralph Masiello. *The Yucky Reptile Alphabet Book*. Watertown, MA: Charlesbridge, 1989.

———. Illustrated by Ralph Masiello. *The Frog Alphabet Book*. Watertown, MA: Charlesbridge, 1990.

———. Illustrated by Edgar Stewart. *The Furry Alphabet Book*. Watertown, MA: Charlesbridge, 1991.

Purviance, Susan and Marcia O'Sheel. *Alphabet Annie Announces an All-American Album*. Boston: Houghton Mifflin Co., 1980.

Rankin, Laura. *The Handmade Alphabet*. New York: Dial Books, 1991.

Seeley, Laura. *The Book of Shadow Boxes: The Story of the ABC's*. Atlanta: Peachtree Publishers, 1990.

Van Allsburg, Chris. *The Z Was Zapped*. Boston: Houghton Mifflin Co., 1987.

Related Music

"Barney." "The Alphabet Song." *Barney's Favorites Album*. Shimbaree Music, 1993

Bartels, Joanie. "The Alphabet Song." Discovery Music, 1995.

Sharon, Lois. "Alphabet Medley." *Sing A to Z Album*. ABC Records, n.d.

2
The Big Pets

by Lane Smith
(NEW YORK: VIKING, 1991)

Background

Of all the books that I share with students and teachers, *The Big Pets* by Lane Smith is perhaps the one I totally enjoy the most. The text is warm and gentle to read, each line giving the audience interesting words to mull over and think about. The illustrations require me to linger even a bit longer, seeking out hidden parts of the pictures, wondering what everything means, asking myself many questions about size and shape and color as I slowly turn the pages. And when I reach pages 24 and 25, I spend the day there.

I think what draws me to *The Big Pets* over and over is the feeling of safety when I read it. When you read the book, you'll know what I mean.

Hook

Materials

Butcher paper, colored chalk.

Directions

Silence is often the best form of communication we have; therefore, it is quite beneficial to sometimes give nonverbal directions to your audience. This method of explanation requires children to use their own observation skills at higher levels and asks them to tune in their listening skills to a greater degree as well. Here is an excellent nonverbal activity that will lead comfortably into the reading of *The Big Pets*.

Have the students find an appropriate place to light, wherever it is convenient for them to observe what you are doing. Stand in front of the group and pantomime the simple direction that they are to watch what you are doing. At one end of a chalkboard or large piece of light-colored butcher paper, draw the very, very large face of an animal (a dog or cat, for example). At the other end of the chalkboard or butcher paper, draw the appropriate tail of that animal, keeping the size of the tail proportional to the size of the head as well. Then, in a nonverbal way, give directions that require the kids to look at the drawing and decide what needs to be added to the drawing. The students will come to the drawing one at a time and complete all the parts of the animal that are missing: the body, legs, ears, hair, spots, etc. Also ask your students (nonverbally) to add environmental aspects to the drawing, such as grass, trees, sky, etc.

Discussion

Now everyone can talk. Discuss with the children the animal, its size and what could be done with an animal that large. Direct the conversation with questions such as How would the animal be fed? Where would it sleep? How would it get to the vet? What might its name be?

Once the lively conversation has ended, read slowly and with great care *The Big Pets*.

Personal Learning Capacities

With this interesting visual introduction to the book and the discussion that follows, most kids will easily tune in to their visual/spatial sense. Some youngsters will be able to draw the missing parts. Some will see the animal take shape for sure, but the best part is that their imaginations will probably take over and yet another drawing will be forming in their heads. Those girls and boys can then use their verbal/linguistic capabilities to explain what the imaginary animals look like.

▶ **Activity 1**
From Here to There

Materials

Toilet paper rolls	Clay
Pipe cleaners	Masking tape or glue
Popsicle sticks	Paper clips
Toothpicks	Paper plates
Construction paper	Paper cups

Directions

Give the youngsters this problem: "Pretend the animal we just drew is really your own personal pet. It is also ALL SCHOOL PET DAY, and your teacher says that you can bring your pet to school on that day. How do you get this pet to school? Remember, it is really, really big."

Give students a choice of working alone or with other students. Have available many different supplies and

materials the boys and girls can use to construct an object or machine that will transport the LARGE animal from home to school. Emphasize two things: (1) How the animal transporter works; and (2) Why the animal transporter works.

Next, ask each student or group of students to create a map that shows the route taken from home to school. They must be mindful of obstacles along the way and the changes that must occur in order to successfully get past those obstacles. Some groups may wish to write directions on how to use the maps.

When the students have explained their "automatic animal movers," read *The Big Pets* again and lead the class in a discussion of what forms of transportation would be needed to get the specific animals in the book from one place to another.

Personal Learning Capacities

This activity is a nice blend of visual/spatial intelligence functioning side by side with the logical/mathematical aptitude in solving a very definite problem. Kids can draw, design, create as well as calculate, figure and show relationships.

Evaluation

Completion of project, teamwork, evidence of thought and follow-through, successful use of materials, following directions, participation.

Activity 2
Balloon Animals

Materials

Extra long thin balloons, manual air pump (optional).

Directions

Creating a balloon animal requires two important things: listening to and following directions. This activity is a wonderful way to teach the art and skill of listening and watching. Sequencing is very important, however, and the class needs to watch carefully as they perform these directions in correct order.

Before the students listen to and follow directions in creating a balloon animal correctly, have them blow up a balloon and create an original animal without any directions. Once the original balloon animal sculpture has been completed, students will

1. Name the animal.
2. Describe the animal.

3. Describe its habitat.
4. Discuss any physical peculiarities the animal might possess.
5. Explain the animal's function.
6. Duplicate the sound the animal makes.
7. Discuss the animal's positive or negative attributes.
8. Discuss its method of survival.
9. List its contributions to the planet.
10. Teach it a trick.

When the kids have finished sharing, they will undo the original balloon animal and concentrate on creating one that makes some sense. Here are those directions:

1. Blow up a long balloon, leaving about 8 inches inflated at the end before the knot is tied.
2. Hold the balloon tightly in your left hand with the knotted end facing right.
3. From the knotted end, travel down the balloon about 1 inch. Twist to form the head.
4. Continue down the balloon another inch. Twist. Go another inch. Twist. Lock twist these two together at the base to form the ears.
5. Again, going down the balloon, form a 1-inch bubble. Twist. Form two 1-inch bubbles. Twist. Lock twist these last two bubbles at the base. Voila! The front legs.
6. Next comes the body, which is a 3-inch bubble followed by two more 2-inch bubbles. Lock twist the 2-inch bubbles at the base to form the back legs.
7. The uninflated part of the balloon will be the tail. To ensure that the back legs stay in place, form a small bubble at the end of the uninflated "tail."

With the completion of the authentic animal, ask the students to compare and contrast the animals, group them according to size and features and describe their characteristics or write about their pedigree. Another interesting activity to do with the children and their authentic animals is to ask each child to think of one thing that can be done with their own animal, realistically and unrealistically.

Personal Learning Capacities

Here is another activity that requires kids to think logically and sequentially. Visual/spatial students will love the sculpture aspect of balloon-making while logical/mathematical–oriented children can use their number sense to calculate and measure correct distances needed to create those legs and heads and things. When discussion time comes, the verbal students will use their particular strengths to make sense and order out of things.

Evaluation

Successful creation of animal, following directions, listening, completion of task.

Activity 3
Poetry at the Milk Pool

Materials
Large white sheet, balloon figures.

Directions
This activity has a twofold purpose. It is a foundation for allowing some girls and boys to create a story as action occurs, and it gives those kids who like to move around a chance to do just that.

Spread out a large white sheet and have the kids hold the edges. (The tighter the better.) The sheet will then become the "Milk Pool," as described in *The Big Pets*. One at a time, the kids will toss their balloon animals into the Milk Pool and describe what is happening to their pets as they "swim" about in the pool.

This activity could be nonverbal as well with the students simply observing what is happening as the balloon animal bounces around on the sheet. Once the bouncing is finished, the kids could tell sequentially the entire story of what happened to the animal while it was in the Milk Pool then write a word cinquain that describes what they saw. A sample word cinquain might be

> *Ocean*
> *Billowy white*
> *Moving like clouds*
> *As happy animals ride*
> *Milk*

As students recite their cinquains, play a soft instrumental selection of music.

Personal Learning Capacities
Students will use their verbal/linguistic and visual intelligences to describe, through cinquain verse, what happened to the animals in the Milk Pool.

Evaluation
Use of correct cinquain format, use of words appropriate to activity, completion of assignment.

▶ Activity 4
Sock Snakes

Materials
Socks
Newspaper
Needle and thread
Stapler
Red, blue and black felt squares
Scissors

Directions
The activities that revolve around *The Big Pets* seem to be visual and linguistic in nature partially because the book itself is such a joy to look at and read. The following activity is no exception.

To bring to life the part of the book that talks about the pet snakes, have each child bring old socks to class. Any color, any size, any condition will do. Spend a little bit of time each day cutting the ends out of the socks, stuffing each as uniformly as possible with newspaper or plastic bags gathered from grocery stores, and pulling one end of a stuffed section over another end of a stuffed section before taping the two sections together. If the students in your class run out of socks, go from room to room and initiate a sock drive. You need lots of socks. Thousands of socks. Millions of socks. Continue stuffing and taping, stuffing and taping until you have created the world's largest multicolored snake. Duct tape comes in different colors, students can create their own colored bands that wrap around the snake. Attach to the first sock a mouth and long tongue made from red felt squares, and two friendly eyes made from Styrofoam packing peanuts.

Place the long snake all around the room, up on the book case, along the chalk tray, under the teacher's desk, up and down the coat rack, anywhere the sock will lie quietly but still be seen.

Now, what do you and your kids do with this snake? Here are some hints:

1. Name it.
2. Measure it.
3. Describe it.
4. Write about it.
5. Create a rap about it.
6. Write a song about it.
7. Research all types of snakes and create a bulletin board about snakes.
8. Create a wordless picture book about it.
9. Collect songs that have the word "snake" in the title.
10. Invite lower grades in to draw the snake.
11. Write a mystery story about where the snake came from.
12. Let other classrooms baby-sit the snake for a week and dialogue with those classrooms about what they did with the snake.

13. Call a newspaper reporter from the local paper to come to your room and interview the class about the snake.
14. Ask the principal into your classroom and read other children's books with snakes as the main character.

Personal Learning Capacities

Interpersonal intelligences come into play here because knowing how to work with other children really helps with the success of this project. Kids who have that ability to understand group dynamics and interactions can help awaken that capacity in other kids who need a little help working in groups. The logical/mathematical aspect of this project becomes apparent too, as some kids will get a chance to measure, calculate, weigh and problem-solve ways to place the snake around the room. Those kids will get some help from the visual/spatial students who have a real eye for balance, shape and form when it comes to the placement of the snake.

Finally, don't worry too much about those kids who want to play with and act with the snake in its finished and unfinished state. We can't keep those kinesthetic girls and boys still for too long.

Evaluation

Staying on task, participation, following through, appropriate behavior, successful drama or writing activities.

Activity 5
"Smart Pets" (Song)

Materials

Song sheet, synthesizer.

Directions

For your children who love to collect lyrics, write poems or limericks, create their own words and music, or tap out rhythms on chair backs or table legs, the following song, "Smart Pets," will be great fun.

Once the kids have learned the lyrics to the song, give them a chance to write other lyrics that describe their own smart pets. Then take the class to a younger grade level and have them read books about pets to those children and teach them their newly created song about smart pets.

Personal Learning Capacities

The musical/rhythmic children will love singing this song, their hands quite often tapping on something as they do it. They will also love the pattern of the song, the repetitive lines, the rhymes. Unfortunately, we as teachers too often go no further than just the singing of a song. But to really bring this particular intelligence to life for those kids who are naturally musical and those who are not, consider, in a thoughtful way, other methods of "singing" the song. For example, give each student a coffee can or small cardboard box. If those are hard to come by, simply have the children clear the tops of their desks and use those spaces.

Once the melody is learned, "sing" the song again, only have students omit the words and tap the melody line on the coffee cans or cardboard boxes. Or perhaps, have the students sing and tap at the same time and just omit the tag line of each stanza, "we got pets, we got smart pets."

Kids love to change the lyrics in songs. It gives them a bit of ownership and authenticity. Don't worry about rhyming or even timing. That's not the point. Words are the point as well as working them out, hearing them and connecting them to the melody. Here's an idea. Go through the book, *Big Pets*, with the children. List all of the animals that are shown or mentioned. Then, page by page, create a group song still using the "Smart Pets" melody. The first page of *The Big Pets* says, "The girl was small and the cat was big." The students may want to change that to, "There's a cat and it's big as a girl." The second page might state, "On his back, she will ride to the pool," etc. The linguistic students will certainly be enthralled with this part of the activity.

You may even want to add a bit of research to this musical activity by having kids collect sound effects or other animal sounds, domesticated and wild. Then have the kids identify and classify animal sounds according to size, type, family, continent, etc.

Evaluation

Creative expression, appropriateness of lyrics, rhyming, completion, contribution to task, working with younger students.

Community Activity

Give your students a homework assignment of going outside at night and finding the Milky Way. They are to take special notice of what it looks like, how it is shaped, where it is dense, how long it looks to the naked eye, etc.

When the boys and girls are back in school, look at the illustration of the Milky Way in *The Big Pets* and talk about the differences in their own visual interpretation and Lane Smith's. Place a long piece of black butcher paper outside on the grass or sidewalk. Give children spray bottles filled with diluted tempera paint and ask them to create their own Milky Way using facts they have gained from their own observations of the Milky Way. The girls and boys will be thrilled at their own creation, which can now be used as another poetry stimulus.

Reflective Question or Journal Entry

"If the Milky Way had a door, what would you see if you opened it?"

Wrap-Up

Just read the book one more time, talk about all of the experiences the children have had associated with the book and then walk over and pet the snake for good luck.

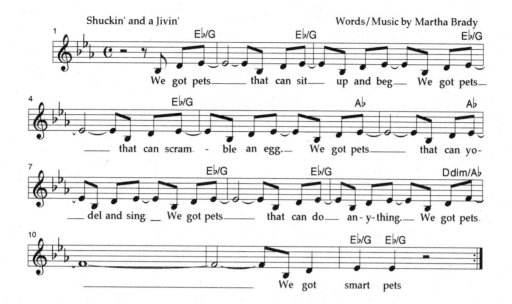

We got fish that can back up a car
We got mules that can shoot golf at par
We got squirrels that can make a souffle
We got deer that play poker all day
We got pets, we got smart pets

We got geese that can cough and can sneeze
We got ants that can say,"Thank you, please."
We got mice that can crochet and sew
We got goats that can bowl like a pro
We got pets, we got smart pets

We got cows that can moonwalk a mile
We got cats that can rhumba in style
We got bats that can answer a phone
We got worms that can sunbathe alone
We got pets, we got smart pets

We got dogs that can read from a book
We got birds that can learn how to cook
We got snakes that can spell any word
We got ducks that can act like a nerd
We got pets, we got smart pets
We got pets, we got smart pets
We got pets, we got smart pets,
Smart pets, smart pets
We got smart pets

Related Books

Aardema, Verna. Illustrated by Leo and Diane Dillon. *Who's in Rabbit's House.* New York: Dial Books for Young Readers, 1979.

Baker, Keith. *Hide and Snake.* New York: HBJ Publishers, 1991.

Barrett, Judy. Illustrated by Ron Barrett. *Animals Should Definitely NOT Wear Clothing.* New York: Atheneum, 1971.

———. Illustrated by Ron Barret. *Animals Should Definitely NOT Act Like People.* New York: Scholastic, 1980.

———. Illustrated by L. S. Johnson. *A Snake Is Totally Tail.* New York: Aladdin Books, 1983.

Barton, Byron. *Buzz, Buzz, Buzz.* New York: Aladdin Paperbacks, 1995.

Carlson, Nancy. *Bunnies and Their Hobbies.* New York: Puffin Books, 1984.

DeZutter, Hank. Illustrated by Suse MacDonald. *Who Says a Dog Goes Bow-Wow!* New York: A Doubleday Book for Young Readers, 1993.

Edwards, Frank B. and John Bianchi. *Grandma Mooner.* Newburgh, Ontario: Bungalo Books, 1992.

Hughes, Langston. Illustrations by students from the Harlem School of the Arts. *The Sweet and Sour Animal Book.* New York: Oxford University Press, 1994.

Leemis, Ralph. Illustrated by Chris Demarest. *Smart Dog.* Homesdale, PA: Boyds Mills Press, 1993.

Rosen, Michael (ed.). *Speak! Children's Book Illustrators Brag About Their Dogs.* New York: Harcourt, Brace and Co., 1993.

Rylant, Cynthia. *Dog Heaven.* New York: Scholastic, 1995.

Walsh, Ellen Stoll. *Mouse Paint.* New York: HBJ Publishers, 1989.

Related Music

Kidsongs. *A Day with the Animals.* Warner Reprise, Video, n.d.

Lanz, David and Paul Speer. *Natural States.* Narada Records, 1986.

Ladysmith Black Mambaza. *Gift of the Tortoise: A Musical Journey through South Africa.*

Original Broadway Cast Recording. *Cats.* Polydor, 1982.

Polisar, Barry Louis. *Old Dogs, New Tricks.* Rainbow Morning Music, n.d.

Sharon, Lois and Bram Sharon. *Pet Fair.* A&M Records, Video, 1994.

3
The Brook

by Alfred Tennyson
Illustrated by Charles Micucci
(NEW YORK: ORCHARD BOOKS, 1994)

Background

This poem, written by Tennyson almost 150 years ago and now exquisitely reborn in Charles Micucci's illustrations, is a seven-course dinner of delicious words. Words that sail off the tongue with grace and power and beauty. Words that capture the moment and send us gently floating down, around and upon the ribbon of water that is *The Brook*.

When I first discovered this new retelling of *The Brook*, I immediately dived headlong into the ebb and flow of Tennyson's use of the English language and just as quickly into the realization that it is indeed the clearest lesson of what letters grouped together really are. They are breath and life and direction. They are fever and solace and movement. They are time and color and nuance. They are words made for speaking and thinking about and much more. They are to be held and smelled and touched.

In one line of the poem, Tennyson describes the sound the brook makes as, "I chatter over stony ways, in little sharps and trebles, I bubble into eddying bays, I babble on the pebbles." Children should experience the beauty those kinds of words create.

With the words and the illustrations that are simply from another time, I envy the journey you are about to take with your children down *The Brook*.

Hook

Materials

None.

Directions

Read *The Brook* by Alfred Tennyson, illustrated by Charles Micucci, one page at a time. After you have read a page, ask two students to come to the overhead and illustrate together what they think is being described. Don't give definitions of the words just yet. After each illustration, give the definitions of the unfamiliar words, and with the new knowledge of the words, ask someone in the class to paraphrase what that page of the poem means. Once the clear meaning is understood, the two students will illustrate, once again, what is being described and compare the two illustrations. This should be done with each page of the poem.

Discussion

Once the entire poem has been dissected, so to speak, and illustrated, ask students to give a brief synopsis of what the poem is saying. Then ask your class to get comfortable as you read the poem. If there is a word in the poem that draws some kind of reaction from your kids, stop and dwell on that word and its meaning. Talk about how it paints a clear picture. Discuss how it feels in the mouth or what it sounds like in connection with the words that go before or after it. Create for your children an artist's palette, if you will, of words.

Personal Learning Capacities

Children's visual capacities will certainly come into play just as strongly as their verbal/linguistic intelligences in this activity that introduces the book. Not only will some visual learners use the overhead experience as a way of tapping into clear thinking, but some of your students with visual learning capabilities will use their imaginations to create their own illustrations to the poet's words.

This is a linguistic endeavor, however, so put those glasses on once more as you carefully watch the levels at which all of your children function within this particular intelligence.

> ▶ Activity 1
> It's My Story Now

Materials

See the following list.

Directions

Before we begin branching out into activities that will enhance all aspects of this poem, in order for your kids to have a clear sense of what it is about, give them an opportunity to retell *The Brook* in their own way. This can be accomplished alone, with a partner or in groups.

Here are some creative ideas students may wish to incorporate in the retelling of the poem:

♡ Textured Mural—Students will collect twigs, leaves, stones, dirt, sticks, cloth, feathers, small boxes,

toothpicks, balloons, clothespins, colored cellophane, plastic flowers and other objects. They will create a mural that uses all of the objects in appropriate ways to create a textured scene.

♡ Radio Play—Students will write an original script that retells the poem. The play can be presented as a radio play complete with microphones and a table of appropriate sound effects.

♡ Choral Reading—Students will write an original interpretation in a choral reading format, which may include onomatopoeic underlying chants.

♡ Wordless Picture Book—Students will retell the story through sequenced illustrations.

♡ Clay Sculptures—Students will tell the story by creating clay sculptures that lead the observer through a clear sequence of events.

Personal Learning Capacities

All of the intelligences will be used in this activity. The question is who will use what? Who will stretch? Who will stay in their own safe learning mode? What intelligences will be combined? What intelligences will be awakened?

When the assignments have been completed and as each project is introduced, have a good discussion with the children about the intelligence or combination of intelligences used for each one. Good data can come from this experience, which will help you in preparing your lessons so that all learning styles are included. It will also be interesting to see if any one learning capacity was used rather infrequently. Was there evidence of kids functioning within the musical intelligence? Did any children function intrapersonally? That bit of information will give you some clues about what kinds of lessons to present to the class in the future.

Evaluation

Teamwork, staying on task, completion of task, good writing skills, performance skills (projection, staying in character, etc.), evidence of effort.

Activity 2
Quiz Show

Materials
Noise makers, answer sheets, question sheets.

Directions

Students will read the poem or look at the illustrations once again. This time they will think of three questions that have to do with the book. A sample question could be "When was the poem first published?" The students will write down their questions and keep them at their desks. They will also write on a sheet of paper only the answers to the questions (for example, 1855) and give those sheets of paper to the

teacher, who will attach a cover sheet to each sheet and tape all the sheets on the chalkboard in a grid format.

Three contestants will sit at the front of the room as the teacher uncovers a sheet that has an answer written on it. The three contestants will use kazoos, whistles or clickers to indicate that they know the question that goes with a particular answer.

Jeopardy? You bet.

Personal Learning Capacities

This is a review technique that allows kids to use their kinesthetic, visual and linguistic qualities to solve the specific problems of this activity, and to communicate to the teacher the depth of their knowledge. It works because the format isn't foreign—there is movement, and the students have input into the formulation of the questions and answers.

Throw in a few wigs, a Quiz Show sign, a commercial or two and videotape the entire procedure.

Evaluation
Correct answers, participation.

Activity 3
Person to Person

Materials
Cardboard boxes, fake plants, desk, chairs.

Directions

Spend some time with your class and the book, looking at the illustrations and talking about all of the living things that depend on the brook for their existence. Discuss events that occurred because of the brook, and changes that occurred because of it. Then ask each student to select one creature, critter, inanimate object or human that can be found somewhere in the illustrations. These creatures, humans or objects might include a farmer plowing, a cow, a stagecoach driver, birds, a toy boat, etc. Each illustration offers many choices.

Students will create a "late-night talk show" set in the classroom, complete with desk, backdrop, ferns, couch and coffee tables. The girls and boys should figure out how to acquire or construct the above furniture and items.

One student, the host of the talk show, will "interview" other students who come on the talk show as the inanimate objects, critters, creatures or humans they have chosen from the illustration.

The host will ask questions regarding their connection to and dependence on the brook. Students will answer as their characters.

Personal Learning Capacities

It is very easy to spot those children in your class who posses a strong interpersonal intelligence. These are the boys and girls who demonstrate an understanding of how others think and feel. You will see these interpersonal students when there is a classroom conflict. They have suggestions to resolve the conflict. You will see these interpersonal students when there is responsible behavior in group dynamics. They are cooperative, give constructive feedback and generally respect and know how to attend to most group situations.

Then there are those students of yours who have yet to get in touch with the part of them that recognizes others and knows what to do about conditions that arise when working with others. For those kids, drama is an excellent teaching tool. What does drama offer? Structure, of course. Freedom to express, certainly. But most importantly, it offers an arena that clearly shows that success cannot happen unless everyone connected watches, listens and senses others. And avenues such as drama are a safe laboratory setting for students to find their interpersonal intelligence and use it. Second to the playground, drama is the one element that can awaken all of the intelligences. And it will, time and time again.

This drama activity strengthens more than just the interpersonal element, however. There is movement and role-playing for the kinesthetic child; there are sets to design, props to create, ideas to imagine for the visual student; there is music to learn, songs to sing for the musical girl and boy and on and on.

Winifred Ward, a renowned drama educator in England once said, "Each time a child walks through the door, drama enters the classroom." If that is indeed the case, then our job as teacher has become just a bit clearer.

Evaluation

Teamwork, positive attitude, characterization, participation.

Activity 4 ◀ • • • • • • •
Gibberish Poetry

Materials

None.

Directions

Students will read the following poem and define the nonsense words by using context clues.

The Cabin
BY MARTHA BRADY

Into the deep, deep Wazzz I walked
until I spied a cabin.
My feet found broken twigs that Tazzz
The brook spoke its own babbling.
The wind caressed my coated back
And tossed the leaves like wafers.
For just a moment I felt trapped
The cabin sight felt Szzzzzzz.
Up to the house I wandered near
With tiny steps I Slllzzzzz.
My breath was all that I could hear
And it indeed was muffled.
There was but twenty feet of ground
To where I might have entered.
But then I heard a thunderous Stzzzzzzz
As if the whole house splintered.
The cabin door sprung open fast,
It clattered as if Blzzzzzz.
And standing there like onyx glass
Was something big and quaking.
A gasp came from my open Mzzzzzzzz,
I turned and ran like lightning
Along a path that headed south,
The whole experience frightening.
I ran until my legs collapsed
Then saw a brilliant shimmer.
It was a river by the path
I dove in like a Swzzzzzzzz.
My heaving lungs and limbs a-twirl
Propelled me from the water.
I looked ashore and saw a Gzzzz
Resembling someone's daughter.
She waved her hand and called to me,
I gurgled back disjointed.
I asked from whence she came that day
"The cabin, yon," she Pzzzzz.
"The cabin in the deep, deep woods?
The cabin that was scary?"
She smiled and shook her golden locks,
"That cabin, be not wary."
"But my eyes saw a monster there
And there I lost my Czzzzzzzz."
"Oh silly, that was Papa Bear
Just eating day-old porridge."

Once they have figured out the nonsense words, give the students the correctly written poem and have them either explain the unknown words, act out the poem, verbally or nonverbally, write more ending verses or draw a picture that tells the meaning of the story.

The Cabin

Into the deep, deep woods I walked
until I spied a cabin.
My feet found broken twigs that talked
The brook spoke its own babbling.
The wind caressed my coated back
And tossed the leaves like wafers.
For just a moment I felt trapped
The cabin sight felt safer.
Up to the house I wandered near
With tiny steps I shuffled.
My breath was all that I could hear
And it indeed was muffled.
There was but twenty feet of ground
To where I might have entered.
But then I heard a thunderous sound
As if the whole house splintered.
The cabin door sprung open fast,
It clattered, surely breaking.
And standing there like onyx glass
Was something big and quaking
A gasp came from my open mouth,
I turned and ran like lightning
Along a path that headed south,
The whole experience frightening.
I ran until my legs collapsed
Then saw a brilliant shimmer.
It was a river by the path
I dove in like a swimmer.
My heaving lungs and limbs a-twirl
Propelled me from the water.
I looked ashore and saw a girl
Resembling someone's daughter.
She waved her hand and called to me,
I gurgled back disjointed.
I asked from whence she came that day
"The cabin, yon," she pointed.
"The cabin in the deep, deep woods?
The cabin that was scary?"
She smiled and shook her golden locks,
"That cabin. Be not wary."

"But my eyes saw a monster there
And there I lost my courage."
"Oh silly, that was Papa Bear
Just eating day-old porridge."

Personal Learning Capacities

There are many ways of supporting the linguistic intelligence and other intelligences through language-centered endeavors such as this poem. Interpersonal students can dramatize this effort in a group format, kinesthetic learners can re-create this poem into a puppet performance, musical students can create a mini-opera from the text and visual students can illustrate the verses or make a book for the entire poem. Logical students can calculate distances in the poem, or they can compare this poem to Tennyson's *The Brook*.

Evaluation

Rhyming, completion, correct answers.

Community Activity

When was the last time your students made salt dough maps? Well, it's time once again to bring out the flour, salt and water. This time, however, it will take the shape of a salt dough river scene.

First, the class needs to bring several pieces of cardboard that can be taped together to form one long runner. Groups of students will then select sections of *The Brook* and using a salt dough medium, re-create their own interpretations of those sections on the cardboard, joining one section to another until the entire brook and all that goes on either side can be viewed. What a catalyst for other learning situations. A good salt dough recipe is

1 part water
1 part salt
2 parts flour
Food coloring (optional)

Reflective Question or Journal Entry

"What is the most beautiful thing you have ever seen? Describe it the best way you know how."

Wrap-Up

There is one continuing line in the poem: "For men may come and men may go, but I go on forever." Conclude time spent with Tennyson's *The Brook* by discussing what that line means and what, in fact, goes on forever.

Related Books

Cherry, Lynne. *A River Ran Wild.* New York: A Gulliver Green Book, 1992.

Ellsworth, Barry. Ilustrated by Steve Day. *The Little Stream.* Salt Lake City: Bonneville Books, 1995.

Frank, Josette. Illustrated by Thomas Locker. *Snow Toward Evening.* New York: Dial Books, 1990.

Gilliland, Judith. Illustrated by Joyce Pow Zyk. *River.* New York: Clarion Books, 1993.

Grahame, Kenneth. Illustrated by Adrienne Adams. "The River Bank" in *The Wind in the Willow.* New York: Charles Scribner's Sons, 1977.

Humphrey, Margo. *The River That Gave Gifts: An Afro-American Story.* San Francisco: Children's Book Press, 1987.

Hurlock, Fiona. Illustrated by Eric Kincaid. *Gorf's Pond.* New Market, England: Brimax Books, 1996.

Locker, Thomas. *Where the River Begins.* New York: Dial, 1984.

McLerran, Alice. Illustrated by Valery Vasiliev. *Dreamsong.* New York: Tambourine Books, 1992.

Related Music

G.E.N.E. "Whispering Brook." *Fluting Paradise.* Innovative Company, 1991.

Ma, Yo-Yo and Bobby McFerrin. "Norwegian Wood." *Hush.* Sony Classical, 1992.

Original Broadway Cast. *Big River—The Adventures of Huckleberry Finn.* MCA, 1985.

Phillips Music. *Mozart in the Morning.* n.d.

Sounds of Nature Sampler. *Sound of a Babbling Brook.* Special Music Co., 1990.

4
Chrysanthemum

by Kevin Henkes
(NEW YORK: THE TRUMPET CLUB, 1991)

Background

There are so many excellent children's books dealing with differences, tolerance and valuing the human spirit that finding the right one to use as a central core for exploring those themes through the arts was quite difficult ... until I read *Chrysanthemum*. The simplicity of the message struck a sensitive chord and thus opened up thoughts and ideas that could be used in helping girls and boys understand the art and skill of accepting themselves and others.

The gentle nature of this story underscores, in a most precise way, how fragile this thing called "tolerance" is, and how the mere acceptance of others in a classroom setting is often times a hard struggle. Perhaps a book as simple as this one, and activities that come from books such as this, may allow children the freedom to explore differences and find their own creative expressions at the same time.

Hook

Materials

Black felt tip pen, poster board, butcher paper, crayons.

Directions

On a piece of poster board or a large piece of light-colored butcher paper, use a heavy marker to draw a big circle that is filled with irregularly drawn compartments. Be sure to draw the same number of compartments as there are students and adults in the classroom. Even though the shapes of the compartments should be different, the sizes should be as uniform as possible. The circle should look like this:

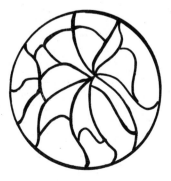

Let each student choose one crayon. Several students at a time will sit on the floor next to the circle, pick a compartment and color it in. The only direction given will be that each student and the teacher may color in only one compartment or section.

Discussion

When the students and teacher have completed coloring all of the sections of the circle, ask the boys and girls to look at the finished product and answer questions similar to these:

1. What is it?
2. What does it remind you of?
3. What is different about it?
4. What things look the same about it?
5. Look closely and describe things you see in the different sections.

Continue the conversation until all the students have had a chance to engage in discussion about the art object. Now take the picture outside, lean it against part of the school building or a nearby tree or fence and ask students to stand about 5 feet away and describe it. In order, they will then stand 10 feet away, 20 feet way and, ultimately, very far away from the object, each time describing what they see and possibly the changes that occur as they view it.

Bring the students back inside and complete the discussion with these questions:

1. What did we see as we stood near the picture? (All sections were separate and different.)
2. What happened to the picture as we got farther and farther away? (The lines blended in and all that was seen was a large colorful ball.)
3. What does that picture and all of that coloring have to do with this class, with this school with this community, with this country, with this world?

Lead the class into a discussion about differences in the classroom. When every child has been heard, end the discussion by reading the wonderful book *Chrysanthemum* by Kevin Henkes.

Personal Learning Capacities

Literally seeing the colored circle segmented first, then as a whole, will offer your students an opportunity to understand more clearly this particular example of differences and how, collectively, they represent strength and unity. Visual/spatial episodes such as this will help students explore, using that intelligence to gain understanding of what the teacher is trying to direct them toward.

Other students in your class may have to talk about the experience, listen to what others have to say or read *Chrysanthemum* and books of that nature to understand, more fully, the real meaning of diversity. Verbal/linguistic experiences, such as the discussions and the sharing of children's books, are learning catalysts for these particular kinds of learners.

Activity 1 ◄ · · · · · · · · · ·
The Thanksgiving Idea:
A Children's Musical

Materials

Christmas lights
Canes (dowels)
Hats
Benches
Towels
Basketball
Cafeteria trays
Portable chalkboard
Globe
Fake tall plants (used as trees)
Original soundtrack—"One," from *A Chorus Line*

Directions

The activities in this chapter have been melted down into one general event, a children's play with music. *The Thanksgiving Idea* is a contemporary play that can be presented very successfully by fourth, fifth or sixth graders. It is the story of a classroom of typical girls and boys who are given the challenge by their teacher of developing an ending for a Thanksgiving play that is to be presented by the class. The story follows the problem-solving scenarios of the class, the inability to work together in spite of differences among the children in the class, and it gives the ultimate solution.

Even though the theme for this particular reading of the play is Thanksgiving, with just a few changes in the script, the focus of the play can be changed to other holidays or even other themes. Boys and girls would love a chance at re-creating this play or possibly writing another ending. (See page 38 for "Suggested Sets and Props.")

The Thanksgiving Idea:
A Children's Musical
BY MARTHA BRADY

Characters

MARY	EDUARDO
CHRISSY	MISS GASTON
MORGAN	MACK
CLYDE	JOHNNY
WAYNE	JAY
PETE	PILGRIM
PHIL	NATIVE AMERICAN

Scene One—Walking to School

[enter MARY, CHRISSY and MORGAN, books in hand, walking to school]

MARY: Well! Do you have an idea? [louder] Do you?

CHRISSY: I'm thinking, I'm thinking.

MARY: [turning to MORGAN] What about you?

MORGAN: I'm thinking too. Not as much as Chrissy is. But I'm thinking.

MARY: [sighs] We're sunk. I know it. We are absolutely, positively, definitely, completely sunk. [ALL stop and think]

CHRISSY: How about the same old story? That meal thing.

MARY: Boring. Really boring. It's been done so much. I don't think I can see another turkey.

CHRISSY: Well then, uh, how about having the people who were at the first Thanksgiving uh, order take out from a Pizza Hut and serve pepperoni at the first dinner.

MARY: [disgruntled] Will you get serious? Have you two forgotten that tomorrow Miss Gaston, our fifth grade teacher, is going to ask us for ideas on how to end our Thanksgiving play … t-o-m-o-r-r-o-w. That's 24 hours from now.

MORGAN: Maybe we could ask to do the Christmas play instead.

MARY: Fourth grade is doing the Christmas play.

CHRISSY: Well, then, the Valentine's Day play.

MARY: [rolls eyes] First grade.

MORGAN: George Washington's bir—

MARY: [interrupting] Kindergarten. [sighs]

CHRISSY: I guess we are sunk, aren't we?

MORGAN: We're sunk all right.

MARY: We are absolutely, positively, definitely, completely sunk.

Sunk

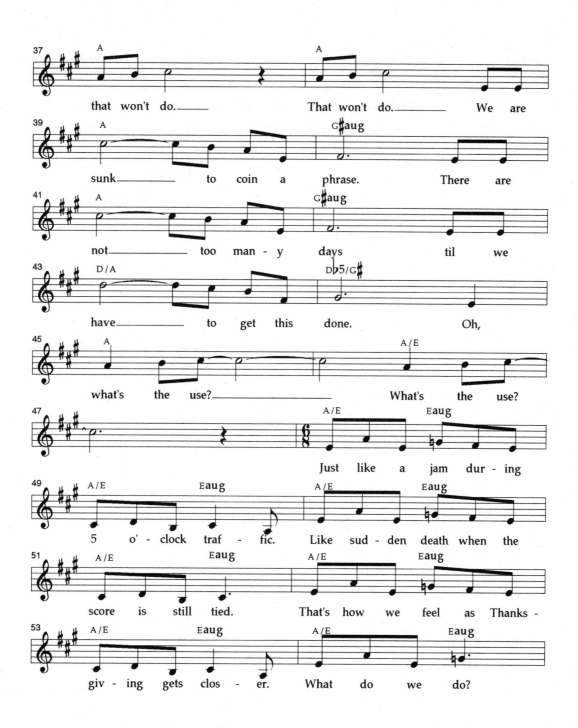

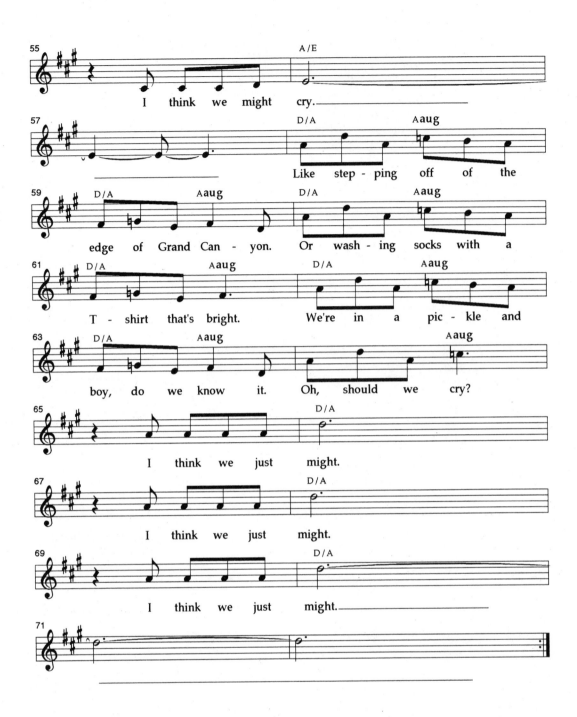

CHRISSY: Hey, I've got it. What if we get some chicken wire and tissue [pause] and make a giant turkey that comes flying out of the woods? Then the turkey can land on the table and we'll all gather round and

MARY: [begins walking off dejectedly] Sunk. I tell you we're sunk. [other GIRLS begin to exit]

[Music up]
[Blackout]
[Change set]

Scene Two—PE Class

[enter CLYDE, WAYNE, PETE, PHIL and EDUARDO and other male students who begin playing with a basketball, shooting baskets, etc. ALL are playing except PHIL]

CLYDE: [throws ball and hits PHIL] Hey, are you okay? You didn't even try to duck the ball. What's wrong?

PHIL: Thanksgiving.

CLYDE: [looks puzzled] Huh?

PHIL: I said Thanksgiving.

EDUARDO: Phil, this is PE class, not Thanksgiving.

CLYDE: [laughing] Maybe the ball hit you too hard on the head. And if it did, well, that's just too bad because

you can't get hurt today. You can get hurt on Mondays, but not today.

EDUARDO: Clyde, what are you talking about? If Phil wants to get hurt today, he can be hurt today. [pauses] Oh, I forgot. Phil you can't get hurt today. The nurse is only here on Mondays.

CLYDE: [feels PHIL's forehead] I don't think he has a fever. I don't see any blood.

PHIL: I feel okay, really I do. It's just that our ideas for the last scene of the Thanksgiving play are due tomorrow. It's an assignment from Miss Gaston. You remember

her don't you? She's our teacher.

WAYNE: Tomorrow? I thought that was due next week.

CLYDE: Phil's right. They are due tomorrow. I forgot.

PETE: We're sunk. We are incredibly, remarkably, horribly, sufficiently sunk.

WAYNE: Think everybody, think.

[ALL think]

PETE: Hey, I've got a box of tissue. Maybe we could get some chicken wire and—

WAYNE: [interrupts] Think!

Who'd a Thunk

Words/Music by Martha Brady

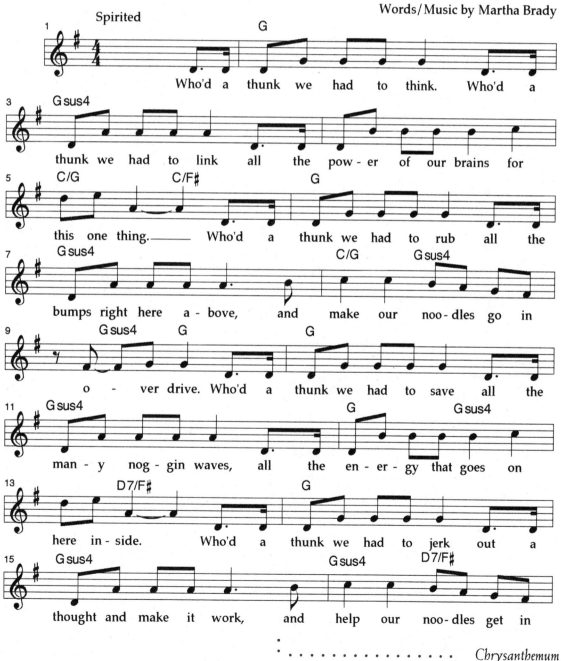

Spirited

G
Who'd a thunk we had to think. Who'd a

Gsus4
thunk we had to link all the pow-er of our brains for

C/G C/F# G
this one thing.___ Who'd a thunk we had to rub all the

Gsus4 C/G Gsus4
bumps right here a-bove, and make our noo-dles go in

Gsus4 G G
o-ver drive. Who'd a thunk we had to save all the

Gsus4 G Gsus4
man-y nog-gin waves, all the en-er-gy that goes on

D7/F# G
here in-side. Who'd a thunk we had to jerk out a

Gsus4 Gsus4 D7/F#
thought and make it work, and help our noo-dles get in

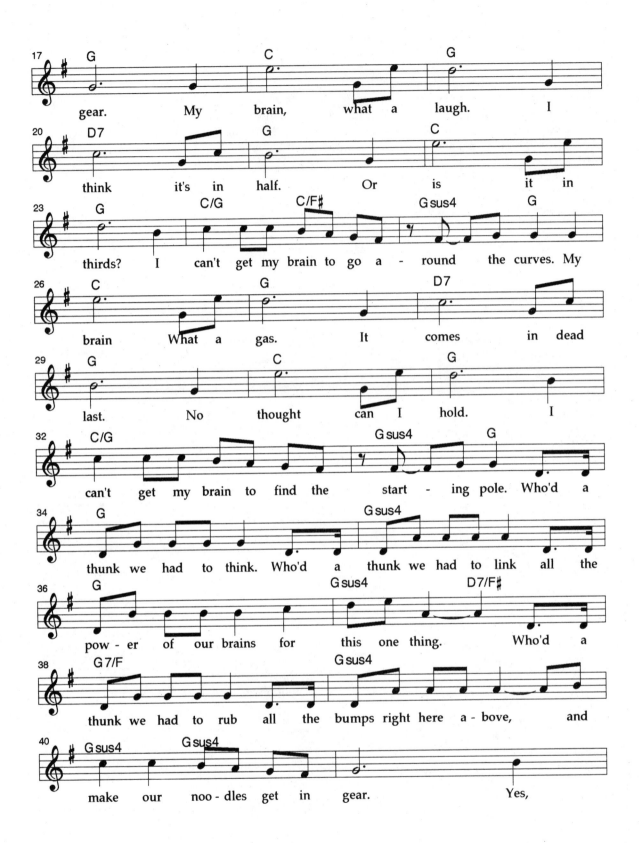

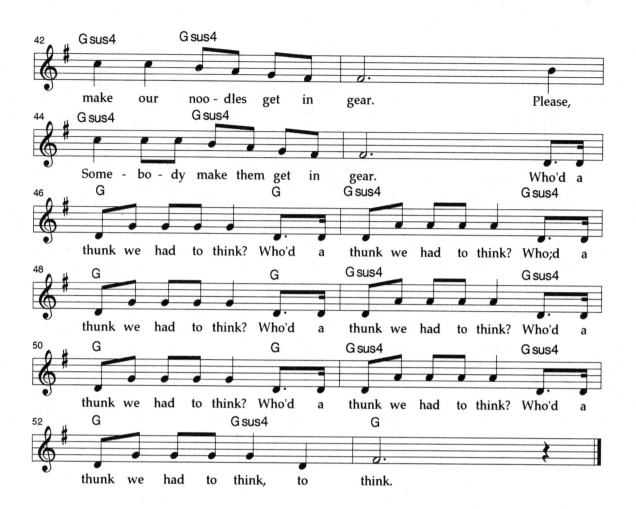

make our noo-dles get in gear. Please,

Some-bo-dy make them get in gear. Who'd a

thunk we had to think? Who'd a thunk we had to think? Who;d a

thunk we had to think? Who'd a thunk we had to think? Who'd a

thunk we had to think? Who'd a thunk we had to think? Who'd a

thunk we had to think, to think.

[fade out song] [ALL pose in thinking stances]

WAYNE: I like Pete's idea. We'll use lots of tissue, and make this gigantic turkey that will fly out of the woods and land on the table.

PHIL: [grudgingly] Sure thing.

[Music up]

[ALL exit]

[Blackout]

[Change scene]

Scene Three—Classroom

[MISS GASTON is standing in front of the class]

MISS GASTON: And that, class, is what MC2 really means. [taps ruler on desk] Now, on to more important matters. The Thanksgiving play. [as MISS GASTON says this, students sink lower and lower into chairs, hiding faces behind books, etc.] Er, Mary, what is your Thanksgiving idea this morning? [waits for response] Cat got your tongue, Mary?

CHRISSY: [raising her hand] Miss Gaston, I can answer

that for Mary. A cat *did* get her tongue. You see, I saw it all happen. On the way to school today, Mary was waiting for the bus. We all were standing around talking about the Thanksgiving play and, anyway, this *big* kitty came up to her and before she could do anything about it, that cat jumped right on—

MISS GASTON: That will do young lady. [looks around room] Pete, what about you? Were you standing around the bus stop thinking about an idea for the Thanksgiving play?

PETE: Miss Gaston. I don't feel like talking. Really. I'm too depressed.

MISS GASTON: Depressed, Pete? Why?

PETE: It was my cat. [CLASS snickers, etc.]

MISS GASTON: Now that's enough, class. All of you have had this assignment about an ending for the Thanksgiving play for a long time now and I want to hear some ideas. I want to hear some ideas right this minute. [EVERYONE begins to call out crazy ideas as introduction to song starts]

Do We Have a Thought for Thanksgiving

Smooth and Moderate

Words / Music by Martha Brady

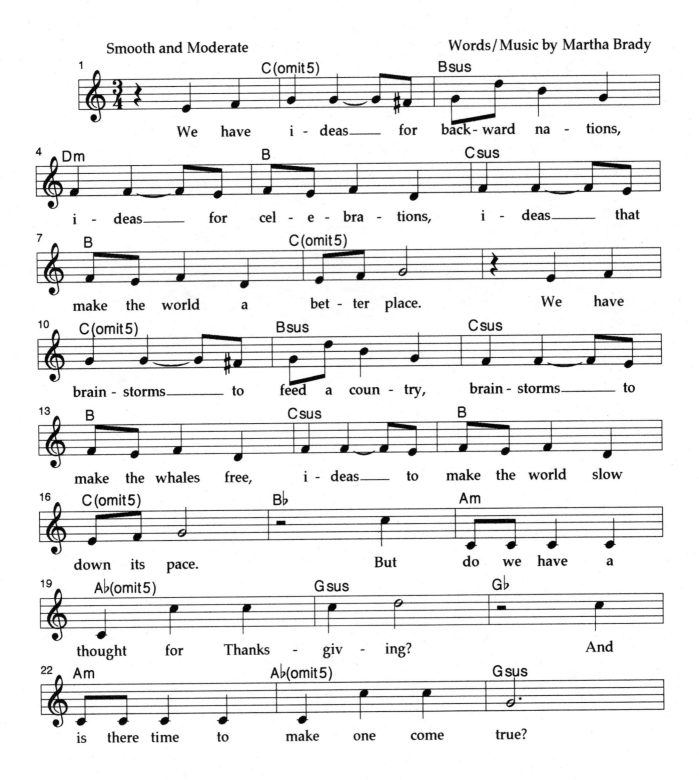

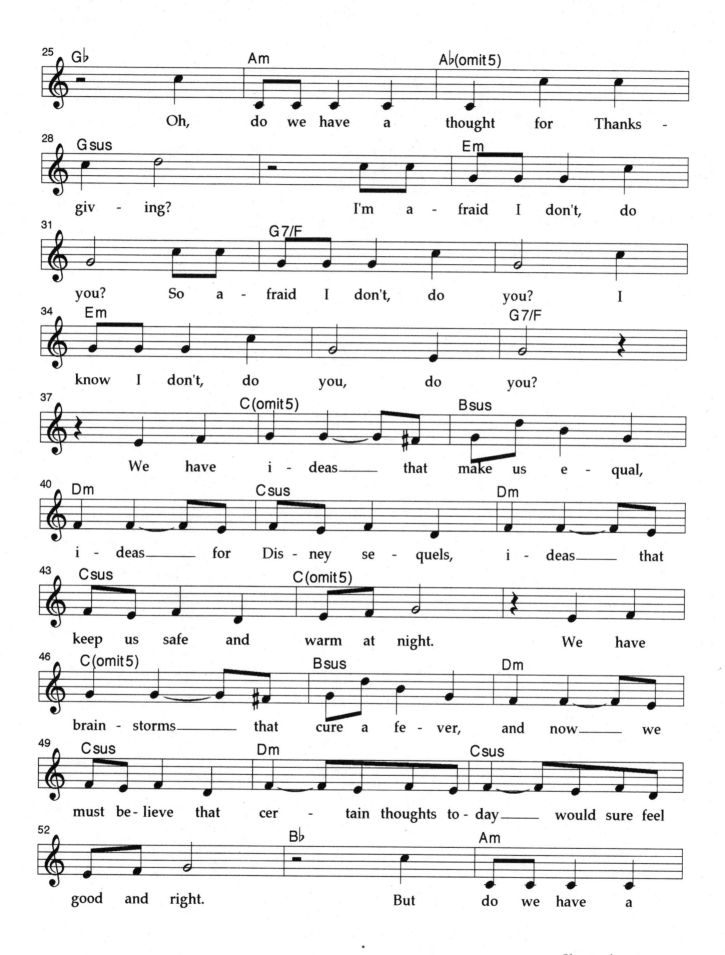

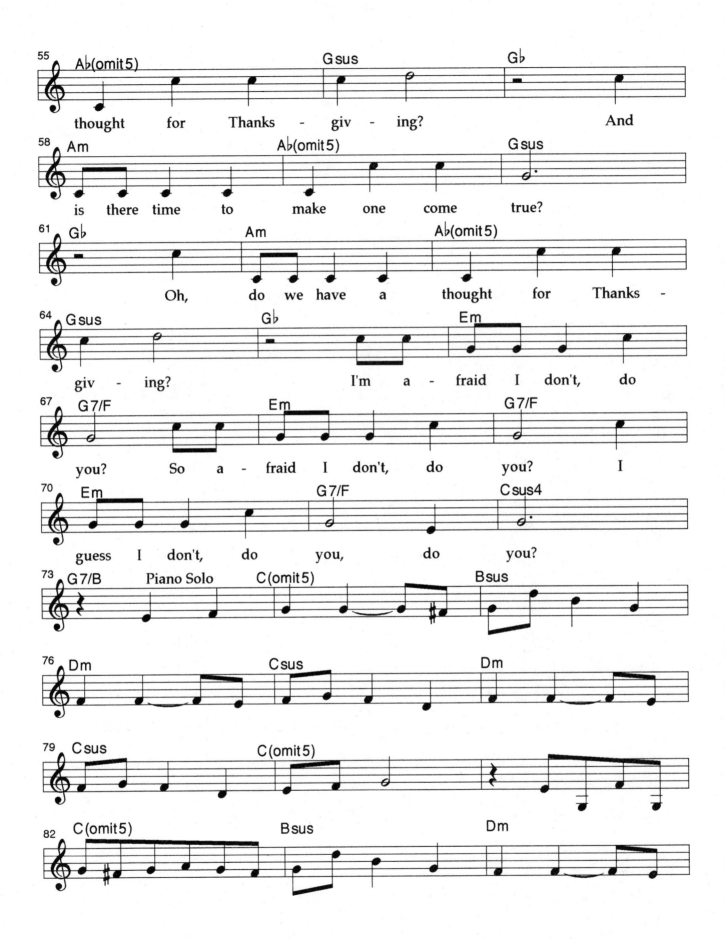

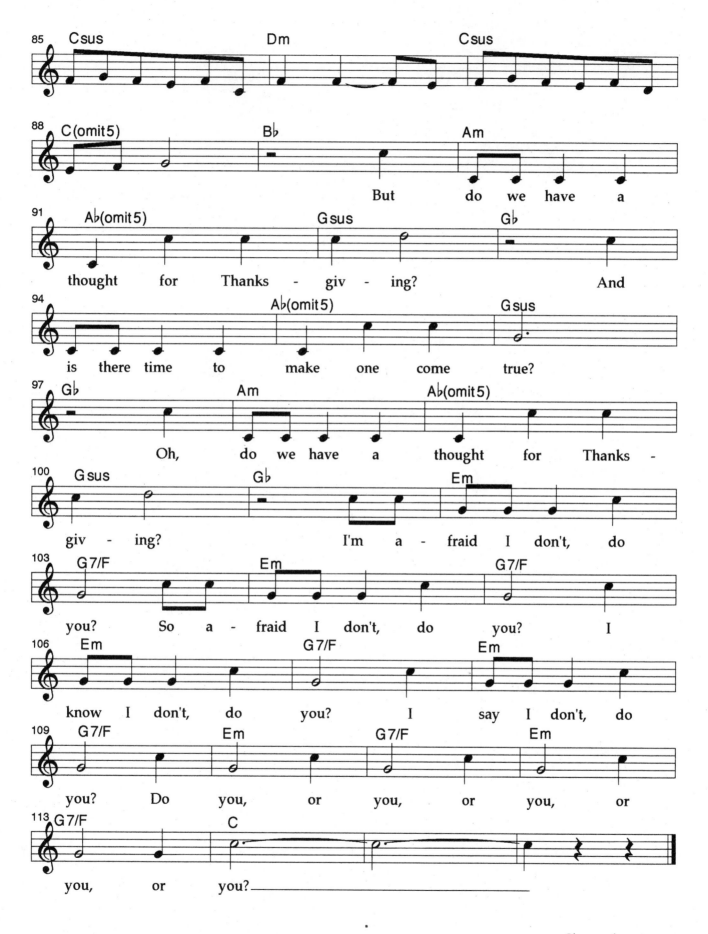

[at end of song ALL ad-lib about the fact that they have no idea, etc.]

MISS GASTON: [a bit upset] STOP!!! I must say that was a very pretty song class, but read my lips. [GASTON silently moves lips to "What Is Your Idea?"]

[ALL STUDENTS watch her lips. When she finishes ALL exit ad-libbing: Yes, ma'am. ... Tomorrow it will be ready. ... Ideas, all kinds of ideas, not just one ... but hundreds ... thousands. ... Every Thanksgiving idea known in the civilized world. ...]

[ALL exit]
[Music up]
[Blackout]
[Change scene]

Scene Four—Cafeteria

[ALL kids are lined up for lunch. Some have paper sacks in hand, some trays]

WAYNE: What's for lunch today? [looks up ahead in line]

CLYDE: The usual.

CHRISSY: Oh no. Manager's Special again. I hate meat balls rolled in Rice Krispies with soy sauce.

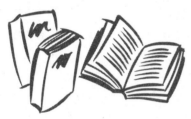

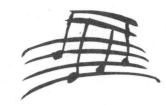

CLYDE: [peers into "food"] I think they are covered with jalapeño mustard this time.

CHRISSY: [grinning] Oh, then that may not be so bad.

WAYNE: [holding sack] How you guys eat that stuff, I'll never know.

MACK: What's in the sack?

WAYNE: My favorite. Sardines and honey on an onion bagel.

MACK: Lucky.

[enter MARY, furious]

MARY: Will you all quit thinking about food. We've got a real problem on our hands.

PETE: I know. Meatballs and Rice Krispies.

MARY: No, no, no. The Thanksgiving play. Have any of you thought of an idea yet?

JOHNNY: I don't have an idea. I never had an idea.

MORGAN: [excited] Wait. I have an idea. ...

PHIL: [shrugs] What is it?

MORGAN: I wish it were Christmas already.

WAYNE: Hey, I have a great idea for a Christmas play.
 [MORGAN pulls cap over WAYNE's eyes]

MARY: Miss Gaston is going to be *soooo* mad.

PHIL: I know. What are we going to do?

MARY: I don't know, but we had better do it quick.

Absolutely, Positively, Definitely

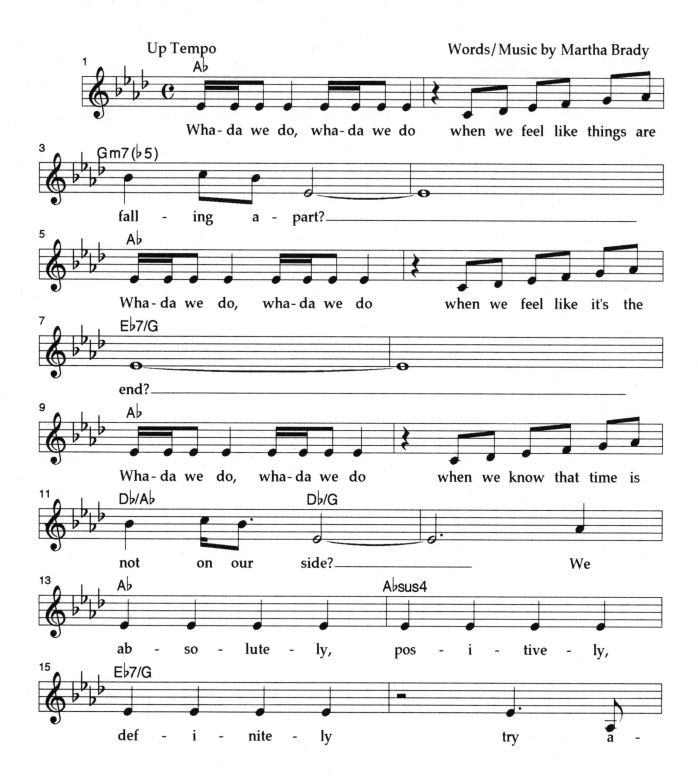

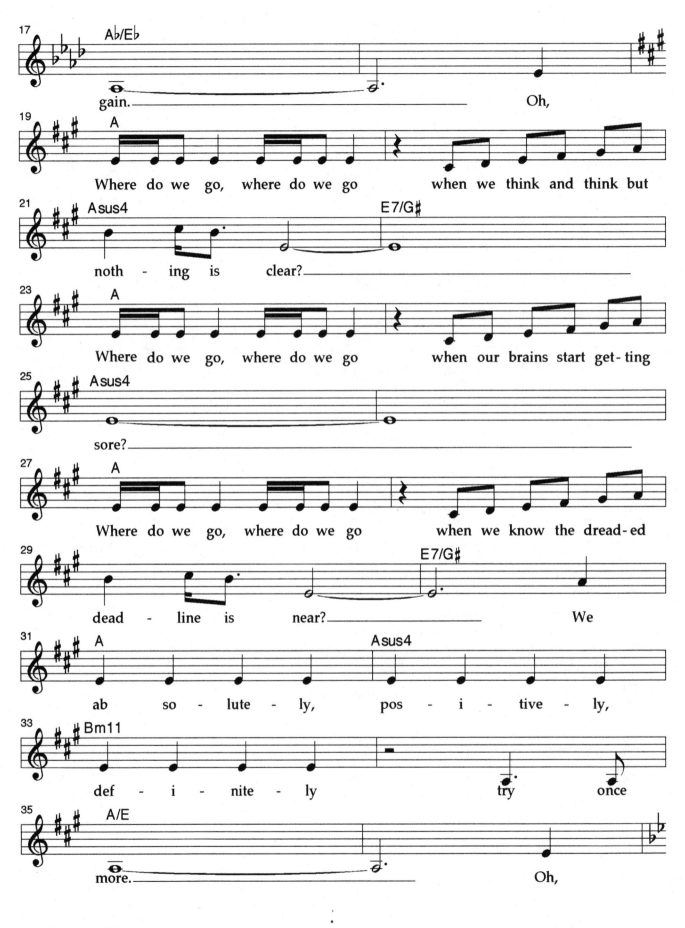

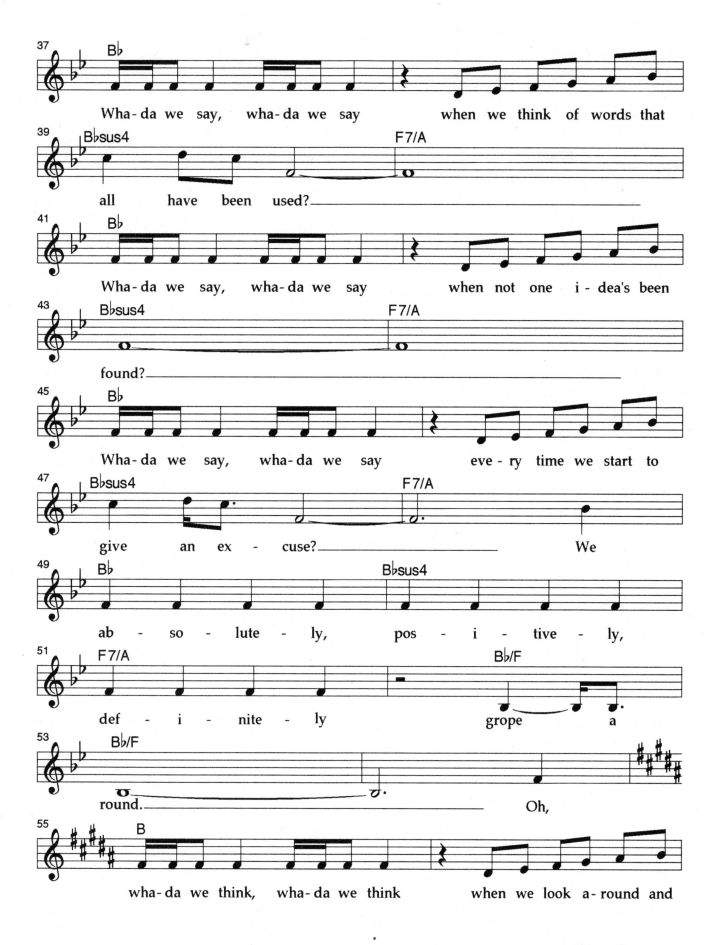

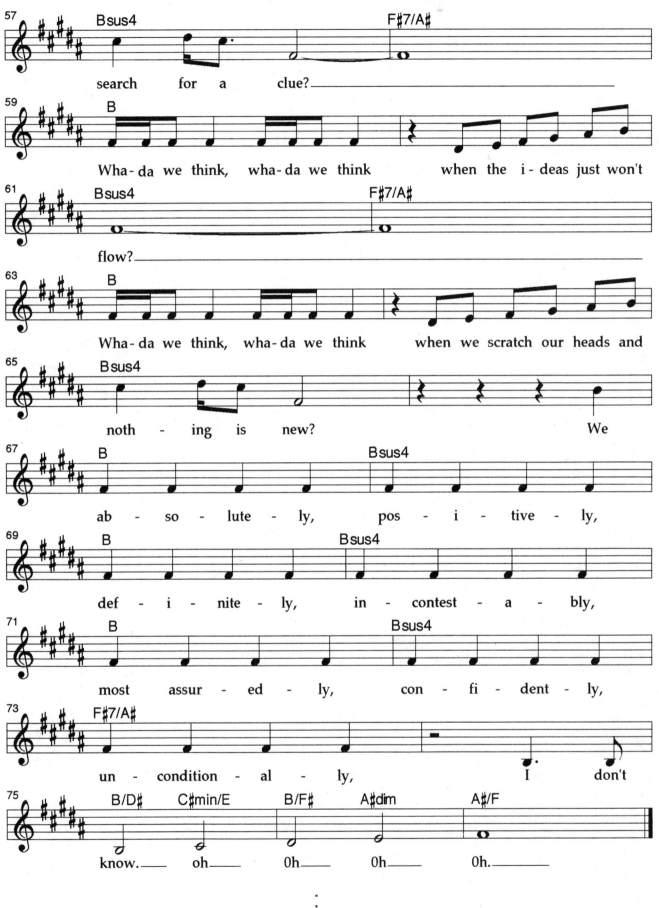

MACK: Well, we just sang pretty, again, but that doesn't solve the problem.

CLYDE: Maybe someone else could give us an idea for the Thanksgiving play.

MARY: Don't be silly Clyde, there are twenty-five of us right here who can't come up with one idea. Who do you think is going to help us? Mickey Mouse? [ALL ad-lib agreement and mention other Disney characters that might help with their dilemma]

PHIL: Wait a minute. What Clyde just said makes sense. Maybe there is someone who could help us. Someone not in this class. Who do we know in some other class that could help us.

MACK: Do we know anybody in 6th grade?

CHRISSY: Nobody in 6th grade talks to us.

PHIL: Nobody?

CHRISSY: Nobody.

PHIL: That's bogus.

MORGAN: How bout 4th grade?

CLYDE: *We* don't talk to anybody in 4th.

MORGAN: We don't?

CLYDE: Nope. [EVERYONE ponders]

MORGAN: Now *that's* bogus. [ALL ponder]

CHRISSY: I don't know anybody who could help us but Judy Blume.

PETE: Is she in 4th grade?

CHRISSY: No silly, *Judy Blume. Judy Blume*, the author. She writes books about kids and their problems. She wrote one once about a girl who had something wrong with her back. I hope they make a movie out of it.

PETE: Judy Blume. Bad back. Give me a break. [rest of BOYS laugh, ad-lib, etc.]

PHIL: Hey, wait a second. You know, that's not a bad idea?

MARY: Writing Judy Blume? I'm sure she would write back. It's not like she has anything better to do. Right! No, that idea is definitely a waste of time.

PHIL: No, it isn't. Her books help kids with problems, don't they. Chrissy, you said you read one.

CHRISSY: Most of her books talk about solving a problem of some kind. I've read all of them.

PHIL: Well maybe, just maybe, she would offer to help us. We certainly have a problem, don't we? Don't we? [looks around] Well, don't we?

PETE: Okay, okay. Maybe she would help. It's worth a try. I'd go for it.

MARY: This is the most ridiculous idea I have ever heard in my— [CHRISSY finds paper and pencil and quickly gives them to MARY]

CHRISSY: [points to paper and pencil and to MARY] Dear Judy!

MARY: [looks at EVERYONE, then begins to write] Dear Judy. [crosses out] Dear Ms. Blume ... Have we got a problem.

[Music up]
[Blackout]
[All exit]
[Change scene]

Scene Five—School Hallway

Bare stage. [MARY is standing center stage, holding an envelope, looking at it. Enter EDUARDO]

MARY: [softly] It came.

EDUARDO: What? Hurry up, we're going to be late for class.

MARY: It came.

EDUARDO: What did you say?

MARY: I said, it came. The letter came.

EDUARDO: The letter from—? [BOTH nod] It came. It came. [gets really excited and begins yelling] Hey everybody, it came! It came! The letter came! The letter from Judy Blume came!

[KIDS enter from all directions and go directly toward MARY. As they near MARY, they begin slowing down. They surround MARY, finally stop, then silently stare at the letter]

PHIL: Well. [quietly] Open it. [MARY slowly opens it and reads, then puts letter down by her side]

MARY: [softly] She has an idea.

CLYDE: [even more softly] What did you say?

MARY: I said, she has an idea. She has a Thanksgiving play idea. It says so right here in the first sentence.

ALL: [in unison, looks at audience] She has an idea. She has an idea.

CLYDE: I feel another song coming on.

She's Done It

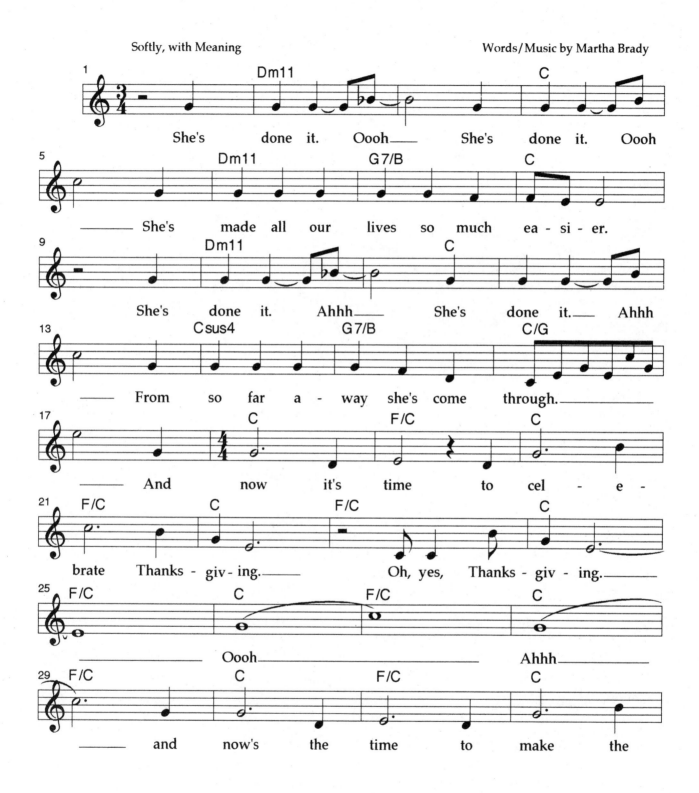

33 F/C C F/C C

best Thanks - giv - ing. _____ Oh, yes Thanks - giv - ing. _____

37 C F/C C

_____ Oooh _____ Ahhh _____

41 F/C Piano Solo C F/C C

Spoken (One Student): I know we haven't taken our responsibilities in this matter seriously.

45 F/C C F/C C

Sure, we waited until the last minute and we used our valuable time doing other things

49 F/C C F/C C

_____ Oooh _____ Ahhh _____

53 F/C C F/C C

____ like holding down two jobs after school and taking care of our little brothers and

57 F/C C F(omit 5) C

sisters, and gosh, school is hard and there are so many demands on our time, and Miss Gaston,

61 F/C C F/C C

well, she is nice, Oooh _____ Ahhh _____

65 F/C F/C C

_____ but she asks so much of us. However, now, with just a little help from Judy, er,

69 F/C C C

Miss Blume, we know we're on the right track. We are going to work together as one energetic

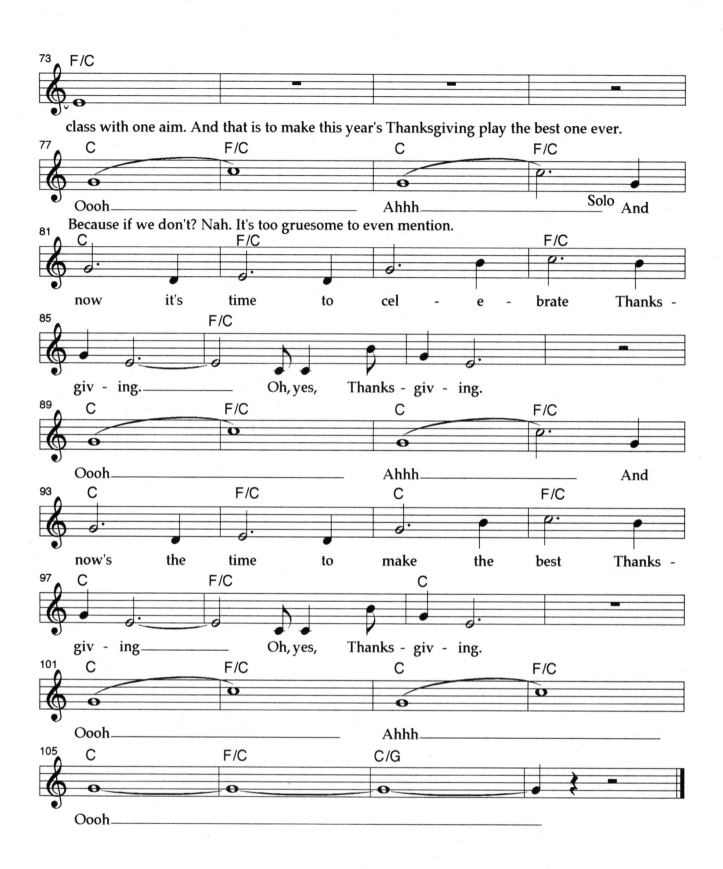

class with one aim. And that is to make this year's Thanksgiving play the best one ever.

Oooh_____ Ahhh_____ Solo And

Because if we don't? Nah. It's too gruesome to even mention.

now it's time to cel - e - brate Thanks -

giv - ing._____ Oh, yes, Thanks - giv - ing.

Oooh_____ Ahhh_____ And

now's the time to make the best Thanks -

giv - ing_____ Oh, yes, Thanks - giv - ing.

Oooh_____ Ahhh_____

Oooh_____

[Music up]
[Blackout]
[All exit]
[Change scene]

Scene Six—Rehearsal Hall

[bare stage with a bench, students in different degrees of dress and pose. Some have towels around necks, some are working with canes, some are rehearsing dance steps, some are stretching, etc.]

WAYNE: Are you sure this is what Judy Blume meant?

PETE: It said so right in the letter. [pretends to tap dance] This is the worst day of my life.

MORGAN: [twirling cane] This is impossible. I try and try but this cane keeps falling on my head.

CLYDE: You can say that again. I've got a football helmet if you want to wear it. Boy, do you look silly.

CHRISSY: Take that back, Wayne. Morgan doesn't look silly. At least she doesn't dance like a duck.

CLYDE: A duck? Me, a duck? Don't call me a duck. Hey, everybody, Chrissy called me a duck.

MARY: [to PHIL] No, no, no. Phillip. That is not the way to do it.

PHIL: Mary, you don't know everything. And don't call me Phillip. You're just as bad at this as I am. Maybe worse.

MARY: Now you take that back. I'm trying as hard as I can and you are so awkward that it's hard for me to teach you a thing.

CLYDE: I'm not doing this any more. It's stupid. It's all stupid.

CHRISSY: I'll never do this again. Boys can't learn anything.

PHIL: I wouldn't do this with you if you paid me all the money in the world. Girls think they know everything. [huffs]

[ad-lib frustration with each other. People try to help but become angry with each other. Noise becomes louder and louder] [enter MISS GASTON]

MISS GASTON: All right class, that's enough. Please be quiet. All of you, sit down. I said please be quiet and find a seat somewhere. Now … let's have a discussion, a nice calm discussion. What's going on here?

MACK: It's the letter Miss Gaston, the letter from Judy Blume.

MISS GASTON: You all got a letter from Judy Blume? *The* Judy Blume?

ALL: [ad-libs of agreements]

MISS GASTON: Why? Why did you receive a letter from her?

CHRISSY: [a bit sarcastically] Well, all of us, that is MARY wrote Ms. Blume a letter asking her if she would help us with a, er, uh, problem.

MISS GASTON: Problem? What kind of problem?

CLYDE: An, uh, an idea, sort of. That kind of problem.

MISS GASTON: What *kind* of an *idea* problem?

MARY: Well, Miss Gaston, we couldn't think of an idea for the last part of the Thanksgiving play so we thought Judy Blume might be able to help us.

PHIL: [gets letter from MARY] And she wrote us back with an idea. Right here, in the first sentence.

MISS GASTON: Let me see the letter. [gets letter from PHIL]

MISS GASTON: [reads from the letter] "Dear Kids, It was very nice receiving your letter and I am writing back to say that I think it is wonderful for your class to try to figure out an interesting way to end your Thanksgiving play this year. Have you ever thought of celebrating Thanksgiving with a lively dance using a hat and cane?"

PETE: See. That's the idea she gave us, using a hat and cane. But it's dumb. It's the dumbest thing I've ever done. These canes are stupid, but wearing these hats, well it's more than dumb, it's—

CHRISSY: [interrupts PETE] Miss Gaston, the boys don't even try. I wish they weren't in my class. I, uh, I wish they weren't even in this school. At all. I hope I never see any of them ever again. [ALL ad-lib anger, confusion, etc.]

MARY: [points at letter] It's all her fault.

MACK: Yeah, it's Judy Blume's fault. We should have never written the letter.

MISS GASTON: But did you really read her letter?

JAY: Of course we did, Miss Gaston. You even read it.

MISS GASTON: But did you read *all* of the letter? Not just the first sentence, but all of it.

JOHNNY: Who cares about the rest of the letter. She probably just gave us directions on how to look really silly when we danced.

[ALL nod in agreement]

MISS GASTON: I think it is something you need to hear.

PHIL: Do we have to?

MISS GASTON: I believe you'll want to. [opens letter and begins reading]

"Dear Kids, It was very nice receiving your letter and I am writing back to say that I think it is wonderful for your class to try to figure out an interesting way to end your Thanksgiving play this year. Have you ever thought of celebrating Thanksgiving with a lively dance using a hat and cane? I also was in many Thanksgiving plays that just had people sitting around a table eating food. When I was a child I always wanted to know how to tap dance. I always thought it would be such fun to celebrate Thanksgiving not only with food but by dancing as well. You know, a joyous ending to a wonderful day."

CLYDE: See!

MISS GASTON: [continuing reading from the letter] There's more. "Of course it doesn't matter if you are sitting around eating turkey or dancing around the

table with a hat and cane. What matters is the way you feel when doing it. Thanksgiving is a time to be thankful. Thankful for your friends, your school and especially for the chance to have the freedom to do and be anything you want to be. Good luck on your play. I know you'll be a great Thanksgiving team. Sincerely, Judy Blume."

MISS GASTON: Well. What do you think?

CLYDE: That was a long letter.

MARY: Yes, but did you hear what she said? What she really said?

PETE: I heard.

CHRISSY: I heard.

PHIL: I guess we all heard.

MARY: Miss Gaston, I guess what she said is true. We really don't have to be eating turkey, or sitting around a table, or any of that. It's really how we treat each other, isn't it?

PHIL: And it doesn't even have to be at Thanksgiving time or Christmas or Valentine's.

JOHNNY: It's being thankful. About everything.

PHIL: And everybody.

MISS GASTON: Everything and [pauses] everybody. I believe so.

[ALL look around and begin to agree and slowly smile]

CHRISSY: Well, I'm thankful that we read the whole letter. [EVERYONE ad-libs agreement]

WAYNE: And I'm thankful that we don't have to sing a song right here in this part of the play.

CLYDE: And now that we understand what Thanksgiving is really about, do we still use her idea?

PETE: The hat and cane?

[ALL begin to say a collective NO! but hesitate]

ALL: [loudly] YES! It's the best Thanksgiving idea we've ever heard.

MISS GASTON: Then what are you all waiting for?

PHIL: I think it's time to really show what Thanksgiving all about. Right everybody?

ALL: Right!!! [ALL exit. Enter PILGRIM and NATIVE AMERICAN and other characters]

PILGRIM: ... And as we celebrate the first Thanksgiving together, let us remember to ...

NATIVE AMERICAN: ... be thankful for our food, our health [pauses] and especially extra thankful for all the many people we love. So let us begin the celebration.

BOTH: Happy Thanksgiving! [At that, rousing MUSIC comes up, enter other cast members dressed in black turtlenecks, top hats and canes, dancing a lively ending number, such as "One" from *A Chorus Line*. Turn on blinking lights that have been strung across the front of the stage and if possible those that have been strung in the back of stage. Students are dressed alike, with top hats, canes, black turtlenecks, jeans, tennis shoes, etc. During part of the dance, quickly turn stage lights (or overhead lights) rapidly off and on, for effect.]

ALL: [at end of dance number] Happy Thanksgiving!

[Music up]

[ALL bow]

[Blackout]

[ALL exit]

The End

SUGGESTED SETS AND PROPS
Scene One—Walking to School

Backdrop of trees, house, school bus, etc., that gives the feel of a typical street. A freestanding fireplug made from an overturned trash can is a nice and simple addition to the scene.

Scene Two—PE Class

1 bench, 2 basketballs, a few towels.

Scene Three—Classroom

Chalkboard on wheels (optional), 4 benches facing diagonal from center, backpacks, books, etc.

Scene Four—Cafeteria

Sign that says TRAYS HERE, a few cafeteria trays that some students will be holding, a small table with a few trays on it.

Scene Five—School Hallway

Bare stage or two refrigerator boxes painted like lockers standing in back.

Scene Six—Rehearsal Hall

1 bench, towels, canes, top hats

Personal Learning Capacities

Where the intelligences are concerned, the most invaluable aspect of involving students in plays and children's musical is the inclusiveness of the process. Offering a classroom play experience guarantees, without question, that all of the intelligences will be addressed. Linguistically, for sure, students will have the opportunity of "bathing" in words, through expression, through characterization, through listening to other actors, through memorization. Using the capacity to work in group situations and knowing how to work in a group process is critical for the success of a play and allows girls and boys an interpersonal advantage. Students with visual/spatial and logical/mathematical capacities flourish in a play environment, as they can create flats and costumes, design backdrops and sets and solve problems relating to stage space. In fact, ask those kids and others to construct a scale model of each scene.

Every facet of a play is, by nature, kinesthetic. From learning lines to polishing characterization, from singing songs to acting, from building props to changing sets.

Go through this particular play, *The Thanksgiving Idea*, and notice how often students must use the capacity of movement to clarify an idea. During rehearsals, take note of those students who are at ease with this element of the play and those who are not. Plays and musicals are yet another excellent opportunity for watching how kids do what they do.

Although I do ascribe to process rather than product, there certainly are some advantages to drama activities. A children's musical is one of them. In the area of musical intelligence, children's plays that include polished, complete vocal musical selections offer kids a multitude of ways to strengthen their musical capacity for learning. The sounds, tones, rhythmic patterns and basic music ambiance that prevails in a children's musical most surely allow an arena for the musical intelligence to reap its rewards. Musical children thrive in this environment.

In ensemble work, such as plays, that end in a finished product, it is advisable to set a grounded tone, a looking inward for centering that allows the entire experience to remain focused and have reason. Awakening the intrapersonal sense of each child to that centering task is as valid as any song sung, any dance learned, any dialogue memorized. Give those babies time to reflect as you prepare for the big event, the performance.

Evaluation

Participation, appropriate behavior, staying in character, memorization of lines, voice projection, learning songs, listening skills, dependability, follow through, responsibility.

Community Activity

Select one student to document, with slide film, the entire undertaking of this play, from selection of cast to dress rehearsal and everything in between. Ask other students to design and set up something appropriate for a title slide, a cast list slide and a dedication slide. Have children arrange slides in appropriate sequence, select music that will fit nicely and enhance the slide presentation and show the slide show to the audience before the play begins. Parents will appreciate seeing all the hard work involved in putting a play together.

Reflection Question or Journal Entry

"Has anyone ever made fun of you before? Draw what that felt like."

"What is the thing you have done that has made you the most proud? Draw what that felt like."

Wrap-Up

Read *Chrysanthemum* once more. Talk about the main theme of that story again. Compare that theme with the theme in *The Thanksgiving Idea*. What were the similarities? The differences? Think of times during play rehearsals that you were kind and helpful. Talk about those times. Sit in a circle and go around the circle complimenting one person for a specific, terrific job well done in the play. Or write a "review" of someone's performance complete with a headline of the "review" created by piecing together parts of actual headlines in newspapers to make the headline personal and appropriate to that particular student. Collect and bind all of the reviews into a book.

Related Books

Asch, Frank. *I Can Roar*. New York: Crown Publishers, 1985.
Baylor, Byrd. Illustrated by Robert Andrew Parker. *Guess Who My Favorite Person Is*. New York: Aladdin Books, 1977.
Brown, Marc. *Arthur's Thanksgiving*. New York: Little, Brown and Co., 1983.
Carlson, Nancy. *I Like Me*. New York: Puffin Books, 1988.
Collins, Pat Lowery. Illustrated by Robin Brickman. *I Am An Artist*. Brookfield, CN: The Millbrook Press, 1992.
dePaola, Tomie. *The Art Lesson*. New York: Putnam, 1994.
———. *Oliver Button Is a Sissy*. New York: HBJ Publishers, 1979.
Facklam, Margery. Illustrated by Jeni Bassett. *So Can I*. Orlando: HBJ Puslishers, 1988.
Martin, Ann. Illustrated by Nancy Paydar. *Rachel Parker, Kindergarten Show-Off*. New York: Holiday House, 1992.

Related Music

Original Cast Recording. "One." *A Chorus Line*. Columbia, 1975.
Tickle Tune Typhoon. "Let's Be Friends." *All of Us Will Sing*. Music for Little People, 1984.

5
Cloudy with a Chance of Meatballs

by Judi Barrett
Illustrated by Ron Barrett
(NEW YORK: ATHENEUM, 1978)

Background

There are 199 people, 71 houses, 50 types of food, 34 animals, 32 birds, 24 different places of business, 22 boats, 2 sofas and 1 frog in *Cloudy with a Chance of Meatballs*, and those, I believe, are enough reasons for anyone to read this delicious book. If your students need an inch more persuasion, however, ask them to find 2 clocks, 2 kites and 1 strange "s" just sitting around sunning itself. In other words, get your children's observation skills working and you have got those short or medium tall folks hooked into what will be a pleasurable experience.

This whimsical book by Judi and Ron Barrett has been around for over fifteen years, yet every time I pick it up, I find something I missed the last time I read it. Chances are, when you last read this classic to your children, you missed something too. Here's hoping the accompanying activities in this chapter will be used to stimulate the observational skills of your girls and boys and assist them in learning and seeing something new this time around.

The text will be a focal point for some activities, but the kids will need a sharp eye to succeed in most of the creative arts events on the following pages. Good luck and don't forget your umbrella.

Hook
Materials

None.

Directions

Write these two words on the board: REALITY and MAKE-BELIEVE. Ask two students to find the definitions of these words in a dictionary and read them aloud. Write the definitions on the board:

> REALITY—The quality or state of being real. A real event.
> MAKE-BELIEVE—Imaginary, pretend.

Ask the kids to listen as you read this following short account of how you got to school this morning.

I woke up as usual around 5:45 A.M. and jumped out of the warm cozy cabbage patch that I had slept in the night be-

fore. I walked into the bathroom and turned on the shower. I climbed into the shower and let the hot, steaming chocolate spray all over me. I scrubbed my body with tree bark until it was squeaky clean then I got out of the shower and dried off with a nice soft pretzel. Wow, did I feel refreshed.

I dressed quickly, blow-dried my hair with my son's trumpet and then went into the kitchen to make breakfast. First, I fried some bacon, then scrambled three ears of corn. I put two pieces of wood in the toaster and poured myself a nice hot cup of liquid laundry detergent. I ate my breakfast, rinsed off the dishes and put them in the closet and went out to get into my car, a 1994 green Cucumber.

I backed out of the driveway and drove toward school. When I was half-way here I realized that I had no money for lunch so I stopped at an automatic teller and put my card in. Out came twenty walnuts, which was more than enough to purchase food from the cafeteria.

I arrived at school, got out of my 1994 Cucumber and came straight to class. I opened the door, walked into the room and got ready for the first lesson of the day. The bell rang and I erased the board with a live squirrel so there would be a clean surface ready for this lesson.

And here I am.

Discussion

The students will discuss things in the story that were real and things that were not. Take the discussion further by asking the boys and girls to relate stories they have read or movies they have seen which had reality based plots and those that didn't. This discussion can be a natural lead in to the reading of *Cloudy with a Chance of Meatballs*.

After you have read the book, spend long periods of time looking at the illustrations and discovering new things about each page. That really is the beauty of this story.

Personal Learning Capacities

This is a linguistic beginning with a bit of visual/spatial imagery thrown in. If your kids have not begun to articulate the many ways in which they learn, activities such as the one above really stimulate that

understanding. Hearing stories that have nonsensical elements not only hooks children quite readily, but typically engages their imagination. This one is perfect in that way, as most children will automatically visualize what you are verbalizing and can then use that tool as a means of explaining what they heard and saw.

Activity 1
Mobile

Materials

Clear fishing line
Coat hangers
Wire
Cardboard
Crayons/markers
Scissors
Tempera paints
Glitter

Directions

Students will reread the book and select one part of the book, which will be re-created as a mobile. For example, some students may wish to cut out and color hamburgers of all sizes. Some boys and girls may want to make hot dogs out of cardboard and tempera paint. Some children may wish to use small cereal boxes to re-create certain buildings in the town. Whatever the example, the objects will be strung on a mobile built of fishing line and coat hangers and hung on the ceiling of the classroom.

Students can then use these mobiles as catalysts for

♡ Writing poetry.

♡ Writing raps.

♡ Writing a script for a drama activity.

♡ Creating math problems.

Personal Learning Capacities

Mobile-making is a good sound activity that incorporates and stimulates several intelligences: logical/mathematical, visual/spatial, body/kinesthetic and intrapersonal. When the students have completed their mobiles, ask them what intelligences they used to insure success in this project. Be sure also to ask how they knew what intelligences were being used.

Evaluation

Good work, positive attitude, completion of task, appropriate assignment, staying on task, completion of extension activities.

Activity 2
Junk Machines

Materials

Aluminum foil
Wire
Coat hangers
Old clock parts
Old radio parts
Tin cans
Hole punch
Duct tape
Washers
Coffee cans
Wooden tongue depressors
Rubber bands
Empty film canisters
Eclectic "junk"

Directions

In *Cloudy with a Chance of Meatballs*, there are many obstacles that present themselves and various problems that must be solved. To name a few, there were too many pancakes, an overflow of spaghetti, green pea fog, a tomato tornado. Children can probably recount almost all of the situations in the book that caused some concern.

Pair students up and ask them to look at the illustrations that clearly show those problems. They are to think of one problem that could be remedied and construct a machine that will take care of that problem. For instance, the book shows the Chewandswallow Sanitation Department's cleanup truck that is in the shape of a knife, fork and plate. Also as part of the assignment the students will write a description of the machine and its specific function(s).

Once again, offer children as many choices of materials and supplies as you can to allow for optimal creative effort.

Personal Learning Capacities

This may be my favorite activity in the entire book. Why? Because it is so difficult for me. I can "see" my machine, but I have a heck of a time "creating" it. So, I know I need activities like this to stimulate intelligences I use less often. Kids, on the other hand, when they have all that junk in front of them, will make magic happen. And that's when learning occurs.

Evaluation

Completion of machine, teamwork, correct write up of description, connection to machine and function.

Activity 3 ◀ • • • • • • • •
The Daily Turnip

Materials

Sample newspapers, computers, glue, scissors, appropriate computer program.

Directions

Use this activity as a language arts episode whereby children work on their writing, interviewing, listening and reading skills. The children will simply retell the story of the events that occurred in Chewandswallow by means of a newspaper. This newspaper will include

1. Front page section
2. Sports section
3. "Arts and Leisure" section
4. Classified ads
5. Editorial section
6. Advertisement

The girls and boys will select a section of newspaper on which to work. Then using the information in the book that relates or that can be retold through their particular section, the students will create that particular section of the newspaper, formatted and all.

Examples might include

♡ Front page—Using the five "W"s (Who, What, Where, When, Why), students will basically retell the entire story of the events that occurred.

♡ Sports section—Students will select, from illustrations or text, events that are relevant to sports.

♡ "Arts and Leisure" section—Students may write a column about movies being shown in Chewandswallow, tea parties being given, best restaurants to frequent, social events, etc.

♡ Classified ads—Kids will use the same format as in regular newspapers and cover items such as "For Sale,"

"Help Wanted," "Houses for Sale," "Personals," "New and Used Cars," "Pets," etc. This section will be much fun to work on.

♡ Editorial section—Have students bring in editorial pages from authentic newspapers in order to get a sense of what letters to the editors, guest editors, guest commentaries, guest columns and such are all about. This section would also be a perfect place in which students or teachers from other grades who are familiar with *Cloudy with a Chance of Meatballs* may respond personally to the book.

♡ Advertisement—This will be an interesting section to work on and should include those kids who wish to draw or sketch, or students who need this kind of practice. This portion includes all the advertisement, whether it be for the existing businesses seen in the illustrations, or original ones evolving from visual clues in the book, such as tornado insurance, sandwich shops, raincoat stores, etc.

There are many good desktop publishing computer or newsletter programs that can be used to create the newspaper. This activity is an excellent example of using technology in the classroom. If, however, computers are not available, children can cut and paste the newspaper model and then make copies before putting the pages together. (Oh, by the way, whatever method you use, be sure to send me a copy when the paper goes to press.)

Personal Learning Capacities

Once again, most of your students will be able to find a successful slot in which to work during this project. Creating a newspaper is a linguistic endeavor, as the class needs to read existing newspapers and write and edit their own pieces. Also the mere putting together of the paper indeed requires good hand-eye coordination, thus involving the kinesthetic intelligence of your boys and girls. Designing the format of the paper itself as well as sketching and drawing ads involves the visual/spatial learning capability.

I think the most important aspect of a project like this is the teamwork required to accomplish it. All of the students who work on this experience will need to understand and use their interpersonal capabilities to ensure positive success. And if no other intelligence is really awakened except the interpersonal one, it is certainly well worth the time and effort needed for that to happen.

Evaluation

Teamwork, staying on task, completion, correct spelling, correlation of personal endeavor to book, appropriate behavior, correct sentence structure, correct capitalization and punctuation.

Activity 4 ◀ • • • • • • • • • •
As Chewandswallow Turns

Materials
Cardboard boxes (different sizes)
Microphones
Markers
Butcher paper
Crayons
Costumes, hats, scarves
Slide projector (optional)
Video camera
Film projector (optional)
Appropriate theme music

Directions
Here is a very organized but energetic informal drama activity that allows your students to once again see *Cloudy with a Chance of Meatballs* in a different way. The set-up is very simple, there is no memorization to speak of and the kids can improvise, yet they must show some knowledge of the content of the story in order to be successful.

Students will use different television genres in which to relate experiences that happened in the book. Divide the students into four equal groups. Each group must choose to work in a particular television area:

Soap opera
The 6:00 news
Sports casting
Weather forecasting
Situation comedy
Other

Each group will choose one of the above television examples and create an appropriate verbal drama scenario that shows or tells something that occurred in the book. In other words, parts of the book will be retold "television style." Like flipping through channels, the teacher or a selected student will aim a "camera" at certain groups. When the camera is pointing to a group, that group must "perform." When the camera points to another group, the new group begins to perform and the previous group freezes and waits until the camera points to them again. When the camera returns to their group they continue where they left off.

Set the space up in a way that each group is in a different area of the room. The television "camera" can be one constructed of two cardboard boxes of different sizes or a film strip or slide projector. The whole point is to move the camera around about every 20 seconds so that groups perform short excerpts of their retelling, freeze when the camera is off them and continue again when the camera is back on them.

It works really well when all groups function in front of an appropriate "set." That is, the weather skit should be in front of a weather map. The news skit should occur in and around a news desk. The soap opera skit could occur in a living room set, etc.

Also, ask students to find music that might be appropriate to their particular TV program. There are several tapes that include television theme songs that can be purchased at local record stores. Don't forget to video tape this activity too.

Personal Learning Capacities
Ask the students to name the intelligences they used for each aspect of the activity in which they took part. Did the linguistic students stick to the linguistic part of the activity? Did the logical/mathematical girls and boys stay in their safe realm? Who used intelligences that had not been used as frequently? What did the girls and boys learn about their own capabilities?

Evaluation
Completion of task, staying in character, building a believable character, appropriate behavior, participation, correct vocabulary.

Community Activity
(Weather Book)
It's time for a field trip. Set up a trip to the local TV station where your class can interview the weather person. Be prepared with questions beforehand because the field trip idea has an ulterior motive, which is gathering information for a weather book that will be put together when the class returns to school.

At the television station ask the weatherperson these and other questions:

1. What causes tornadoes to form? How often do they touch down? Where are they more likely to appear? What makes them different than other weather conditions?
2. What is a typhoon? Is it dangerous? What are misconceptions about a typhoon? Where do typhoons usually exist?
3. What is sleet? How is it different than snow or hail?
4. What is a cold front?
5. What conditions must prevail for a hurricane to form?

Students will select one aspect of weather. They will take notes on that aspect while at the television station, then they will continue gathering information by going to the school library to complete their report. The report will be condensed, and an appropriate piece of art work will accompany the report. All of the reports will then be bound into one laminated book.

Reflective Question or Journal Entry

*"What is the best thing
you can do on a rainy day?"*

Wrap-Up

Before you end your experiences with this particular book, contact your local PBS television station and ask for information on *The Savage Skies*, a four-hour television series that shows, in dramatic fashion, the devastation and destruction caused by certain weather conditions, such as tornados, hurricanes, snow, etc. It might be an excellent way to redefine the difference between reality and the make-believe weather of *Cloudy with a Chance of Meatballs*.

Finally, have your students sit comfortably one last time as you begin telling the story of *Cloudy with a Chance of Meatballs*. At some point in the story, stop talking and ask a student to continue telling the story. At some point during that telling, stop the student and ask another student to con-

tinue telling the story. Follow this procedure until the entire story has been told. Then talk about why it was so easy to remember every little aspect of the story.

Related Books

Aardema, Verna. Illustrated by Beatriz Vidal. *Bringing the Rain to Kapiti Plain: A Nandi Tale.* New York: Dial Books, 1981.

Burton, Virginia Lee. *Katy and the Big Snow.* New York: Houghton Mifflin Co., 1971.

Cole, Joanna. Illustrated by Bruce Degen. *The Magic School Bus Inside a Hurricane.* New York: Scholastic, 1995.

Harshman, Marc. Illustrated by Mark Mohr. *The Storm.* New York: E.P. Dutton, 1995.

Sanfield, Steve. Illustrated by Jeanette Winter. *Snow.* New York: Philomel, 1995.

Scheer, Julian. Illustrated by Marvin Bileck. *Rain Makes Applesauce.* New York: Holiday House, 1964.

Wiesner, David. *Hurricane.* New York: Clarion Books, 1990.

Zolotow, Charlotte. Illustrated by Stefano Vitale. *When the Wind Stops.* New York: HarperCollins, 1995.

Related Music

Braheny, Kevin and Tim Clark. *Rain.* Hearts of Space, 1995.

Fink, Cathy. *When the Rain Comes Down.* Rounder Records, 1988.

In Harmony with Nature. *Whispering Winds.* Madacy Records, n.d.

Muldaur, Maria. *On the Sunny Side of the Street.* Music for Little People, 1992.

6
The Great Kapok Tree

by Lynne Cherry
(NEW YORK: HARCOURT BRACE JOVANOVICH, 1990)

Background

The following activities that use as a basis the beautiful children's book *The Great Kapok Tree* by Lynne Cherry, have a sense of community about them. These activities offer children the chance to learn more about the rain forest, but more importantly, they offer ways for girls and boys to learn more about themselves.

Mostly kinesthetic and visual in nature, the experiences on the next few pages will give your students the opportunity to "see" the rain forest in different ways—through music, through art, through imagery. And while many of these activities require your students to work together toward a common goal, there will be instances where children can work alone.

Whether the kids work together or by themselves, I am hopeful that a feeling of "one place in time" becomes apparent, much like the same feeling captured in *The Great Kapok Tree*. A gentle feeling of community.

Hook
Materials

A selection of percussion instruments
Rainstick
Digital Encyclopedia of Sound Effects (The Special Music Company, Essex Entertainment, 87 Essex Street, Hackensack, NJ 07601)

Directions

Set the mood with quiet. Children will sit or lie in safe comfortable places in the room. With lights out, they will listen as you play a tape of forest sounds, which include birds, wind, rain, monkey chatter, etc. Space the sounds with silence so that the students can create their own images. If you have children of your own at home, ask them to create this tape for you, using sound-effects tapes and original sounds.

Now play a variety of percussion instruments, such as a rattle, drum, cabasa, recorder or some other South American–type instrument that your music teacher will let you borrow for this activity. Finish by slowly turning a rainstick around and around so that the stones or seeds inside have a chance to work their way down through the spikes.

Discussion

Lead a discussion on what the students heard or imagined. How did they feel as they listened to different sounds? What sounds were familiar? What sounded strange? Were some sounds funny? Did some sounds seem sad? Talk about the instruments. What do they look like? How are they made? Do they sound like sounds heard in nature? Which ones?

Now gather your children around you and read *The Great Kapok Tree*.

Personal Learning Capacities

Using guided imagery in an activity or creating a scenario that requires active imagination, such as the one mentioned above, is an excellent way of teaching to the visual/spatial learners in your classroom, those kids who must "see" in order to learn best. In addition, the logical/mathematical students can sequence the sounds once they have been played and categorize them according to birds, animals, humans, etc. The verbal/linguistic students, who naturally have highly developed auditory skills, will be able to listen to the sounds and redefine them by creating new onomatopoeic words that can then be used in poetry, scriptwriting or oral storytelling.

► Activity 1
Musical Rainstick

Materials

Paper towel rolls
Christmas wrapping rolls
Birdseed
Straight pins
Clear packing tape
Duct tape

Directions

Rainsticks are ceremonial musical instruments found in ancient and present-day Chile and other Southern Hemisphere countries. Used primarily in ceremonies to bring much needed rain to certain regions, these sticks are soothing to the ear and bring a quiet sound of gentle rain. They work successfully as a percussion instrument or a prop for

storytelling. Some children may simply want to quietly handle them.

Play appropriate rain forest music as intermediate age children create their own rainsticks:

1. Provide one paper towel roll or Christmas wrap cylinder per child.
2. Stick straight pins into the cylinder at random.
3. Close one end of cylinder with duct tape or packaging tape.
4. Insert a small handful of birdseed into the cylinder.
5. Close the other end of the cylinder with duct tape or packaging tape.

It is recommended that younger children not use straight pins. Tubes, tape and birdseed will work just fine for them.

Personal Learning Capacities

What a way to activate the musical/rhythmic intelligence of those kids in your class who learn best through music, sound and rhythm. By making the rainsticks themselves, these musical learners can create the sound (more birdseed, less birdseed, more pins, fewer pins) that is the most pleasing to them while the logical/mathematical learners can answer those "what and how" questions as they problem-solve the best placement for the straight pins, as well as the amount of birdseed to be used. The intrapersonal students may succeed with this activity in a big way too, as this independent project allows them to think things through by themselves, and by working alone, they are responsible for the final outcome.

Evaluation

Completion of project.

Activity 2
Rainstick Stories

Materials

Tempera paint, paper plates, nature objects, newspapers, paper towels.

Directions

Once the rainsticks are completed, students will go outside and collect three objects of nature, such as small rocks, sticks, clumps of leaves, small twigs with leaves attached, pieces of wood, etc. Ask the students to think of one "chapter in their life," one event or one experience that they wish to share with the rest of the class. They will then "write" that chapter or event onto the rainstick in the form of pictures or symbols that illustrate that particular life chapter. The children will use tempera and use the three found objects as "paintbrushes" to apply their symbols and paintings onto the rainstick. (If tempera paint is poured onto paper plates, several students can use one color at a time.)

When the students have finished drawing their stories onto the rainsticks, quietly play an appropriate rain forest tape and ask the students to sit on the floor in a circle and share their stories. Modeling is very appropriate here, so it would be nice if the you are the first person to share a rainstick story.

Personal Learning Capacities

The visual/spatial learners will have a heyday drawing their pictures and symbols, dabbing and mixing colors, using their "paintbrushes" in just the right way for just the right texture. They will sit back and look and think, and mix colors again for that perfect hue. And because they use their imaginations so well, expect their finished product to be interesting, a bit different and extremely well done. They will also use their picture as a guide when they tell their stories. It's what makes sense to them.

And what about those girls and boys who love everything about words, the sound a word makes, the shape of the letters, the look of words in print, the feel of words in their mouths, on their tongues. My, oh my, what an activity for the verbal/linguistic children. They will not hesitate to tell their story. It will be done crisply, with depth and exaggeration, possibly with a little humor added, and it will be done well. They will listen to other stories too, listening for words they have not heard or don't understand. Later, they may even want to write down their stories or even make a list of all of the new words they hear. Whatever, the oral storytelling will be the most important aspect of the activities surrounding *The Great Kapok Tree* for those students who love every thing about language.

Evaluation

Student's appropriate behavior, completion of task, teamwork, student participation.

Activity 3
Music and the Rainstick

Materials

Percussion instruments, song sheets.

Directions

As you and the students read *The Great Kapok Tree* again, ask the children to make a list or write on the board, or simply remember, the characters mentioned in the book. Ask them to categorize the different animals and birds and possibly even the characters who were given the power of speech by

the author and the characters who were illustrated on the pages but didn't speak. Now teach "It's My Home," on page 48. Once the children know the song, give them a chance to insert the names of other animals into a line of the song. For example

> It's my home, I'm the jaguar, It's my home, here in the rain forest, It's my home, I'm the jaguar, what are you doing to my home?

becomes

> It's my home, I'm the boa, It's my home, here in this big tree, etc.

or

> It's my home, I'm the butterfly. It's my home, here on the branches, etc.

As a change of pace, ask students to create new words for the song by looking only at the pictures. This will come very easy for some students, as the pictures are far more important in the understanding of the book than the text. It is also critical to give equal time to the efforts of the illustrators, for to validate the illustrators role in children's books is to pay honor to the importance they play in the overall integrity and, certainly, clarity of the book. In this particular case, Lynne Cherry is both writer and illustrator, so her vision and words really do offer the oneness of thought this book presents.

This is also a great time to use the rainsticks again. Let the kids accompany themselves with their rainsticks as they sing "It's My Home" and listen to the other rain forest songs whose titles are included at the end of this chapter.

Personal Learning Capacities

Here come the hummers and tappers, those musical learners who know every piece of music ever written. Of course these students will learn this song in a second, then turn around and play their own rhythm as they sing it. Watch them when they use the rainstick. They'll use their little homemade instrument in ways you haven't imagined. What fun! These children who are tuned into their musical intelligence will take this activity and learn everything about *The Great Kapok Tree* through the words and music of this song. They will ask to sing the song over and over so they can try different beats and listen to different sounds being made. They will even take a song sheet with the words deleted and put new words under the right notes, in the right place. Even those word lovers, your verbal/linguistic students will take to this. Ways of knowing, you bet.

Evaluation

Listening for accuracy, observing movement to music, student participation, rainstick accompaniment to music, staying on task.

Activity 4
Choral Reading

Materials
Copy per child of the choral reading piece.

Directions
Choral reading is a very successful teaching tool. This particular activity reinforces the book *The Great Kapok Tree* and gives children a chance to "live" the story. Select six children to read aloud the six different parts. A dry run is always very important. It gives the kids a chance to tackle hard-to-pronounce words. Next, group all the boys and girls appropriately and perform this reading once or twice. Give the groups a minute or two to decide on their particular "voices," then have them read their particular lines again. By incorporating this type of linguistic activity, *The Great Kapok Tree* will make even more sense because the children themselves are now an integral part of the story.

The Sun Is Hot
1: The sun is hot. Very hot. And there is not much air.

2: The sun is hot. Very hot, And there is not much air.

1, 2: The sun is hot. Very hot. And there is not much air.

4: I walk into the forest. The thick, thick, forest. I walk into the forest. Hear my sounds.

2: The sun is hot. Very hot. And there is not much air.

1: The sun is hot. Very hot. And there is not much air.

4: What should I cut? The tall, the small. What should I cut? All? All?

1: The sun is hot. Very hot. And there is not much air.

2: The sun is hot. Very hot. And there is not much air.

4: I see the tree. The perfect tree. Gigantic tree. Stupendous tree. Cut it down. Cut it down. Cut it down now.

5: Whack! Chop! Whack! Chop! Whack! Chop! Whack ! Chop! Whack! Whack! Whack!

4: I am tired ... tired ... tired ... I am tired. I want to sleep.

1: The sun is hot. Very hot. And there is not much air.

1, 2: The sun is hot. Very hot. And there is not much air.

3: SSSSsssssssssssssssss. I slither down to take a peek. This man. He's in my house.

It's My Home

Words/Music by Martha Brady

Nice and Even

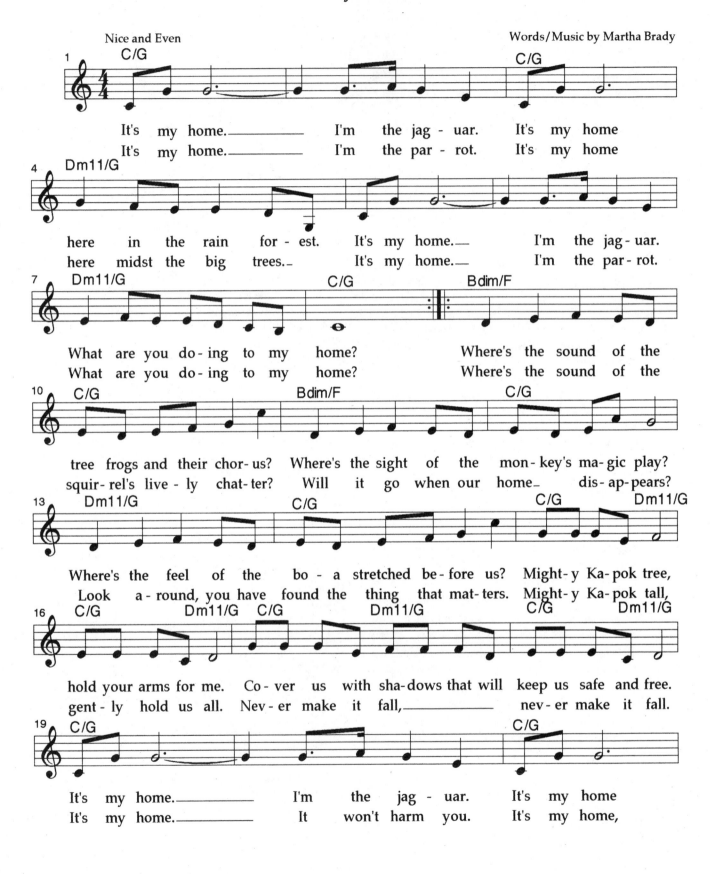

It's my home.———— I'm the jag - uar. It's my home
It's my home.———— I'm the par - rot. It's my home

here in the rain for - est. It's my home.— I'm the jag - uar.
here midst the big trees.— It's my home.— I'm the par - rot.

What are you do - ing to my home? Where's the sound of the
What are you do - ing to my home? Where's the sound of the

tree frogs and their chor - us? Where's the sight of the mon - key's ma - gic play?
squir - rel's live - ly chat - ter? Will it go when our home— dis - ap - pears?

Where's the feel of the bo - a stretched be - fore us? Might - y Ka - pok tree,
Look a - round, you have found the thing that mat - ters. Might - y Ka - pok tall,

hold your arms for me. Co - ver us with sha - dows that will keep us safe and free.
gent - ly hold us all. Nev - er make it fall,———————— nev - er make it fall.

It's my home.———————— I'm the jag - uar. It's my home
It's my home.———————— It won't harm you. It's my home,

here | in | the | rain | for - est. | It's | my | home._____ | I'm | the | jag - uar.
here | in | the | rain | for - est. | It's | my | home,_____ | let | it | warm you.

What | are | you | do - ing | to | my | home?_____
What | are | you | do - ing | to | my | home?_____

6: BBBZzzzzzzzzzzzzzzz. I dart and dash across his face. Why is he resting at my door?

5: Chatter, chatter, chatter, chatter, chatter chatter chatter. Who invited him here. Did you?

3: SSSsssssssssssssssssssss. Not me.

6: BBBzzzzzzzzzzzzzzzzzzz. Not me.

1: The sun is hot. Very hot. And there is not much air.

Narrator: And the creatures came, one by one, to look at the man and ask, "Do you know him?"

1: Not me.

2: Not me.

3: Not me.

5: Not me.

6: Not me

1, 2, 3, 5, 6: NOT ME!

3: He's waking now. We were too loud. We must not run. We must not run. We must be still … still … still.

4: [Yawn] I slept too long, too long. I slept too long. It's time to cut.

1: The sun is hot. Very hot. And there is not much air.

2: The sun is hot. Very hot. And there is not much air.

4: How beautiful … too beautiful … too beautiful to cut … too beautiful to cut.

3: He's leaving.

5: He's leaving.

1: He's leaving.

6: He's leaving.

2: He's leaving.

1: The sun is hot. Very hot. And there is all this air.

1, 2: The sun is hot. Very hot. And there is all this air.

1, 2, 3: The sun is hot. Very hot. And there is all this air.

1, 2, 3, 5: The sun is hot. Very hot. And there is all this air.

1, 2, 3, 5, 6: The sun is hot. Very hot. And there is all this air.

Narrator: The sun is hot. Very hot.

Now comes the best part. Give your girls and boys time to write their own choral rendition of *The Great Kapok Tree*. It's the best thing you can do.

Personal Learning Capacities

Need I say that this is the verbal/linguistic child's dream. To read, to read, to read. The interpersonal students are smiling too, as they interact with other students and work toward a common theme.

Evaluation

Effort, staying on task, teamwork, listening skills, appropriate responses, vocal interest.

Activity 5
Imagery

Materials

None.

Directions

With or without music in the background, ask students to get in a comfortable position while you take them on an imaginary trip. Any of the related music selections at the end of this chapter will work to set the correct mood if you choose to use music. Read slowly and clearly to insure success with imagery activities.

The Jungle
by Martha Brady

I want you to get in a comfortable place. A place that feels good and safe and pleasant. If you need to lie on the floor, please do, or if your desk is exactly where you want to be, that will be fine too. Now, close your eyes and begin taking some deep breaths. I hear your breathing now. Very good. As you exhale try to let all of the breath out of your lungs. Very quietly. Yes, that is the way.

You are now breathing very evenly, very quietly, and as you do you find that your entire body is beginning to move. It is moving without your help, all on its own. You are moving up, up, up, through the clouds, past flocks of birds. As you look down, you see the ground far below you.

Everything looks so tiny. There are tiny buildings, tiny cars, tiny railroad tracks. You are lying on your back as you move through the clouds. This is more comfortable for you. You begin to close your eyes as you move through the clouds and then you begin to gently lower yourself toward the earth. Slowly, slowly, very gently. You feel your feet touch the ground. You hear the sound of animals and birds and the wind.

You open your eyes now and find that you are in a jungle. A green overgrown jungle. In front of you are huge vines and plants with large, large leaves. Everything is so green. Off to your right you see a small trail. You begin following the trail. It winds deeper and deeper into the jungle. In the trees above you are hundreds of monkeys, all swinging back and forth from the tree limbs. You try to grab the tail of one, but it skitters away and swings to another tree. You laugh at its playfulness.

As you walk on the path, you come to a clearing and there in front of you is a small beautiful lake. The water is so clear you can almost see to the bottom. There are red and pink and yellow flowers surrounding the lake. You can smell them. Such a sweet wonderful smell. In the lake you see fish that are the color of the sun. Large fish with golden scales. They swim and jump up out of the water like porpoises. You wish you could jump in and swim along with the fish.

You walk around the lake and continue on the path. Soon you come to a sprawling tree with hundreds of birds sitting on its tree limbs. The tree reminds you of a rainbow. You look to the very top of the tree and wedged very carefully among two very large branches is a treehouse. Your treehouse. The tree has a ladder attached to its side. The ladder will make it easy for you to get to your house. You climb the ladder. Up, up, up you climb. High off the ground. Safe. You crawl into the treehouse and find a piece of fruit on the table. You are hungry. It has been a long journey. You eat the piece of fruit.

I am going to slowly count to 10. When I have finished I want you to open your eyes, stretch a bit, then I want you to write me a story about how you came to live in the treehouse in the jungle. 10, 9, 8, 7, 6, 5, 4, 3, 2, 1.

Students should have a choice of writing, speaking, acting or drawing their answers.

Personal Learning Capacities

Using the "mind's eye" is never more apparent than with guided imagery activities. Therefore, you can rest assured that your visual/spatial girls and boys will readily succeed in this experience. It is what they do easily. However, for those kids in class who don't function in their spatial intelligence as often as they could, this imaginary trip is just what the doctor ordered. It is one more opportunity for those boys and girls to work on an intelligence that isn't quite as strong as some of their others. That's what teaching is all about, isn't it? Giving all kids a chance to succeed?

The intrapersonal kids will thank you for this too, as it gives them another chance to "go inside."

Evaluation

Appropriate behavior, listening skills, completion of task, creative conclusion.

> · · · · · · · · · ▶ **Activity 6**
> **Some Creatures Slither,**
> **Some Creatures Fly**

Materials

Cassette player, blank tape, list of rain forest creatures, scarves.

Directions

Having children define or describe what they know through body movement is such an easy task. Wonder why we don't do more of that. Too much noise, too little space, too little time, too much concern. Perhaps so, but what if we were to spend time watching what our kids do with their bodies? Maybe, just maybe, we could learn a bit more about their abilities, their attitudes, their wants, their questions, their answers, their ways of understanding.

This movement activity gives your girls and boys a chance to explore how animals move and why they move the way they do. It also gives them a chance to "sense" what that animal really is.

The children must do a bit of research before this activity can begin. Make a list of animals and birds that live in the rain forest. Such creatures might be tree frogs, tapirs, three-toed sloths, tree boa constrictors, toucans, squirrel monkeys, anteaters, ocelots, parakeets, tree porcupines, macaws, spider monkeys, jaguars, army ants, peccaries and many kinds of butterflies. Let the boys and girls select one

or two creatures on which to gather information. The school or town library is an excellent place to start. If you live in a city that has a zoo, make a phone call, or better yet, take a trip to the zoo and locate appropriate zoo personnel who will help in your research.

Once the research has been completed and the children have a sense of how their particular creatures move, begin a dialogue with your children about their creatures. What sound might their creatures make? Where are their homes in the rain forest? Do they live in the middle layer, somewhere in the canopy or hidden in the understory? Do they ever walk the forest floor? How would the creatures move? Would they fly or flit or slither? Would they perch or leap or scurry? Give each child one or two scarves to be used as props in helping define their creatures. Children who are butterflies might use the scarves as wings. Children who are monkeys might use the scarves as tails. Girls and boys who are frogs might use the scarves as tongues.

Place a tape recorder in the middle of the room. Ask the children, one at a time, to go around the room, making sounds and movements appropriate to their creatures. Tape the sounds. When everyone is finished, replay the tape. Initiate a conversation about the sounds and give the children a chance to name all of the creatures.

Personal Learning Capacities

The bodily/kinesthetic girls and boys may not want to necessarily read or write a report about an ocelot, for instance, but if those students have a chance to *become* the ocelot, make sounds the ocelot might make or create an appropriate scenario for the ocelot, then this exercise will make sense to them. Let the kinesthetic children tell their stories or give their information by moving or acting in a dramatic format. Again, it is their way of knowing. Remember that random moving, or moving without purpose, is not a true measure of kinesthetic capability. Kids must have a purpose, a reason to tap into the kinesthetic side.

Finally, this add-on activity taps into your musical/rhythmic children as well because of their ability to hear tonal quality, understand music patterns, etc.

Evaluation

Movement participation, appropriate responses, effort, teamwork, paying attention, positive interaction.

Community Activity

Play the tape of the accumulated sounds just made by the students or perhaps a selection of rain forest music that you have played during a previous activity. With whatever tape you choose, let your entire class respond to those sounds in ways that best fit them, individually. Some students may want to write another ending to *The Great Kapok Tree*, while some students may want to create creatures with clay. Others may want to use scarves to dance and move around the room. Still others may want to draw with water colors or

tempera paints. You may have a few who wish to graph the animals according to size or species. Several may want to work together and make a salt map of one tropical rain forest of the world. One child may simply wish to listen and imagine. Share these wonderful contributions with each other and possibly another class or two. And finally, gather the children around one more time as you read *The Great Kapok Tree*.

Reflective Question or Journal Entry

"What means more to you than anything? How would you take care of it?"

Wrap-Up

To conclude this exciting trip into the rain forest, sit with your students in a circle on the floor and ask them, one at a time, to show you, through pantomime, one thing that they learned about the rain forest through the activities that were presented. Now give them each a piece of fruit and relax for a bit.

Related Books

Baker, Jeannie. *Where the Forest Meets the Sea*. New York: Green Willow Books, 1987.

Cowcher, Helen. *Rain Forest*. New York: Straus and Giroux, 1988.

Dunphy, Madeleine. Illustrated by Michael Rothman. *Here Is the Tropical Rain Forest*. New York: Hyperion Books for Children, 1994.

Gibbons, Gail. *Nature's Green Umbrella*. New York: Morrow Junior Books, 1994.

Leesem, Don. Illustrated by Michael Rothman. *Inside the Amazing Amazon*. New York: Crown Publishers, 1995.

Related Music

Andina, Savia. *Classics*. Sukay Records, 1993, 3315 Sacramento Street, San Francisco, CA 94118.

Baka Beyond. *Spirit of the Forest*. Rykodisc USA, 1993, Pickering Wharf, Building C, Salem, MA 01970.

Heart of the Forest. *Music of the Baka Forest People*. Rykodisc USA, 1993, Pickering Wharf, Building C, Salem, MA 01970.

Hooper, Richard. *Tropical Rainforest*. World Disc Productions, 1994.

Inkuyo. *The Double-Headed Serpent*. Celestial Harmonies, 1993, P.O. Box 30122, Tucson, AZ 85751.

Jay, Stephen. *Africa*. Elektra Records, 1976.

Lewis, Brent. *Earth Tribe Rhythms*. Ikauma Records, 1992, Los Angeles, California.

Oldfield, Terry. *Spirit of Africa*. New World Cassettes, 1993.

Williams, Anne. *Song of the Jaguar*. Earthsong Productions, 1989, P.O. Box 780, Sedona, AZ 86336.

7
The Greedy Triangle

by Marilyn Burns
Illustrated by Gordon Silveria
(New York: Scholastic, 1994)

Background

Some time back I asked a second grader to define a circle. Without hesitation, he looked at me and said, "It's what you find under a round rock." I wish I had come up with that definition when Mr. Blankenship asked me the same question in high school geometry class so many years ago. I didn't have that definition then, and consequently felt, at least in terms of math, algebra and geometry lingo, that my IQ was the same as my shoe size.

Because of that educationally bleak moment in my life, I have spent a fair amount of time thinking about this thing called "math." Not necessarily that the area of a rectangle equals length times width, or that to find a perimeter we simple add all four sides, but something a bit more important. It is the question "Where do my senses spend their weekend when I'm working in my head?" In other words, how can the rest of my body enjoy all that is math in ways other than diameter, circumference and the like?

Marilyn Burn's *The Greedy Triangle* gives us a glimpse of where those senses reside. This delightful book creates an atmosphere in which we can use intelligences other than the logical/mathematical to understand or at least appreciate geometric shapes. I loved this book immediately and knew that after reading it, I would look at the shapes that make up this world a little differently.

This chapter, therefore, deals with using our senses and creative expressions to understand and appreciate the shapes of things around us. And when it's all over, hopefully we will be able to define circles and other equally intriguing geometric concepts as deliciously as that smart little second grader.

Hook

Materials

None.

Directions

Students will stand face to face with a partner. The teacher will say "Go," and the girls and boys will have 1 minute to locate things on each other's bodies that have round shapes.

Once again, they will stand face to face with partners and locate things on each other's bodies that have square shapes. Working alone, students will then have 1 minute to look around the room to find objects that are triangular in shape. Once these events have been accomplished, seat everyone comfortably and read *The Greedy Triangle* by Marilyn Burns, illustrated by Gordon Silveria.

Discussion

Now that the class is in the mode of observing the shapes of things, let's get more specific. Ask the youngsters to really look closely at the illustrations in *The Greedy Triangle* and call out all the different shapes that can be seen on each page. Write the words "circle," "square," "triangle" and "rectangle" on the board and begin making a list of geometric objects the children notice in the illustrations.

Finally, ask children to go outside and find three things that are triangular in shape. Bring the objects back into the room, place them on a table and ask the youngsters to give them all personal names. (That information will come in handy later on.)

Personal Learning Capacities

As a classroom teacher, it becomes apparent fairly quickly that most kids breeze through class with their eyes at half mast. With my own child, I often wondered if he ever actually "saw" anything during the course of the day. It seemed that I always had to remind him to pick up something, put something back, retrace his steps, watch for cars, etc. Most days are like that until you mention the two magical words, "scavenger hunt." Then the backs straighten, the heads turn and the eyeballs roll around in their sockets. You've got 'em.

Scavenger hunts work because there is a sense of competition about them, the experience is kinesthetic and the whole episode is usually a race against time. To be successful, however, students will need to attend to a few things. They must concentrate on observing, problem-solve by looking in the right areas and have the ability to move around appropriately. So we have a good strong kinesthetic activity that requires kids to function at their visual/spatial level as well.

Activity 1
Triangle Stories

Materials

None.

Directions

Students partner up and write a poem, song, rap, puppet play or story about the three or six triangle-shaped objects they brought in from outdoors. For older students you may want to ask them to use the three objects in their stories as turning points for some event in history. For example, if one of the objects is a triangle-shaped rock, it might have been the rock that Lewis and Clark found to correctly direct them westward.

In addition, if there is time, ask students to illustrate the stories as well.

Personal Learning Capacities

This is another writing assignment that is a bit directed but still allows students to take ownership in its content. Your verbal/linguistic children will work successfully in this endeavor, and you may wish to pair them with students who function at a lower level in this intelligence. For the logical/mathematical students, activities such as this one offer these youngsters an opportunity to work in that intelligence as they map out the story in sequential order before it is written.

Also, if you give kids a wide choice in their writing, such as song lyrics, rap, etc., then students will have a chance to hone in on their own personal capacities, and we certainly know what the results will be.

Evaluation

Completion of assignment, sequencing that makes sense, teamwork, evidence of creative effort.

Activity 2
Me and My Shadow

Materials

None.

Directions

Here is a quickie. Take the kids outside in the morning when the shadows are profuse, and ask them to find as many round, square, triangle or rectangle shadows as they can. They will make a list of the shadows then come back into the room and have a discussion about their discoveries.

Personal Learning Capacities

Kids who appreciate activities such as this one are functioning in their visual/spatial intelligence. Shadow watching, which can also conjure up some reflective thought and imagery episodes, is also a pleasing experience for the intrapersonal child.

Evaluation

None.

Activity 3
Touch and Chant

Materials
Objects mentioned above, cardboard box with lid.

Directions

Fill a covered box with small round, rectangular, square or triangular objects. Students one at a time will reach into the box and grab an object. Without pulling the object out, they must describe the object they are touching to the rest of the class who will try to figure out what the object is. Suggested objects include marble, small match box, ruler, quarter, dime, penny, die, domino, small envelop, floppy disk, balloon, cassette tape, rubber ball, rubber band, round rock, Popsicle stick.

Once the objects have been removed from the box and described, place them on the floor so all the children can see them. Then begin a body rhythm, such as thigh pat, hand clap, finger snap, hand clap, over and over. With that rhythm, students will create chants that apply to the objects in front of them. Start them off with these little ditties below that have a missing word. Students must think of, then call out the missing word for each chant. Begin the body rhythm first.

1. Marble is round, marble is round, marble is round
 You find it on the _____. (Ground)
2. Copper penny, copper penny, throw it in the water
 You don't have _____. (Any)
3. Popsicle stick, Popsicle stick, swallow it and
 It will make you _____. (Sick)
4. Rubber band, rubber band, it makes a circle
 When you hold it in your _____. (Hand)

Personal Learning Capacities

This user-friendly activity asks children to use body sounds. Watch this one very closely and it will be evident that some of your kids will have a bit of trouble doing this. All the more reason to offer activities that require kids to function in their musical and logical intelligences.

Evaluation

Participation, rhyming, appropriate behavior, authentic connections.

Activity 4
Object Habitat

Materials

Shoeboxes with lids
Sand or dirt
Twigs, leaves, sticks
Construction paper
Glue
Scissors
Tissue paper
Round, square, triangular or rectangular objects

Directions

Using the box of objects from the previous activity, partners will select one object and create a habitat for that object in a shoebox. Other applicable geometric objects can be included in the scene.

When the scenes are completed, students will discuss

1. How the object came to live there.
2. Why it lives successfully in that particular habitat.
3. Where it lived previous to now.
4. What it is.
5. When it arrived there and how long it has lived in that specific place.

Personal Learning Capacities

First and foremost, this is a visual/spatial experience. But it is also a real marriage of many intelligences. The logical learner can use their capacity for creating, problem-solving, sequencing, thinking through, manipulating and putting together the habitat exhibition or demonstration. That same learner will use their kinesthetic intelligence to help cut out, staple together, carve and glue pieces, shapes and objects for the habitat. When it comes time for presentation, the linguistic intelligence takes over, and that same child will tune in to appropriate words needed to successfully describe the habitat and answer the questions about the habitat. Finally, a good reflective question should just about do it.

Activity 5
Shape Book

Materials

Art paper, crayons.

Directions

Students will select a certain geometric shape and create a book of facts and figures and original ideas or stories regarding that particular shape. The title of the book will be the particular shape, and the pages of the book will be in the form of the particular geometric shape. Each page will represent a different piece of information about the shape.

Here are some suggested ideas that may be used to stimulate the children in their own quest of facts, figures and original stories for their particular shapes:

1. A dictionary definition.
2. An illustration of that definition.
3. A list of objects that are of that particular shape.
4. Well-known objects in history that are that shape.
5. A math story problem that includes the shape.
6. A comic strip that includes the shape.
7. A complex drawing that includes a hidden shape.
8. Drawings of different objects of the particular shape, labeled and categorized according to size.

Personal Learning Capacities

This is another multilayered activity that engages several different learning capabilities. To be sure, the visual/spatial student will create through color and patterns and shapes and drawings. The logical/mathematical student will feel comfortable working on the portion of the book that is their element, possibly creating math stories. The linguistic student will have time and permission to include language in as many pages as possible.

What I see as the most important aspect of this activity is simply how children perceive the idea. Where do they put their energies? How do they sequence it? Where do their ideas come from? When do they become frustrated? Do they ask for help? I've said this statement often throughout the pages of this book, but once again, this is a time for kid-watching. Seeing children work through this project is a golden opportunity to learn more about your students.

Evaluation

Completion, time on task, neatness, appropriate information, correct spelling.

Activity 6
The Shape of the Story

Materials

Construction paper cut into geometric shapes.

Directions

Students will read the following story and underline all of the words in the story that describe something that has a definite geometric shape. Or, give each student several pieces of construction paper that have been cut into

different geometric shapes. As you read the story and say a word that has a certain shape, students will hold up the appropriate shaped card to signify the correct shape of the object in question.

Sammi and Carlos
BY MARTHA BRADY

There once was a golden retriever named Sammi. She was a good dog and she seemed to always have a smile on her face. Her best friend was Carlos, a Chihuahua that lived in the **house** across the **street** from Sammi.

One day, Sammi wiggled through her **doggy door** and raced to the backyard **gate**. She nudged the handle with her nose and popped open the latch. The **gate** swung open and Sammi bounded out past the **slide** at the side of the **house**, past the red **wagon** that was sitting in the **driveway** and past the **hula hoop** that was lying on the grass in the front yard.

Standing next to the **FOR SALE sign** that was in the neighbor's yard, Sammi began to bark. She barked and barked. Suddenly she saw Carlos in the **house** across the **street**, standing on the **window sill**. Carlos barked and ran to the front screen **door**. With a slight bump, the **door** opened and out scampered Carlos.

The two ran side by side to the end of the **block**. They turned left and continued to run down that **street** until they came to the neighborhood Baskin-Robbins. Both dogs ran into the store and jumped on two **stools**. "I'll have two **scoops** of Rocky Road, in a **cup**," Sammi said. Carlos looked behind the glass divider at all of the ice cream **barrels**. "I think I'll have 3 **scoops** of Cookie Dough, in a **cone**," he said.

The two ate their ice cream, wiped their muzzles with a **napkin**, paid the clerk with **dollar bills**, and ran home.

"Same time tomorrow?" asked Carlos. "Same time," said Sammi, and the two pooches ran into their own houses, where they stretched out on the living room **sofas**, munched on **Dorito chips** and watched a rerun of *Lassie*.

Personal Learning Capacities

This is about as linguistic as you can get.

Evaluation

Correct response.

Materials
Copies of music, synthesizer (optional).

Directions
It's time to look at and read *The Greedy Triangle* one more time. This time as you read, ask your youngsters to notice anything on the pages that are striped or long in a rectangular sort of way. For instance, the cover pages show a wooden fence that has two horizontal strips (stripes).

When the book is finished, ask the boys and girls to look around the room and find things that are striped in design. Kids will immediately check each other's clothing. Then they will begin to notice other objects on the ceiling, on the floor, around their desks, that have stripes.

Once you have spent time talking about all the things in our daily lives that are striped by nature, teach them the rollicking song "Stripes" on the next page. Some kids may want to write their own words when they've learned the melody. Superb idea!

Personal Learning Capacities

This is a fast little number that requires students to use their linguistic intelligence as well as their musical capacities. Most of the students will certainly appreciate the song itself, as it has funny lyrics and is fast-paced. A lot of your kids will open their mouths, rare back and give it their best shot because they are comfortable in their musical intelligence and because it is part of who they are. Then there are those who will want to do more with the song. Perhaps they wish to create body rhythm patterns to accompany the song. Perhaps, as I said earlier, they want to write new lyrics. Some, if not all of the kids, may want to make more original musical instruments with which to accompany this particular song. If all of those options can happen in your classroom, then, my friend, you are teaching to the intelligences. More power to you.

Evaluation

None.

Community Activity

The girls and boys in your room will fan out with a partner and go into all the kindergarten and first grade rooms where they will interview students and ask those young ones to define circle, square, triangle, rectangle, pentagon, hexagon, heptagon, octagon, nonagon, decagon, undecagon and dodecagon. Now, if your kindergartners are like the ones in schools near me, chances are that very few will succeed with the correct answers. But if your own kids create an atmosphere that is nonthreatening, fun and interesting, some wonderful definitions should come pouring out of those 5-year-old mouths. If you have, for the moment, forgotten

Stripes

Lively Is As Lively Does

Words/Music by Martha Brady

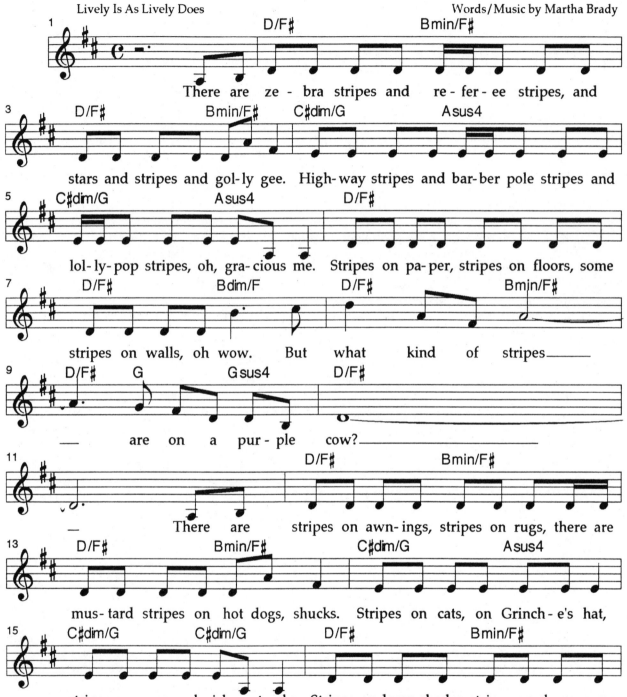

There are ze - bra stripes and re - fer - ee stripes, and stars and stripes and gol - ly gee. High - way stripes and bar - ber pole stripes and lol - ly - pop stripes, oh, gra - cious me. Stripes on pa - per, stripes on floors, some stripes on walls, oh wow. But what kind of stripes_____ _____ are on a pur - ple cow?_____ _____ There are stripes on awn - ings, stripes on rugs, there are mus - tard stripes on hot dogs, shucks. Stripes on cats, on Grinch - e's hat, stripes on vans and pick - up trucks. Stripes on lamp - shades, stripes on shoes, some

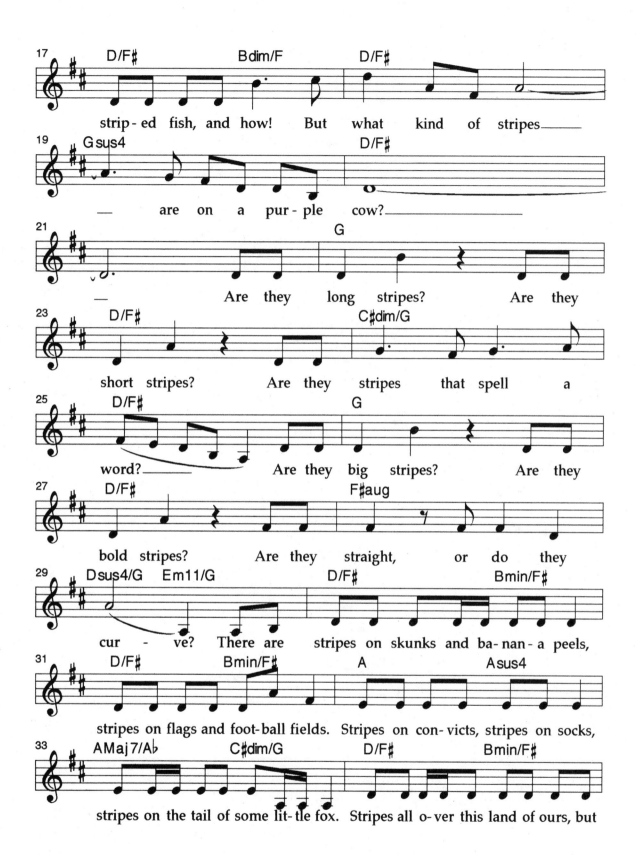

strip - ed fish, and how! But what kind of stripes_____

_____ are on a pur - ple cow?_____

_____ Are they long stripes? Are they

short stripes? Are they stripes that spell a

word?_____ Are they big stripes? Are they

bold stripes? Are they straight, or do they

cur - ve? There are stripes on skunks and ba - nan - a peels,

stripes on flags and foot - ball fields. Stripes on con - victs, stripes on socks,

stripes on the tail of some lit - tle fox. Stripes all o - ver this land of ours, but

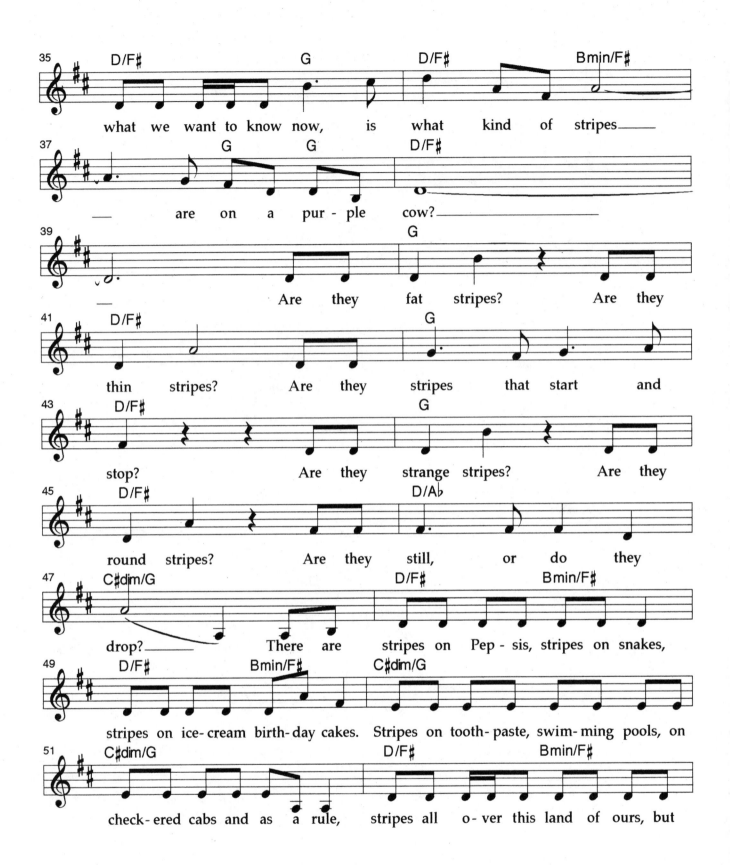

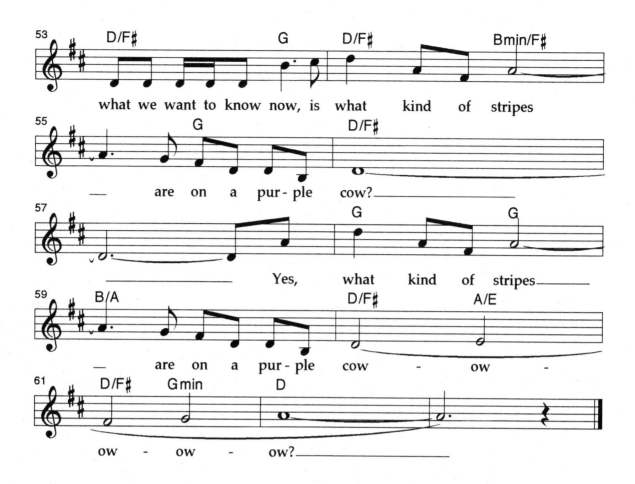

what we want to know now, is what kind of stripes

— are on a pur-ple cow?

Yes, what kind of stripes

— are on a pur-ple cow - ow -

ow - ow - ow?

the definitions of these shapes yourselves, Ms. Burns has given us that information in the back of her book.

The students in your class will write down the definitions given then create a bulletin board entitled "Everything I Ever Wanted to Know about Shapes I Learned in Kindergarten." The bulletin board, complete with all of the definitions gathered from those younger kids, will be placed in the teacher's lounge so everyone can smile throughout the day.

Reflective Question or Journal Entry

"Think of how things would be different if the world was rectangular instead of round."

Give one example of an object in daily life that is now round and talk about or write about how it would be used differently if it were rectangular. An example is a basketball.

Wrap-Up

Seat your students on the floor near you and ask them to close their eyes, take a trip to their own homes and call out three items or objects that they use every day. Then talk

about why those items may be shaped that particular way. Now read *The Greedy Triangle* one last time, change the word triangle to another geometric shape and ask your boys and girls to create correct illustrations, in their heads, that go along with the change.

Related Books

Charles, N. N. Illustrated by Leo and Diane Dillon. *What Am I?* New York: Scholastic, 1994.

Hoban, Tina. *Dots, Spots, Speckles and Stripes.* New York: Greenwillow Books, 1987.

———. *Spirals, Curves, Fanshapes and Lines.* New York: Greenwillow Books, 1992.

Rogers, Paul. Illustrated by Sian Tucker. *The Shapes Game.* New York: Henry Holt and Co., 1989.

Snape, Juliet and Charles. *The Boys with Square Eyes.* New York: Simon and Schuster Books for Young Readers, 1987.

Tompert, Ann. Illustrated by Robert Andrew Parker. *Grandfather Tang's Story.* New York: Crown Publishers, 1990.

Related Music

Various Artists. *School House Rock Rocks!* ABC Records, 1995.

8
I Am an Artist

by Pat Lowery Collins
Illustrated by Robin Brickman
(BROOKFIELD, CT: THE MILLBROOK PRESS, 1992)

Background

"... I am an artist when I follow a line where it leads me. I am an artist when I find a face in a cloud or watch the light change the shape of a hill." These words begin a small, beautiful children's book that defines artist in ways children can understand. *I Am an Artist* gently brings to girls and boys not only a different view of what being an artist is, but shows in a soft somber way the value of simple pleasurable things.

Using the book as a guide, the activities in this chapter will help children define the word "artist" in a personal way and clarify how that definition may relate to them in a visual sense. The experiences will also show that being an artist can be accomplished in many visual disguises and in many visual and tactile forms.

Hook

Materials

Dictionary.

Directions

Take your boys and girls for a walk outside around the school grounds. Grab a dictionary before you go out the door. When the kids get outside, don't give them directions or explanations of what is to happen. Just ask them to listen and look. If there are trees on the school ground, gather at the base of one tree. Ask your students to look up through the branches. Tell them to look closely at how the branches bend and stretch out. Ask them to carefully look at the leaves and the shadows that the leaves or branches throw on the tree trunk or ground. Ask them to find leaves or shadows or branches that remind them of something else. A branch might be shaped like a letter of the alphabet. Bunches of leaves might resemble spiders or birds in flight. Single leaves might resemble stars. Give the children enough time to make their visual discoveries then sit on the ground beneath the tree and engage them in a conversation about what they observed.

Discussion

When the students have shared those discoveries, ask them if anyone in the class personally knows an artist? Allow for discussion. Then ask the girls and boys to think of other artists that they've seen or heard about. See if the conversation includes actors, musicians, dancers, sculptors. Ask what all of those people have in common. Again, allow for discussion. Now ask for someone to define the word "artist." Read the definition from the dictionary. Connect the dictionary's meaning of the word with the children's discussions of what artists do have in common (doing something well). Thus, if doing something well means being an artist, ask them to think about the "artist side" of their mother or father or brothers or sisters. Is Mom an artist if she builds shelves for your bedroom? Is Dad an artist if he cooks a pot of spaghetti to perfection? Lead the students into discussions of what they themselves do well. When that conversation is done, take them back, in thought, to the experiences with the shadows. Direct them as they connect those interesting views of what it is to be an artist with their own experiences of "seeing" something different in the trees.

Conclude by suggesting that being an artist is much more than drawing or singing or sculpting. It could simply be using one's eyes and hands and feet in ways never imagined.

Now ask your class to get comfortable where they are while you read *I Am an Artist* by Pat Lowery Collins, illustrated by Robin Brickman. And remind them that in no time at all, they too will become artists.

Personal Learning Capacities

Students are going to attack this hook activity in different ways. Some of your boys and girls who have visual/spatial acuity will easily succeed in "seeing" those other things in the trees. Some will simply see those things with a little help from their imaginations or their friends. Others will see nothing. That is okay. Remember, we understand why.

Activity 1
Body Still Life

Materials
Index cards.

Directions

Students will divide into equal-numbered groups of perhaps five or six people. The teacher will show each group a different word that connects in some way to a certain content area. For instance, if weather is being studied in the classroom, then different vocabulary words appropriate to that topic might include "tornado," "meteorologist," "flood," "barometer," etc. After each group has selected one of the appropriate words, they will use their bodies to create a "frozen" scene that clearly defines the word chosen. In other words, a still-life scenario. As their "picture" remains frozen, other students will guess the word that is being described.

Suggested words for different content areas are

♡ Holidays—"Easter," "Valentine's Day," "Christmas," "Hanukkah," "Kwanza," "Fourth of July"

♡ Community helpers—police officer, sanitation worker, ambulance driver, fire fighter

♡ Careers—doctor, lawyer, teacher, computer programmer

♡ Types of transportation—river raft, steam engine, hang glider, hot-air balloon

Personal Learning Capacities

Children continually need safe positive experiences in group interactions that, while allowing them to be integral to the group, also give them chances to remain a bit independent. This activity works well in both categories. Kids proudly get the opportunity to create their own niche in the development of the whole picture yet must use their interpersonal skills to make sure they are blending in and acknowledging what others in the group are doing.

This is also a sound kinesthetic experience too, as some girls and boys, by using their bodies to shape and form the picture, will be able to understand the concept much more clearly.

As the groups brainstorm and then create their body still life, watch how problem-solving occurs. Do the boys and girls try out body arrangements many times? Do some children stand back and wait for others to form their bodies appropriately first? Who does all the talking? Who thinks it is silly? Who thinks it is neat? Again, observation is the clearest clue you can give yourself on how your children learn best.

Evaluation

Appropriate behavior, appropriate body definitions, teamwork, creative expression, ability to describe still life, participation, ability to see detailing features of still lifes.

Activity 2
Found Objects Jewelry

Materials
Found objects
String, twine, yarn, leather strips
Tempera paints, brushes
Paper cups
Glue
Safety pins
Cardboard strips
Small nails
Hammer (optional)
Hole punch

Directions

Give each student a paper sack and head for the outdoors, possibly to a park or to a nearby field. If all else fails, the school ground will suffice. Students will collect "found objects," small objects such as twigs, small stones, leaves, bottle caps, pine cones, etc. Anything will work if it is small and fairly light in weight.

Students will come back into the room where they will use problem-solving skills to create pieces of jewelry out of the found objects. Encourage the students to be creative in their endeavors. Some students will stick to the tried and true kinds of jewelry pieces. Others will venture forth into the jewelry unknown.

Set up workstations that are geared for certain types of jewelry. Some workstation choices may be brooches, bracelets, necklaces and rings. The workstations should include pieces of leather, yarn, twine, scissors, glue, small nails, hammers, cardboard strips, tempera paint, brushes and other supplies that will ensure success in the particular type of jewelry the children choose to work on.

When the kids have completed their jewelry-making, give them time to show off the pieces. Be sure to have a discussion about the artistic aspect of this activity. What was difficult in the process? What did the kids feel they accomplished? Why is their particular jewelry considered a piece of art? Ask them to write an account of the birth of their jewelry from beginning to completion. This can be done through poetry, rap, cinquain or any other writing format. Now comes the best part. When the writing is done, the girls and boys in your class will choose teachers on the school faculty and give their pieces of jewelry, complete with stories they have written, to those teachers as a random act of kindness.

Personal Learning Capacities

This activity is logical/mathematical at its best. Why? The kids have to take unrelated things and use their noodles to arrange, design and

create patterns in some kind of order. The boys and girls with this capacity will like the organizational aspect of this experience. They will also ask you a thousand questions as they create their jewelry pieces. Be ready for frustration levels, however, because the students who don't have strong logical/mathematical capabilities will have a difficult time with this. All the more reason to offer activities such as this to strengthen those lesser-used intelligences.

Of course other intelligences can be demonstrated here, the strongest being visual/spatial. Continued development of the spatial intellect involves activities such as this where students perceive things by seeing, touching and interpreting what they see and touch.

Evaluation

Time on task, completion of task, description of process, attitude.

Activity 3 ◄ · · · · · · · · · ·
Overlay Story

Materials

Overhead transparencies, overhead markers, transparent tape, scissors.

Directions

Children will take three acetate sheets (clear overhead transparencies), cut them in two and tape them together to form a booklet. Beginning with the bottom sheet, students will select an existing illustration from one page of *I Am an Artist* or a generic illustration, such as a forest or ocean scene, and draw that scene on the bottom page of the acetate booklet. Then on each succeeding page, from the next-to-last page to the first page, students will add, or overlay, additional drawings that fit into the previous scene. As each page is illustrated, a completed picture emerges so that when they look at the top page, they are seeing all of the work from the other pages as well.

Now, each group will create their own sequential story that describes or enhances the meaning of the chosen illustrations. For example, one illustration in the book *I Am an Artist* shows a forest in winter with the line "... and stop to gather winter's hush around me" If that illustration were

selected by a group, those children or the teacher, perhaps, would create a story, either in written form or on cassette tape, about that forest.

Once all of the overlay booklets have been completed and the individual stories written, the objective then is for other children to read or listen to the different stories and then illustrate those stories in newly created overlay transparency booklets, one page at a time overlaid on another to form one ultimate scene.

Here's a suggested story line that goes with the forest illustration:

Once there was a thick, thick forest. There were many trees in this thick, thick forest and every leaf and pine needle on the trees was covered with snow. The trees shook with the wind that was dancing through them, making the snow on their branches float gently to the ground like fairy dust.

High up in a branch of one of the trees was a lonely owl. He sat very quietly on the branch and made no movement or sound. He simply listened.

Suddenly, he heard a strange noise. The sound startled him. He looked first one way and then another but saw nothing. He settled on the branch once again and continued just to listen. He heard the noise again. This time he quickly turned his head around, and there hidden among the branches of another tree was what looked to be a strange container. [Turn to the next-to-last page of the overlay booklet and draw a tiny portion of the hidden container somewhere in a tree. Remember, the bottom page of the overlay has the chosen illustration of the forest already drawn on it.]

The hidden container was very heavy. It was so heavy, in fact, that the branch that it was balanced on could not hold it. The branch cracked, then broke, and down fell the container crashing onto the snow below. Not long after, three winter squirrels stood behind trees at the forest's edge and looked at the object lying in the snow. [Turn to the third-to-last page of the overlay booklet and draw the entire container lying in the snow and the three winter squirrels hiding behind the trees.]

The squirrels were puzzled. They had lived in this forest all of their lives and had never seen anything that resembled what was lying on the ground. "Do you think it will harm us?" asked one of the squirrels, looking at the strange container. "It doesn't look too dangerous," said another. "Well, I don't like it," said the third squirrel. "It doesn't belong here. It doesn't fit into this forest environment."

The three squirrels stared at the thing for quite a long time. Finally they all agreed that it didn't belong in the forest. "Let's cover it up so no one else can see it," said the squirrel who was standing behind the tree nearest the container. "That way, it won't spoil our view or anyone else's who lives in the forest."

The squirrels worked and worked until they eventually covered up the strange thing that had fallen from the tree. They then scampered back into the safety of the forest. [Turn to the fourth-to-last page of the overlay booklet and draw how the squirrels covered up the container.]

Not long after, a family of four came trudging through the forest at precisely the place where the container was hidden. "Let's keep our eyes open for just the right Christmas tree," the father said, "the tree we got last year came from around here." The two young children, a girl and a boy, giggled and ran to a clearing by the edge of the forest looking for the perfect tree. "Don't run off too far," said Mom, "it will be getting dark soon." [Turn to the fifth-to-last page of the overlay booklet and draw the family of four at a clearing near the edge of the forest.]

Almost instantly, the little girl spotted a large mound in the snow. "What is that!" she yelled as she ran toward it. "Well, let's find out," said Dad, and they all rushed to the mound. "Look," said the boy, "there's something almost hidden in the snow."

Just as the three squirrels had worked to hide the container, Mom, Dad and the two children worked equally hard to uncover the mysterious thing. They spent a long time uncovering the container, and when they had finished they stopped to rest for a while. "We'd better see what's inside," said Dad. "Yippee!" screamed the kids, and all four of them began to pry open the lid of the container. They pulled and tugged and shoved and kicked and finally were able to undo the top. When they finally, and with great effort, removed the lid, they stopped and stared into the container. The family of four grinned and laughed and could hardly wait to get back home so they could tell their friends what they had seen. [On the first page of the overlay booklet draw what was hidden in the container.]

There are several variations on this particular activity. Groups could do all of the drawings and other kids could write stories that come to mind as the drawings unfold, sequentially. Or, groups could write stories and other children could draw, sequentially, appropriate overlays that go with certain stories. Either case requires good thought processes and completion of tasks.

Personal Learning Capacities

Like the previous activity, this one gathers in the logical/mathematical students who love to combine art with patterns and design. The orderly way in which this activity is completed also caters to those students who think in logical terms.

The story writers can awaken their linguistic capabilities too, when given permission to use descriptive language in the writing of the stories that go with the overlays.

Evaluation

Teamwork, completion of task, appropriate relationship between story and overlay, sequencing skills, appropriate behavior, time on task.

► Activity 4
Artist Flash Cards

Materials

5 x 7 cards.

Directions

Give students several 5 x 7 cards. Have them go through *I Am an Artist* and write words that come to mind from reading the book or looking at the illustrations. Suggested words are "clouds," "pebbles," "sand," "moon," "walnuts," "bubbles," "seeds," "rainbows," "bee," etc. During a period of time, perhaps a week or more, children are to simply take the cards with them, either to home or school, and when they "see" something, "touch" something or "hear" something that relates to the words on the cards, they are to write those experiences on the back of the cards.

When time is up, the students can share their artist flash card experiences with each other.

Personal Learning Capacities

The hope is that children will use their "inner vision" to create their own artist flash cards. The intrapersonal child will relish this activity. Children who need to massage that particular intelligence in themselves will have a chance to do so in the safe private moments that come about when there is an interaction between personal experiences of seeing, touching, hearing and the words on the cards.

Evaluation

None.

Community Activity

Select several well-known illustrators, such as Lane Smith, Steven Kellogg, Jim Harris, Debra Frasier, Chris Demerest or others who are favorites of yours and your students, and have each child write a letter to a different illustrator asking this one question: "When did you know that you were an artist?" Compile all of the replies you receive and create your own class book. Don't forget to have your kids answer that question themselves. Their answers should go into the book as well.

Reflective Question or Journal Entry

"I am an artist when I_____."

Wrap-Up

Go back to the tree where you first read *I Am an Artist*. Ask the children to look up into the branches and leaves one more time. And again, ask them to find one last visual discovery. Talk about that experience and how it compared with the first time they were asked to look for something different. Are some students seeing things through a broader lens? Keep your fingers crossed that they are.

Related Books

Baylor, Byrd. Illustrated by Peter Parnall. *I'm in Charge of Celebrations*. New York: Charles Scribner's Sons, 1986.

Brown, Ruth. *If at First You Do Not See*. New York: Henry Holt and Co., 1982.

dePaola, Tomie. *The Art Lesson*. New York: Putnam's Sons, 1989.

Goffstein, M. B. *An Artist*. New York: HarperCollins, 1980.

Heller, Ruth. *Color*. New York: Putnam and Grosset, 1995.

Hoban, Tana. *Look, Look, Look*. New York: Greenwillow Books, 1988.

Johnson, Stephen T. *Alphabet City*. New York: Viking, 1995.

Koss, Amy Goldman. *Where Do Fish Go in Winter and Answers to Other Great Mysteries*. Lost Angeles: Price Stern Sloan, 1987.

Nixon, Joan Lowery. Illustrated by Bruce Degen. *If You Were a Writer*. New York: Macmillan, 1988.

Shange, Ntozake. Illustrated by Romare Bearden. *I Live in Music*. New York: St. Martins Press, 1994.

Testa, Fulvio. *If You Take a Paintbrush*. New York: A Puffin Pied Piper, 1983.

Rylant, Cynthia. *All I See*. New York: Orchard Books, 1988.

Related Music

Boston Pops. *Salute to Disney*, 1976.

Strickland, Mike. "My Favorite Things." *My Favorite Things*. MSP Records, 1994.

Timeless Classics. *Little Pieces of Great Composers*. Madacy Music Group, 1995.

Various Artists. *The Impressionists*. Windham Hill Sampler, 1992.

9
My Aunt Arizona

by Gloria Houston
Illustrated by Susan Condie Lamb
(New York: HarperCollins, 1992)

Background

I grew up in a small southern community that had a court-house in the middle of town, one movie theater and no traffic lights. Living there allowed me to feel safe every day, ride my bike anywhere I wanted, play after dark and know my teachers really well. I loved the playing after dark bit. And riding my bike anywhere was just the natural thing to do. But knowing all my teachers—well—and them knowing me equally as well—now that was a different story.

They were everywhere, my teachers. I saw them at school, of course. I also ran into them in the aisles of the grocery store. I sat next to them at church on Sunday. I cheered with them at Friday-night football games. I ate at tables next to them at the only hamburger joint in town. I even spent every night of my childhood with my fifth grade teacher. She was, for lack of a better word, my mother.

Regardless of how often I dreaded going to the post office because "they" would be there picking up their *Saturday Evening Posts* too, the foundation was set very early for me to choose teaching as a career. At times the choice has been thrilling. Many times frustrating. Often times bewildering. But at all times correct. It was the thing for me to do then. It is the thing for me to do now. Teach.

What about you? Have you ever asked yourself *why* you became a teacher? Have you ever wondered why this particular line of work drew you to it? Kept your there? Before you introduce the excellent children's book, *My Aunt Arizona*, ask yourself that question. What mentor/teacher in your childhood became a critical factor in your decision to pursue education as a career? Was that person nurturing? Did that teacher help you out of a jam? Was that the class you dissected the pig in? Was it the teacher who smiled a lot and listened in a way that outshined the smile?

Why not share those kinds of stories with your students? Let them know that you, too, had a favorite teacher. Describe that person. Why was that person so special? Make that person real and touchable. Give your students a glimpse of you as a child.

When the conversation about favorite teachers ends, show your class the cover of *My Aunt Arizona*.

Hook

Materials

Chart paper.

Directions

Talk about the cover. Ask the students for first impressions. What is happening? What is the mood of the day? What emotions are the children feeling? What is the adult saying? Notice the way the kids are dressed. Elaborate on that aspect with the students in your classroom. What time period is represented? Where are these children? Why are they there? Putting these ideas down on chart paper may be helpful for some students, and the information may come in handy later on.

Discussion

Turn to the title page picture on the inside of the book. Ask the girls and boys to be as thorough in their observation of this new illustration as they were with the cover picture. This particular picture shows a road leading to ... where? Ask students to use their imaginations and think about where the road might be leading. What is around the bend? Is this road wide enough for cars? For wagons? Are there stop signs anywhere? What is at the end of the road? What era does this picture represent? What are the clues for knowing that? You may want to use chart paper again to list these ideas. When the discussion has ended, sit comfortably with the boys and girls and read *My Aunt Arizona*.

Personal Learning Capacities

When children are consistently allowed to speak, listen, read and write in all aspects of the curriculum, their linguistic intelligence will continue to strengthen and broaden. What better way to permit this growth than by introducing all children's literature in thoughtful, thorough ways. Reading books, of course, is the key. All kinds of books, all the time. Now it is time to go a bit further. Make the books you share with your class come alive with every linguistic idea you and they can think of. But don't stop with linguistic ideas. There are six other avenues to take.

Materials

Appropriate phone books, envelopes, stamps.

Directions

Where in the world is Arizona? How far is it from the town you live in? What do people do in Arizona? Here are some ways your students can learn more about the state for which baby girl Arizona was named:

♡ Write to the Arizona Department of Tourism for brochures, maps and general information about the state. The address is:
1100 W. Washington Street
Phoenix, AZ 85004

♡ Write to U.S. West Direct White/Yellow Pages
Corporate Office
198 Inverness Drive West
Englewood, CO 80155-6572
Ask for *White Pages* phone books from some or all of the areas of Arizona. Each phone book will have an "Easy Reference Guide," which includes lists and written accounts of area history and attractions.

♡ Write to Arizona Highways Magazine
2039 W. Lewis Avenue
Phoenix, AZ 85009
Ask for a copy of any *Arizona Highways* magazine that may include feature stories or pictorials of Arizona cavalry posts or historical or military accounts that helped create that state's history.

Personal Learning Capacities

Engaging children in authentic written correspondence activities is a strong verbal/linguistic addition to your weekly lesson planning. First, if the correspondence is authentic (i.e., writing for a specific purpose), then it will make sense to the kids, and the response to doing the activity should be positive. The formal writing aspect should come easier. Second, it has a payback. The kids will get something for their efforts. In this case, hopefully they will get a magazine or a reprint of a story in the magazine. They will also get phone books from another state. What a treat!

Other learning capacities come into play here too. Girls and boys will use their intrapersonal intelligences to think very carefully about the wording of their correspondence letters. Their interpersonal skills will be activated as they brainstorm with other students about appropriate words to be used in the letters.

Evaluation

Good handwriting, appropriate letter format, completion of task, complete sentences, teamwork.

Materials

Cardboard boxes
Tissue boxes
Pretzel sticks (logs)
Popsicle sticks (furniture or desks)
Cloth pieces (ruxgs, table cloths, bed linens)
Colored cellophane (fire, window panes)
Construction paper
Glue
Scissors

Directions

Using large cardboard or tissue boxes, Popsicle sticks and other listed supplies, small groups of students will design and construct the interiors of log cabins or one-room schoolhouses similar to the one found in *My Aunt Arizona*. Time need not be spent on the exterior of the buildings, as the focus will be the children's perceptions of the interiors. Students can work on one large cabin or school room, or they can divide into groups of three and create smaller replicas. Looking at the illustrations in the book will help them get on the right track. Most kids will look for assistance in that way. Then, without much more interference from you, gather all of the materials and supplies, some of which are listed below, lay them out and let the children decide how they will be used in the construction of the log cabins or school rooms.

Personal Learning Capacities

This is a very interpersonal activity; a team will be constructing the cabins or schoolhouses. Look closely, however, and you may see other learning styles emerge. For instance, pay attention to the roles taken as the activity develops. Are there students in the groups who work well with others, know how to listen to others, understand the concept of sharing the load? Do some in the group find their linguistic intelligence and simply describe what needs to be done or how the interiors should look? Do they make lists of materials needed? Do they write down the directions on how to construct the interiors? How about those students who bypass the talking and immediately get to the construction? Do they begin cutting, pasting and building? Does their visual/spatial sense assist them in their vision of what the entire creation should look like? Are there students who decide what should be done first and in what order? Do they look logically at the sequence of directions? Do they measure for building to scale? Children attack the problem of learning in so many different ways. A good lesson accounts for those differences.

Look carefully at your students when they work in groups. Put what you see into your own mental portfolio. What are certain children doing

to succeed? Use this information as you plan your next lesson.

When the cabins or schoolhouses are complete, look at the pictures illustrated in the book. Compare the differences. Note the likenesses.

Evaluation

Completion of project, authenticity, teamwork, describing the project verbally or by written report, appropriate use of materials.

Activity 3
Paper Dolls

Materials

Matte board/poster board, Exacto knife (for teacher only), tissue paper, cloth pieces, yarn.

Directions

Purchase two sheets of matte board or poster board from a local art supply store. Construction paper will work in a pinch even though it really isn't stiff enough. Cut the sheets into wide strips. Students will trace body shapes on the strips and then cut them out. Read *My Aunt Arizona* once again and concentrate on the children in the book and the way they are dressed in the illustrations. Children will select one or two children from the book as models to create paper clothing. The paper clothing will then be attached to the matte board body shapes. Once again, let the kids problem-solve how to attach the clothing onto the matte board cutouts.

Place the paper dolls in the one-room schoolhouse or log cabin interior and use this physical catalyst as a creative writing stimulus for poetry, one-act plays, lyrics, short stories, etc.

Personal Learning Capacities

Even though it might be easier to give each child a piece of art paper and have them draw one of the children in *My Aunt Arizona,* the paper doll variation offers just a bit more substance for the visual/spatial learner. There needs to be more thought and planning involved. Kids also are required to be more careful in their decisions on textures, color, design, size, etc.

Evaluation

Completion of task, authenticity, appropriateness, explanation of paper dolls and how they apply to the text of the book or the illustrations.

Activity 4
Interviewing Grandparents

Materials

Video camera and film.

Have students use video cameras to interview their grandparents or great-grandparents about their own school experiences when they were children. The interviews should not be too long and should include some questions that will be asked by all of the students during the interview process. Those questions could be

- Describe the school you went to when you were a child. How did you get to your school every morning?
- Who was your favorite teacher when you were growing up?
- Why did you choose that person?
- What was the thing you liked to do the most when you were in school?
- What kinds of clothes did you wear to school? Name one thing that is different from today's schools and the schools you went to as a child.
- Tell me the thing you remember most about your school experiences when you were young.

Students will bring the videos back to class, maybe with a grandparent in tow, and share those stories with the rest of the class.

Of course, with the information gathered from the interviews, many extension activities can occur. Students could

- Break down the information and create a graph.
 Write a personal poem using the information from the videos and present the poem and video to the grandparents.
- Create a class book that contains a narrative piece from each child, which expands on something learned in the videos. A drawing of the grandparent would be a nice addition to the page too.
- Students can project into the future and try to see themselves as grandparents. They can then video tape each other, complete with costumes and ask the same questions that were asked in the grandparent videos.

Personal Learning Capacities

This activity demonstrates person-to-person communication, which, for the interpersonal learner, is an easy task. It is also a good experience for boys and girls who must work to enhance their ability to interact with others in a verbal way. Often times just having the camera to "fiddle with" is enough of a hand prop to allow those particular children an easier entrance into the interpersonal and linguistic intelligence.

Evaluation

Clarity of video, presentation of video, participation in graphing, completion of writing assignment.

Activity 5 ◄ · · · · · · · · ·
Square Dancing

Materials

See "Related Music" at the end of the chapter.

Directions

Ask your class to do some research in your community of where to find someone who can come in and teach a square dance to them. They may want to contact churches, retirement homes, senior citizen groups, even some golf clubs that have social functions. Next, go to the library and find out when, why and where square dancing had its origin. If all else fails, go straight to your PE teacher.

Personal Learning Capacities

Dancing can be a logical/mathematical activity when the focus is more than just moving or jumping around. For instance students are actually problem-solving when answering questions such as "Where do I put my feet? How many steps to the left do I go? How many beats do I count before I take my partner's hand?" If they can answer those questions through the movement itself, then the kinesthetic intelligence is working as well.

Some students will use the music as a means of problem-solving for success. Hearing the steady beat will allow them to stay focused to the task at hand: dancing. Music also helps in successfully duplicating the movement patterns that make up the dance.

Evaluation

Participation, appropriate behavior.

Community Activity

Designate one day as "Aunt Arizona Day." Restructure your room into a one-room schoolhouse. Have children come to school dressed in clothes of the period. Play games particular to that time in history. Design a one-day curriculum that would have fit the needs of children in that era. Eat food appropriate to what the children ate way back then. Ask another class to document the day for you. This can be done by observation, video, drawings, written comments. Then have that class come in and share the documentation.

Conclude by having a discussion about the differences in experiences of the day and typical experiences of any other day at school. What felt good? What felt awkward? What did the teacher do differently?

Reflective Question or Journal Entry

*"How would you learn things
if you could not go to school?"*

Wrap-Up

Read *Aunt Arizona* one more time. Lead a discussion in which the students share instances when they have been teachers themselves. Someone may have taught their younger brother to ride a bike. Someone may have taught a friend to count change, etc.

Related Books

Allard, Harry. *Miss Nelson Is Missing.* New York: Scholastic, 1977.

———. *Miss Nelson Is Back.* New York: Scholastic, 1982.

Baer, Edith. *This Is the Way We Go to School.* New York: Scholastic, 1990.

Brown, Marc. *Arthur's Teacher Trouble.* New York: The Trumpet Club, 1986.

Cazet, Denys. *Never Spit on Your Shoes.* New York: Orchard Books, 1990.

Chardut, Bernice and Grace Maccarone. Illustrated by G. Brian Karas. *The Best Teacher in the World.* New York: Scholastic, 1990.

Cooney, Barbara. *Miss Rumphius.* New York: Viking, 1982.

Cullum, Albert. *Blackboard, Blackboard, What Do You See?* Holland: Harlin Quist, Inc., 1978.

———. *The Geranium on the Window Sill Just Died but Teacher You Went Right On.* Holland: Harlin Quist, Inc., 1971.

Hallinan, P. K. *My First Day of School.* Nashville: Ideals Children's Books, 1987.

Howe, James. Illustrated by Lillian Hoban. *The Day the Teacher Went Bananas.* New York: Puffin Unicorn, 1984.

Related Music

Conti, Bill, and the London Symphony Orchestra. *Grand Canyon: The Hidden Secrets.* Grand Canyon Theatre Venture, 1985.

Davol. "Fronties." *Mystic Waters.* Silver Wave Records, 1989.

The Judds. "Old Pictures." *Heart Land.* RCA, 1987.

Meyers, Dick, and the Left Hand Stars. *Square Dance.* Gateway Records, 1995.

New York Philharmonic Orchestra. "Rodeo." *Copland Album.* CBS Records, RCA, 1993.

Sons of the Pioneers. "Tumbling Tumbleweed." *Country Music Hall of Fame Series.* MCA Records, 1991.

Various Artists. *The Cowboy Album.* Kid Rhino Records, 1992.

Various Artists. *Songs of the West,* Vol. 4. Sony Music, 1994.

10
My Mama Had a Dancing Heart

by Libba Moore Gray
Illustrated by Raul Colon
(NEW YORK: ORCHARD BOOKS, 1995)

Background

Read this lyrical book by Libba Moore Gray without moving, tapping your toe, nodding your head or smiling. Look at the illustrations by Raul Colon without touching the page, smelling rain, feeling a kite string tug in your hand or remembering. You can't. You cannot simply "read" this book. Too many of its pages take you away to your own moments, your own experiences, your own memory dances with those who were and still are very important to you.

With that feeling in mind, with that sense of free-form celebration *My Mama Had a Dancing Heart* depicts so vividly, think about the children in your class. How many of them have dancing hearts? It's easy to tell, you know. They are the ones who laugh a lot. They are the ones who notice when the sun comes through the window and deposits a rainbow on their math book. They are the girls and boys who jump into mud puddles, not around them. They are the youngsters who use all of the crayon colors when drawing pictures. They are the little critters who memorize the shadow dance the tree outside the room performs every morning and afternoon. They are the young people who elevate your blood pressure. They are the children who put a sparkle in your eye.

So, get out your dance card, my friend. It's time to boogie.

Hook

Materials

None.

Directions

Clear a large floor space in your room. Ask your boys and girls to stand or sit at the perimeter of the space and watch you. Play some music and dance the different stages of your life. That's right. Dance the different stages of your life. Begin by moving and stutter-stepping like an infant. Then move and pantomime, with the music, something you did as a child, like climbing a tree or skiing or playing with dolls. Next, create dance movements that define your teenage years. It may be the pantomiming of a job you had. Or of studying. After that, show your students dance moves that interpret your young adulthood. Perhaps feeding a baby or

driving a car. Finally, interpret through movement the stage you are now in. Offer something visual the kids can understand, like teaching school or grading papers or performing something related to a hobby.

Turn off the music and begin asking your students questions.

Discussion

Lead your youngsters into a discussion about what they saw you do. How did you define the different stages? What was interesting to watch? What was easy to understand? What was difficult? Bring the conversation to the topic of dance and why people dance. Go to the city or school library beforehand and research cultures that hold dance as a critical component of their cultural experience and history. Explain that dance is a form of communication. Talk about comfort levels when dancing. Ask why dancing might be embarrassing to some students and not to others. Ask if any students were embarrassed by watching you, the teacher, dance. (Why do children find it hard to dance and adults find it so much fun?)

Introduce *My Mama Had a Dancing Heart* and ask the kids what the title means to them. Set the groundwork for this chapter with a clear explanation of people who have spirit. Talk to them about different ways of looking at life. Show them your own dancing heart. When that discussion concludes, share this wonderful book with your students.

Personal Learning Capacities

This activity requires you to shake up that kinesthetic intelligence of yours and offer a good clear example of a different form of communication. Children will do many things while observing you. They will internalize your efforts and experience what you are doing in their own way. Some kids will see the shapes and twists and turns you make with your body and appreciate that in an esthetic sense. All of the children will function at their linguistic intelligence when the discussion takes place.

This beginning activity is probably a snap for quite a few of your youngsters, especially if they are first or second graders. However, it will probably be difficult for you to get through yourself. Oh, the joys of stepping out of one's comfort zone. Congratulations! You did it.

Activity 1
Tissue Paper Poetry

Materials

Tissue paper, glue, construction paper or drawing paper, markers or calligraphy pens.

Directions

When reading the book to the children, point out the phrases of two-word descriptions that describe movement and the kind of dancing the mother and daughter engaged in. Words like "frog-hopping, leaf-growing, flower-opening." You may wish to ask volunteers to demonstrate what those phrases look like. Now ask students to think about certain kinds of days that are their favorites. Some kids may really love rainy days. Some may only like bright, sunny days. Some kids may be partial to twilight.

When the kids have thought for a while, ask them to use several two-word adjectives to describe those days. For me, a favorite day might be a "grass-growing, spring-smelling, dirt-warming, tree-budding day" because I love the spring-time so much. Or it could be a "leaf-crunching, tree-speckled, nose-frosting, mitten-wearing day" because I also like autumn. Write several examples on the board to help your kids get started.

When they have finished writing their own personal two-word phrases, the girls and boys will tear up small bits of colored tissue paper, wet the tissue paper with a combination of water and glue and create a collage effect on a piece of construction paper. The collage design should connect in some way with the two-word phrases. Once the tissue paper has been glued on and the entire surface has dried, students will use wide-nibbed markers or calligraphy pens to write the two-word phrases on the tissue collage.

Personal Learning Capacities

Even though part of this experience includes a writing assignment, which is linguistic, the task in this activity is not necessarily in the writing of the words nor the tearing of the tissue paper. It is, simply enough, in thinking about how to apply the tissue paper, design-wise, so that it will fit the mood of the words. Children who accomplish that task easily and with interest are using their visual/spatial intelligence.

Evaluation

Appropriate connection between design and words, participation, following directions, completion, appropriate behavior, appropriate use of materials.

Activity 2
Rain Poems

Materials

None.

Directions

Read *My Mama Had a Dancing Heart* again and dwell a bit on pages that entertain dancing in the rain. Engage students in a discussion that includes personal stories about rain and how rain affects our sense of touch, taste, smell, sight and hearing.

As you play a rain and thunderstorm sound-effects tape, students will write a poem about rain. Below is an example of a rain poem:

Rain Is ... Having a drink of water without dirtying a glass.

One Drop
BY MARTHA BRADY

The clouds were gray, the wind was high
I did not like the darkened sky
I raced from first to second base
And then it hit me on my face
One little drop so small and weak
But there it was right on my cheek
I looked around expecting more
Just as my coach yelled, "try to score."
I ran to third, a ball flew near
This time a drop fell on my ear
I brushed it off, it wasn't much
But it was wet where I had touched
"Oh, no," I thought, "delay of game."
"This cannot be. It is a shame."
And then I caught my coach's sign
And it said, "Son, it's sliding time."
I rounded third without a stop
And plum forgot about that drop
I gathered speed and half way there
I quickly looked up in the air
At just that moment, who knows why
A single drop plopped in my eye
My running slowed, I tried to see
But things weren't very clear for me
"One little drop," I heard me shout.
Too late, the catcher tagged me out.
Rain Sounds
Drip, drop, splash, splush
Puddle, duddle, slash, slush
Plip, plop, gash, gush
Muddle, buddle, clash, crush

Personal Learning Capacities

It will be interesting to see what level of linguistic intelligence your kids are functioning at when they engage in this experience. With this activity certain children will easily do it all: think, write, create, perform. Some, however, will just as soon enjoy listening to the poems of others. Then you have the strong linguistic learners who go beyond even the thinking, writing, creating and performing. They are the ones who develop a real sense of original creative expression. Those are the children who have an "author's voice" and a distinctive writing style. Your job? To offer a safe environment that allows all levels to take place.

Evaluation

Completion of task, creative expression, performance, staying on task.

Activity 3
Creating a Dance

Materials

Appropriate music selections.

Directions

In this book, the two characters use all kinds of natural stimuli to create dance moods. There is rain, of course, and waves and blowing leaves and snow, to name a few.

This activity asks your students to find their own stimuli, in or out of the classroom, and create dance movements that focus on those stimuli. For example, a student may wish to create different movements that represent recess. Another student may want to spend time creating movements that depict spending time in the library, and so on.

Children will decide on the stimuli, think of three or four appropriate jumping, leaping, twirling, spreading, floating or hopping movements (there are many more locomotor movements) and choreograph those movements in sequential order. Give students several selections of music with which to accompany their dances.

When each dance is completed, lead your students in a positive discussion of the event.

Personal Learning Capacities

Of all the capacities for learning, the kinesthetic intelligence is the one that is most prevalent in elementary children. They simply learn best when they are engaged in a physical way. This activity will allow for

most of your children to get in touch with that intelligence in a positive way. Some kids will love the performance aspect, some will like the problem-solving aspect and some will simply enjoy the music, the movement and the whole ambiance of this kind of energy.

Evaluation

Appropriate behavior, completion of task, participation.

▶ Activity 4
Dance Vocabulary Book

Materials

White drawing paper
Tempera paint
Crayons
Markers
Laminating material
Music

Directions

Go through *Mama Had a Dancing Heart* with your students and write down all of the ways the author expresses the many movements found there. There are about twenty-five wonderful ways Libba Moore Gray describes dancing. Each student will select one, for example, "Up and down, squish-squashing." Then on white drawing paper, each student will

1. Define the movement in original terms.
2. Draw what that movement looks like.
3. Give three examples of something in nature that moves like that.

The drawing papers will be collected, sequenced and bound into one Dance Vocabulary Book. With this book students may

♡ Write original stories.

♡ Practice the moves on the playground.

♡ Write a rap using the movement words.

♡ Ask other classrooms to create a dance using the words.

♡ Send a copy of the book to the illustrator.

Personal Learning Capacities

This is one of those activities that engages in four definitive learning styles. The linguistic child writes and creates. The kinesthetic child puts the book together. The visual/spatial child designs. The intrapersonal child thinks of and incorporates their own feelings into the project.

When the book is completed, here comes the musical child with a rap or song using the words. There goes the interpersonal child putting

together a play using the dance information. The logical child will merely show everyone else how to do everything in the book. Of course each of your children is capable of doing all of the facets listed above. Each child has all of the intelligences. Some are just hidden a bit deeper than others.

Evaluation

Staying on task, tidy work, following directions, best work, teamwork, appropriate behavior.

Activity 5 ◀ • • • • • • • • • •
The Wind Who Would Not Dance
(A Puppet Play/Informal Drama Activity)

Materials

Paper sacks
Cotton
Pipe cleaners
Paper cylinders
Cardboard
Puppet theater
Cloth/felt swatches
Scissors
Glue
Styrofoam balls
Buttons

Directions

I'm a real sucker for puppetry in the classroom. I've seen it bring out the most remarkable work in children of all ages, and if that were its only attribute that would be enough. The magic comes, however, with the many facets of puppetry. Puppetry is a teaching tool that encompasses several excellent elements: problem-solving, working together, creative expression, characterization, timing, performance, to mention just a few. And, bottom line, it is so much fun. The energy is high, there is good constructive noise and the children are in charge. What more could we want in our classrooms?

With all that in mind, introduce your students to the play below and let them add to, delete, change, rearrange, redo,

undo and generally cut and paste this little puppet play any way they need in order to make it their own.

The Wind Who Would Not Dance
BY MARTHA BRADY

Characters
NARRATOR
3 KITES
WIND
4 LEAVES
TORNADO
HURRICANE
6 RAINDROPS

Setting—a Calm, Sunny Day

NARRATOR: One lovely afternoon, in the spring of the year, three young kites came outside for a nice day of flying and soaring and sailing and looping in the sky.

[enter 3 DANCING KITES]

NARRATOR: [KITES try to fly] The kites tried to lift off but could not. They tried and they tried, but nothing happened.

KITE 1: This is no fun. We've been out here for two hours and there isn't enough wind to make us fly even a foot off the ground.

KITE 2: I know. I can't even get my tail to wiggle. [wiggles "tail" of kite]

KITE 3: This is depressing. We come outside on this bright spring day to fly for a few hours, and zip. No wind, no breeze, no nothing. Let's go back inside and watch TV.

KITE 1: There's got to be wind somewhere. Did we look everywhere for it? I know it's not in the sky, but maybe it's hiding. [begins looking around] W-i-n-d, where are you?

KITE 2: [looking also] We know you are here someplace. Come out, come out, wherever you are.

NARRATOR: The three little kites looked everywhere for the wind. But they couldn't find him anywhere.

KITE 3: I tell you, it's no use. There is no wind. Now let's go back home. We can get back just in time to see a *Flipper* rerun.

KITE 2: Wait! I think I see something moving in the top of that tree over there.

[ALL look up]

KITE 3: I see it. Wind is that you? Quit hiding and come out. We want to fly today. Now you come out right this minute.

KITE 1: We know you're up there, so show yourself. We just want talk to you.

NARRATOR: There was a tiny stirring at the very tip top of the tree. Suddenly, a tiny voice said—

WIND: [tiny voice from behind stage] Nope.

KITE 1: Nope? What do you mean nope? Please come out and talk to us. This is important.

WIND: [tiny voice] I don't want to.

KITE 3: Why? What's wrong with you? Why are you hiding?

WIND: I don't want to play anymore.

KITE 2: But why? That is what you do. You blow and howl and dance around. That's your job. What do you mean you don't want to do that anymore?

WIND: I just don't want to.

KITE 1: You know, this is getting to be ridiculous. [sound of tree shaking] Now quit that shaking and peek your face out so we can see you. We're not asking you to huff and puff until you are all red and your eyes are bulgy. We just want you to blow a bit so we can sail around up in the sky.

WIND: I'm not doing that anymore. Nope. No way. I'm never going to blow or dance around again. I'm just going to stay way up in this tree and sit very still so no one knows where I am.

[enter 4 LEAVES]

LEAF 1: Yo! Have any of you seen the wind? We've been looking all over the place for that little guy and he seems to have disappeared.

LEAF 2: Yeah. We want to do a little twirling and spinning and flipping around, if you know what I mean. But we sure can't do it without his help.

LEAF 3: It's a drag, all right. I haven't moved all morning and I'm getting mighty stiff and cranky. [begins to yell] W-i-n-d, where are you?

KITE 3: He's up there. [looking up at the tree]

LEAF 3: Up where? In that cloud?

KITE 3: No. In the tree.

[ALL look up]

NARRATOR: Well, the leaves begged and pleaded with the wind to get out of the tree and blow and howl and dance around, but the wind would not budge.

WIND: I don't want to play anymore.

NARRATOR: So the kites and the leaves huddled together to come up with a plan to get the wind out of the tree.

KITES and LEAVES: I know what ...

NARRATOR: They said.

KITES and LEAVES: We'll go get your mama. She'll get you down.

WIND: No. No. No. Not my mama. Please don't get my mama. Please, please, please don't go get my mama.

NARRATOR: But the kites and the leaves were determined to get the wind out of the tree so off they went, looking for the wind's mama.

[exit LEAVES and KITES]

WIND: Now, I'm in big trouble. My mama. They're going to go get my mama.

[enter 6 RAINDROPS]

RAINDROP 1: It's called velocity. That's the speed we travel when we start from way up there in those dark clouds and fall straight down until we hit the hard ground.

RAINDROP 2: Boy, does that hurt. That last fall squashed all of the water out of me. When I slammed into the dirt I thought I was a goner for sure.

RAINDROP 3: All the more reason to find the wind. If the wind blows just a little, that will make us drift sideways a while and that will slow our speed down enough so that we might have a softer landing.

RAINDROP 4: But where is the little rascal. We've made seventeen trips straight as an arrow right into the ground. I don't think my body can take much more. W-i-n-d, where are you?

NARRATOR: The raindrops splashed around looking for the wind and finally saw the shaking tree top.

RAINDROP 5: There you are. Climb on down and help us out, will you? We need for you to blow a little so we don't fall so fast.

WIND: I'm not blowing anymore. I'm not dancing around anymore. I'm not wailing or howling any more.

NARRATOR: The raindrops were stunned. They couldn't understand why the wind, who had been their friend for so long, would suddenly stop doing what he did so well.

RAINDROP 6: Where is your papa? That's who needs to talk to you. Does your papa know that you're acting this way?

WIND: My papa is out in the Atlantic Ocean—at a convention.

RAINDROP 4: Well, we are going to find your papa and bring him back so he can talk some sense into you.

WIND: No! No! No! Not my papa. Please don't get my papa. Please, please, please! Don't go get my papa.

NARRATOR: But the raindrops were determined to get the wind out of the tree, so off they went, searching for the wind's papa.

WIND: Now I'm in big trouble. My papa. They are going to go get my papa.

NARRATOR: Before long, the leaves and kites located the wind's mama and brought her to the tree where her child was hiding.

[enter TORNADO, LEAVES and KITES]

TORNADO: [spinning] Junior! Come down from that tree right this instant. Do you hear me?

WIND: But Mama, I don't want to play any more. I don't want to dance around or blow or howl anymore. It's all so noisy.

TORNADO: Noisy? Darlin' child. You're not noisy. I'm the one that's noisy. You didn't get any noise from my side of the family. You're gentle. Now come on down.

NARRATOR: But the little wind continued to stay up among the limbs of the tree. And while the wind stayed up in the tree, his mother circled and circled and tried to talk him down.

TORNADO: Come on, sweet pea. Climb on my back and I'll lower you down. Just let go, honey baby, everything's going to be all right.

NARRATOR: But the little wind didn't budge. Pretty soon the raindrops came scurrying back with the wind's papa.

[enter RAINDROPS]

RAINDROP 1: He's right up here in that tree. Gosh, sir, are we glad we found you. We've all tried to get him to come down and start blowing again, but he won't listen to any of us.

[enter HURRICANE, loud and grumbly]

WIND: Papa!

HURRICANE: Son, what are you doing up there? Now you come down right away before you get hurt. You hear me?

WIND: But I want to stay here, Papa. I don't want to dance around or blow or howl anymore. It's all so blustery.

HURRICANE: Blustery, little scout? You're not blustery. You didn't get any bluster from my side of the family. You're gentle. Now come on down.

NARRATOR: But the little wind continued to stay up among the limbs of the tree. And while the wind stayed up in the tree, his father kept his eye on him and tried to talk him down.

HURRICANE: Come on, Li'l tiger. Crawl down on my shoulders and I'll lower you down. Just let go, Li'l puff, everything's going to be all right.

NARRATOR: But the little wind didn't budge.

NARRATOR: By now the afternoon sun was high in the sky and its rays were beating down on the tree and everything around it. And things began to change.

RAINDROPS: [take turns speaking] My, the sun is awfully hot. We have been standing around so long waiting for the wind to carry us to other places that we're drying up. Yikes! I can't see my feet. They are disappearing. Where are my hands? Has anybody seen my hands? This is terrible. This is really terrible.

LEAVES: [take turns speaking] Feel my skin. It's so rough and dry. My edges are splitting. I think I'm curling up. I've been sitting in one place so long that I'm crumbling. Help! This is bad. This is really bad.

KITES: [take turns speaking] We feel so heavy. There's nothing to make us move. Our tails are long and weigh so much. Our frames are sticking into our bodies. Oh, no. This is tragic. This is really tragic.

TORNADO: I've been spinning so long I'm beginning to break up. Papa! Papa! I'm disappearing.

HURRICANE: Mama! I can't help. I've lost my strength. I'm turning into just one little old dark cloud.

NARRATOR: Now all the wind's friends and his parents were in real trouble. They moaned and cried and tried to move around but since there was no wind, they all just lay there. Suddenly, the tree in which the wind was hiding began to shake. Slightly at first, then harder and harder. The limbs began to sway back and forth. In no time at all the entire tree was blowing and moving and dancing from one side to the other.

TORNADO: Look Papa! Junior's coming down.

HURRICANE: I see, Mama. I see. Come on Junior, come to Papa.

NARRATOR: The wind jumped out of the tree and began to dance around the leaves, the raindrops, the kites and his mama and papa.

KITE 1: Wow! Here we go up in the air. Whew! We're flying.

[all KITES fly around]

LEAF 3: Yow! We're spinning and tumbling. Here we go across the field. Catch us if you can.

[all LEAVES laugh and tumble about]

RAINDROP 6: Look! the wind has moistened our skin. I'm filling with water again. And off we go aiming across the sky. It's a roller-coaster ride. Whee!

[RAINDROPS fly about in all directions]

TORNADO: Thank goodness I'm finally moving around in the same direction. I tell you, breaking up like that was giving me a headache.

[TORNADO spins around]

HURRICANE: Son, you've saved us all. That's my little waterspout. I'm going to gather up my clouds now and head on back to the Atlantic Ocean. Got to get back to that convention, you know. I'll see you this weekend when I get back. Be good. [HURRICANE exits]

NARRATOR: The little wind kept blowing, and as he danced around, all of his friends spun about him, laughing and feeling very happy to be alive.

LEAF 2: Now this is what a wind is supposed to feel like.

KITE 2: Yes. Even my tail is wiggling. Up and up we go. But wind, why did you decide to blow again?

RAINDROP 4: Yes, little guy. Why did you all of a sudden decide it was time to huff and puff and start the world in motion again?

WIND: Well, you know. I was sitting in that tree, staring out at all of you. And I pouted and felt really sorry for myself. And I wasn't even thinking of how you all must have felt. I was so busy thinking about me that I forget to even notice that you all were in trouble. All because of me.

RAINDROP 2: I'm so glad that you saw how we all needed you. Now we can all float and dance and sail and fly and scamper about. Thank you, Wind.

KITE 1: Yes. Thank you Wind for coming back to us. We all are so grateful to have you in our lives.

LEAF 1: Promise you will never ever hide from us again.

WIND: I promise. I promise that to all of you. And now there is just one more thing we have got to do.

ALL: [ad-lib] What is that?

WIND: Dance everybody. ... Dance.

[ALL laugh as the wind blows and the characters "dance" off the puppet stage.]

The End

Personal Learning Capacities

Every child in your classroom can engage in this activity. I rest my case.

Evaluation

This is creative expression at its best. The only evaluation worthy of this activity is evidence of effort.

Community Activity

Children will draw a large four-section mural representing the four seasons. In each section they will draw their own bodies in creative shapes and forms. Instead of drawing faces on the bodies they will bring two school pictures of themselves, blow up the pictures on a copier and paste the cut-out heads onto their drawn bodies.

Reflective Question and Journal Entry

*"If your heart could speak,
what would it say?"*

Wrap-Up

If there is a ballet performance in your city, take your children to the matinée. If you live in a smaller town, call the nearest PBS television station or video store and ask for names of videos that show a dance performance. Do some research on well-known dancers. Share that information with your students.

Related Books

Komaiko, Leah. Illustrated by Petra Mathers. *Aunt Elaine Does the Dance from Spain.* New York: Doubleday Books for Young Readers, 1992.

Raczek, Linda Theresa. Illustrated by Katalin Olah Ehling. *The Night the Grandfathers Danced.* Flagstaff: Northland Publishing, 1995.

Ryder, Joanne. Illustrated by Norman Gorbaty. *Earth Dance.* New York: Henry Holt and Co., 1996.

Related Music

Marxer, Marcy. *Jump Children.* Rounder Records, 1989.

Penner, Fred. *Happy Feet.* The Children's Group, 1992.

Sound Effects Sampler. Madacy, 1994.

Tickle Tune Typhoon. "There Is a Fine Wind Blowing." *All of Us Will Shine.* Music for Little People, 1987.

11
One Watermelon Seed

by Celia Barker Lottridge
Illustrated by Karen Patkau
(TORONTO: OXFORD UNIVERSITY PRESS, 1986)

Background

Have you ever taken a slice of watermelon and held it up to the light? Have you ever closed your eyes and traced a red, yellow or green pepper with your hands? Have you ever counted the sections of an orange and multiplied by 3? Have you ever tried to spin an eggplant? Have you ever followed a strawberry vine to wherever it takes you?

Questions like these and answers that are even stranger make up this chapter, which focuses on using fruits and vegetables as stimuli for creative expression. The next few pages should be interesting for the kids in your classroom—primarily because the activities rendered in this chapter, in all likelihood, have not been experienced by your youngsters. So to get us started, let's begin with *One Watermelon Seed*, a cute, colorful, easily read children's story that combines counting and color in a brightly illustrated format. Girls and boys will read the story, look at the pictures and then let those fruits and vegetables take a life of their own. And not once do they have to plant a garden on the windowsill of your classroom.

Hook

Materials

Strawberries.

Directions

Before you read *One Watermelon Seed*, make a list of all of the fruits and vegetables that are mentioned in the book. Scramble the spelling of each fruit and vegetables and write the scrambled version of the words on the board. Here are the following words and their scrambled counterparts: watermelon (retawnlome), pumpkin (ppmunik), eggplant (gpgleatn), pepper (pppeer), tomato (oottam), blueberry (rryebbule), strawberry (wartbysrre), bean (neab), potato (tatopo), corn (crno).

Discussion

Ask students to look at the words and try to unscramble them. The only hint you can give is, "You can find most of these in a refrigerator." When the kids have figured out the words, give them all strawberries to nibble on as you read

One Watermelon Seed by Celia Barker Lottridge, illustrated by Karen Patkau.

Personal Learning Capacities

Unscrambling these words will allow your students an opportunity to function in their logical/mathematical intelligence, whatever level that function is. Some students will be mildly interested in unscrambling the words while some kids will demonstrate a real desire to solve this particular kind of problem. Whatever the level, engagement is what your kids are striving for.

> ► Activity 1
> Watermelon Poetry

Materials

Watermelon, knife, newspapers, paper towels, overhead projector.

Directions

Because the whole point of this chapter is for boys and girls to do something different with the information they gathered from the book, I'll start off with an activity that uses a watermelon as a catalyst for stimulating interest in poetry.

Bring a watermelon to school and place it on a table in front of the children. Before you talk about the melon or explain why it is there, place this poem on the overhead projector and have the children recite it with you.

Eatin' Melon
BY MARTHA BRADY

I run through the front door, I barrel down the hall.
I race to the kitchen, my backpack and all.
I open the fridge, searching each separate rack.
And quickly I spot it, right there in the back.

I grunt when I lift it, I pose a wide stance.
I know if it drops Mom will ship me to France.
I struggle and wobble and buckle and bend.
And finally find Momma's clean counter end.

Like holding a baby, I lower it down.
I wonder whose baby weighs twenty-nine pounds.
I look for a knife as I open the drawer.
I make the incision, the best one by far.

The melon creaks open, its mouth wide and fat.
I pop in some seeds and nail Barney, the cat.
The cat jumps like lightening then lands on his feet.
Which gives me a clue that it's now time to eat.

It oozes, it dribbles, it slushes, it drips.
It swoozzles my t-shirt, it slathers my lips.
It sticks to my fingers, it spurts in my eye.
It slurps down my Levi's, no time to ask why.

It spazzles, it spizzles, it liquids my chin.
It colors my face, what a mess I am in.
It splats on the floor like a water balloon.
It snorkels my nose. Do I live in Cancun?

It drizzles, it snibbles, it drabbles, it dwerks.
It sloshes my fribble, a napkin won't work.
It googles my navel, it gaggles my neck.
It sprinkles my noodle, I say, "What the beck."

It douses my earlobes, it splatters my hair.
It sprays down my toe bones, and all that is bare.
It drenches my elbow, it rolls 'round my waist.
For one tiny moment I stop just to taste.

My mom grabs my shoulders and heads for the bath.
I squish when I walk and that makes my mom laugh.
She fills up the tub and I give her a wave
As I grab one more piece that I eat while I bathe.

Here comes the fun part. Keep the poem on the overhead projector and direct your girls and boys to gather around the melon. Be sure you have plenty of newspaper on the floor underneath the melon, and it might be a good idea to give each child a napkin as well.

Begin by asking the students to touch the watermelon. When they do, write down all the descriptive words they verbalize when touching the melon. Then ask them to listen to sounds as you cut the melon, once again writing the descriptive words that come from the children's responses. Now, slice into small chunks, enough pieces of melon to go around. This time ask your youngsters to smell their little bits of melon. Words like "fresh" and "grass" often come to mind. Whatever the responses are, write them down on the board.

By this time, most of the kids are clammering to taste the watermelon, but not yet. There's more to do. Before they chomp into the juicy red tidbit, the children will look at their own piece of melon and try to find "something

different" in the melon flesh. Some kids may see a bird. Many often see a whale. Some of your boys and girls may glimpse a letter of the alphabet. Perhaps mountains, a hot dog or even the face of a monkey. Give them all time to find something and discuss those findings. Be sure to acknowledge all of the hidden faces, creatures or objects, and write that list on the board for possible later use.

When the kids have touched, listened to and smelled the watermelon, it is finally time to taste it. As they eat the piece, write down all the descriptive words or phrases that emanate from those juicy little mouths. Again, put those on the board. By now the board should be full of words that describe one simple thing: a watermelon.

Talk about the words a bit, use them in sentences, incorporate those words with synonyms, rhyming words, etc., and then read the poem one more time. The words in the poem should be much more meaningful this second time around.

Personal Learning Capacities

When looking at this activity straight on, it, of course, is very linguistic. The kids are observing, speaking, thinking about, defining, writing and playing with words. And that's good. That is very good. I believe there is more here too. The color, shape, texture and form of the melon are magnets for your visual learners. The color, shape, texture and form make the words understandable and meaningful in relation to the text of the poem. The same can be said of the logical/mathematical function of students who will be keen on seeing how this melon looks on the inside. These students will take great joy in finding the natural patterns of the flesh. They will no doubt find many faces or creatures hidden in their piece of melon. And that discovery will assist them in understanding how the actual melon relates to the poem. And we haven't even mentioned counting the watermelon seeds.

Evaluation

Appropriate behavior, participation.

Materials

Knife, watermelon.

Directions

You simply cannot do Activity 1 without doing Activity 2. The two go together like a, well, you know. All you need is a knife and a little bit of time.

Cut several chunks of melon and carefully get rid of all of the red. Cut it right off. Keep the white and green part of the rind. Now cut off a thin sliver of the white part of the rind. The piece should be about $2^1/_2$ inches long and an inch wide. Cut a slit down the length of the piece of white rind. When you make the slit do not cut through the top or bottom of the rind. Here is a crude drawing of what it should look like:

Next, cut several vertical slits down and through the horizontal slit you just made. Here is a crude drawing of what that should look like:

The white piece of rind should resemble a zipper by now. Place the piece of rind into your mouth over your teeth. Voila! Watermelon teeth. Of course all of the students will want a pair, so begin cutting. Then when every kid in your room is wearing a pair of those fruit dentures, read the poem one last time.

Personal Learning Capacities

Here is a quick trip through many intelligences. Your visual/spatial students will be engaged. Your verbal/linguistic children will be engaged. Your kinesthetic students will be engaged. Not bad for a simple set of teeth.

Evaluation

None.

Materials

None.

Directions

Give the folks in your class a large handful of stringbeans. Sitting on the floor or at their desks, they will play the game Pick-Up Sticks with the stringbeans. When enough time has elapsed to ensure that students can work with the stringbeans in an appropriate manner, introduce math activities that require them to use the string beans as a means of finding solutions. Examples might be addition problems, graphing, multiplication problems or even story problems. Stringbeans work best if they have been kept cold before the kids use them. Here is a math-problem story (written by the author) your kids can work on. Read the story and have the girls and boys use stringbeans as counting tools for finding the solution to the story.

Thomas loved grapes. He loved red grapes and white grapes and even green grapes. Every morning when he awoke, the first thing he did was run to the refrigerator to grab a handful of grapes. His mother knew how much he loved grapes so she made sure there were always grapes in the refrigerator for him to munch on. He loved that his mom always remembered.

Early one Saturday Thomas decided to go outside to play. He went to the refrigerator and grabbed a handful of grapes to take outside. As he shoved the bunch of grapes into a plastic bag, he ate 3 just to see how they tasted. When he went outside he tossed 2 grapes to his dog, threw away 2 grapes that were brown and ate 5 more. He walked down the street and came to a stop sign. He counted all the sides of the stop sign and ate that many grapes. He waited for 2 cars to pass and then he crossed the road. On the other side Thomas stopped and bit into 1 grape that was so sour he spat it out. He then found 2 more that were perfect so he gave them to the mail-carrier who was walking by.

He looked at his watch and saw that it was 10 o'clock so he raced back home and ran up the 5 back steps that led to

the kitchen. He ate 1 grape for every step he climbed. When he got into the kitchen and looked into the plastic bag, he realized that half of the grapes were gone. How many grapes did he have to begin with?

When the solutions have been discussed, reward the youngsters with a handful of grapes. Or stringbeans.

Personal Learning Capacities

Kids who function within their visual intelligence will use that intelligence to help them image as the story progresses. Kids who function within their logical intelligence will demonstrate skills in numbers and problem-solving. Kids who function best with a full stomach will simply eat the stringbeans. Oh well.

Evaluation

Correct answer, evidence of process, listening skills, following directions.

Activity 4
Potato Head Story

Materials

Potatoes, plastic knives, newspapers.

Directions

Give each student a potato with which to carve a face, a creature, a being, an object. Students will use that potato as a creative writing stimulus. The written work can be a poem, a play, a story, a list of descriptive words, a puppet script, a journal entry, etc.

Personal Learning Capacities

Use this activity to once again help identify the learning styles among the children in your classroom and to assist you in seeing at which level of the intelligences they function. This activity embraces the visual, logical, interpersonal, kinesthetic, intrapersonal and linguistic intelligences and is a good clean activity that will allow students to see how these intelligences relate to each other. A discussion about these relationships is really the objective of this particular activity.

Activity 5
What Is the Eggplant?

Materials

"Stuff," eggplant.

Directions

Let students spend 5 or 10 minutes gathering "stuff," such as pencils, rocks, wadded up paper, leaves, paper clips, rubber bands, clay, hats, erasers, crayons, plastic cup lids, etc. Collect the stuff and categorize it. For instance, all rocks go in one spot, all leaves go in another and so on.

Everyone will sit in a circle on the floor. One at a time students will arrange alike objects or eclectic objects on the floor in front of them. When that is done, place one eggplant in a strategic place among the objects. Then ask the question "What is the eggplant?" Students will have to look at the arrangement of objects and try to guess what the eggplant represents in the display. Here are a few examples:

♡ A pile of rocks laid out on the carpet and an eggplant = an astronaut walking on the moon.
♡ An eggplant with leaves covering it= an Easter Egg Hunt.
♡ Rubber bands and an eggplant = a teacher teaching a class how to Hoola Hoop.

Personal Learning Capacities

This is higher-level problem-solving, so your kids who like to create and develop new strategies or solutions will be able to use their logical/mathematical skills to accomplish this experience. And because this is a tactile activity, the kinesthetic learner will appreciate working in this situation and should participate and perform very successfully.

Verbal aptitude is present in this activity as well and allows those kids in your class a chance to be creative in their descriptions of the objects and the eggplant.

Evaluation

Thinking strategies, sensible solutions, participation, appropriate behavior.

Activity 6
Fruit and Vegetable Chant

Materials

None.

Directions

Students will create a rhythmic "body jive" movement of 2 knee slaps, 2 hand claps, 2 finger snaps, 2 head taps, repeated over and over until a steady rhythm occurs.

When that happens they will divide into groups and recite the following chant:

Strawberries, pumpkins, watermelon, corn
What did you eat on the day you were born
Blueberries, eggplant, tomatoes and beans
2 big pizzas, what do you mean?

Strawberries, pumpkins, watermelon, corn
What did you eat on the day you were born
Blueberries, eggplant, tomatoes and beans
4 long hot dogs, what do you mean?

Strawberries, pumpkins, watermelon, corn
What did you eat on the day you were born
Blueberries, eggplant, tomatoes and beans
6 scoops of ice cream, what do you mean?

Strawberries, pumpkins, watermelon, corn
What did you eat on the day you were born
Blueberries, eggplant, tomatoes and beans
8 syrupy pancakes, what do you mean?

Strawberries, pumpkins, watermelon, corn
What did you eat on the day you were born
Blueberries, eggplant, tomatoes and beans
10 greasy cheeseburgers, what do you mean?

Strawberries, pumpkins, watermelon, corn
What did you eat on the day you were born
Blueberries, eggplant, tomatoes and beans
12 beef tacos, what do you mean?

Strawberries, pumpkin, watermelon, corn
What did we eat on the day we were born
Blueberries, eggplant, tomatoes and beans
We had a stomachache, what do you mean?

Personal Learning Capacities

Offering chants in the classroom is a user-friendly way of successfully bringing attention to the musical intelligence in all of your children. The rhythmic pattern is precise and predictable, the students are able to use their hands and bodies to create those predictable rhythms and the kiddos get to actually create music from those slapping, snapping, thumping body sounds. All in all, this activity is great for the musically capable child and for the child that needs a little nudge to function strongly in this intelligence.

Evaluation

Participation, teamwork, maintaining rhythm.

Materials

Selected fruits and vegetables.

Directions

Remember the questions that were asked at the beginning of this chapter? Well, let's have the kids answer them through creative writing or drawing experiences.

Here's the first question: "Have you ever taken a piece of watermelon and held it up to the light?" If there is any watermelon left from the watermelon teeth activity, slice thin slivers of the fruit and give to each of your children. Ask them to hold the piece up to the light and look one more time for a natural design that is somewhere in that sliver. When the design has been found, students will

1. Relate how the object got into the watermelon.
2. Use markers, watercolors, torn tissue or clay to duplicate the design.
3. Write an account of "one day in the life of the object."
4. Connect with another student and combine two designs into one story.
5. Create a math-problem story that uses the design in an integral way.

The second question reads, "Have you ever closed your eyes and traced a red, yellow or green pepper with your hands?" Most children haven't, so it is time to give them this experience. Place several fruits and vegetables, including green, red or yellow peppers, out on a table and have your youngsters close their eyes and feel them. Then ask your girls and boys to

1. Talk about differences in shapes, likenesses, interesting characteristics the fruits and vegetables have.
2. Keeping their eyes closed, draw the shapes and

contours of the fruits and vegetables, then compare and talk about the strength of the sense of touch versus the sense of sight.

Here is question three: "Have you ever counted the sections of an orange and multiplied by 3? Using an orange, students will

1. Create a math problem.
2. Graph the sections of oranges according to weight, length, number of seeds, etc.
3. Separate the sections and create a face.

The last question is "Have you ever followed a strawberry vine to wherever it takes you?" Using imagery students will take an imaginary trip to "wherever a strawberry vine takes them." At the end of their journey they will share their location through discussion, watercolor, movement, pantomime or verbal skits.

Personal Learning Capacities

These questions bring to the students a chance to be mindful, thoughtful and focused as they answer in different ways. And the ways they choose to answer will rely heavily on the intelligences within which they easily function. Create your own intelligence graph. Give students choices of answering the questions with the activities listed here or by creating their own activities. Then graph the intelligences used to accomplish the activities. Don't forget to ask yourself where you would be if you came to the end of a strawberry vine.

Evaluation

Participation, completion of task, appropriate behavior, sensible answers.

Community Activity

Take a trip to the local grocery store. Spend some time with the produce manager and learn about all the fruits and vegetables on display and where they were grown. Your boys and girls should take notes because when they get back to their room, they will use maps to locate what areas of the world all of the fruits and vegetables were grown in. Encourage the youngsters to use pushpins and yarn on the maps to track the different routes the fruits and vegetables took to find their way to the local grocery store.

Reflective Question or Journal Entry

"You are a small seed underground. How does it feel to finally pop up through the dirt and see the sun and feel a breeze for the first time?"

Wrap-Up

Read *One Watermelon Seed* again and compare that book with other children's books that talk about food and growing things. Then ask the children, one at a time, to describe their favorite meal.

Related Books

Brown, Laurene Krasny. *The Vegetable Show.* New York: Little, Brown and Co., 1995.

Cole, Henry. *Jack's Garden.* New York: Greenwillow Books, 1995.

Ehlert, Lois. *Eating the Alphabet.* New York: HBJ Publishers, 1989.

———. *Growing Vegetable Soup.* New York: HBJ Publishers, 1990.

———. *Planting a Rainbow.* New York: HBJ Publishers, 1988.

Everitt, Betsy. *Mean Soup.* New York: HBJ Publishers, 1992.

French, Vivian. Illustrated by Alison Bartlett. *Oliver's Vegetables.* New York: Orchard, 1995.

George, Jean Craighead. Illustrated by Paul Mirocha. *Acorn Pancakes, Dandelion Salad and 30 Other Wild Recipes.* New York: HarperCollins, 1995.

Mallett, David. Illustrated by Ora Eitan. *Inch by Inch.* New York: HarperCollins, 1995.

McCloskey, Robert. *Blueberries for Sal.* New York: Puffin, 1948.

Rae, Mary Maki. *The Farmer in the Dell: A Singing Game.* New York: Viking, 1988.

Wexler, Jerome. *Sundew Stranglers.* New York: Dutton, 1995.

Related Music

Broadway Kids. "Food, Glorious Food." *The Broadway Kids Sing Broadway.* IDOC Productions, 1994.

Chipmunks. "All I Want for Christmas Is My Two Front Teeth." *Christmas with the Chipmunks.* EMI, 1963.

Hall, Tom T. "Old Dogs, Children and Watermelon Wine." *Greatest Hits.* Polygram, 1975.

McCutchen, John. "Watermelon." *Family Garden.* Rounder Records, 1993.

Raffi. "Brush Your Teeth." *Raffi on Broadway.* MCA, 1993.

Various Artists. *Funny Food Songs.* Disney, 1996.

12
The Other Way to Listen

by Byrd Baylor
Illustrated by Peter Parnall
(NEW YORK: CHARLES SCRIBNER'S SONS, 1978)

Background

Living in the Southwest, Arizona specifically, gives one many advantages. The weather is generally perfect. (Yes, but it's a *dry* heat.) The highway system gets you where you want to go. Most cities are small enough to find your way around in, yet big enough for a museum or two. But the biggest advantage, I suppose, is that if you live in the Southwest, Arizona specifically, you live in Byrd Baylor country.

And what is Byrd Baylor country? It's a sky so blue that you swear you're looking through cellophane. It is an orchestra of rocks playing "The Red Chorus." It is thunderous trees holding up thunderous snowcapped peaks. It is a parade of cacti waving their arms at the sun. It is where Byrd Baylor lives, it is what she lives, and happily for us, it is what she writes about.

The Other Way to Listen is a road map through this country of Byrd's. And with her illustrating sidekick, Peter Parnall, it is, as are most of their books, not so much a trip through the deserts and mesas and craggy canyons of the area as it is a trip through the deserts, mesas and craggy canyons of ourselves.

The creative arts activities gathered for *The Other Way to Listen* are quiet thoughtful activities that can be used to enhance children's understanding of Baylor's quiet and powerful message of nature and all that is touched by it.

Hook

Materials

CD/cassette player, appropriate musical selections.

Directions

Appropriate music is the perfect lead-in to this sensitive book, and Native American music is the only music that is appropriate. There are numerous CDs and cassette tapes that feature Native American flute music, chanting and drumming. Several titles for this type of music are included in this chapter, and you can go to your nearest record store to find these and other choices as well.

Darken the room a bit, bring down the chatter and play a selection of Native American flute or drum music. Let the children listen for a while, then as the music still plays, ask them to describe how the music is affecting them and where it is taking them in their minds.

When the time is right, read one or two pages of *The Other Way to Listen*, then stop, play a short segment of the music again and discuss what the author is trying to say. Do this until the entire book has been read.

Discussion

If you have several copies of the book, distribute them so there can be a book among three or four students. The girls and boys will take selected passages, discuss those passages among their group members then come back to the whole group and talk in more depth about what they thought the author and illustrator were trying to say. This time, however, they will define the meaning of their particular section with three words that encompass color, size and feel. For example, in the first page where the two characters are describing the sound of corn popping, students who select that page or section might describe it as white, wide and crunchy.

Personal Learning Capacities

Even though students will be working together on the passages of the book and must do so collaboratively, they too must have a sense of themselves in such a way as to be able to identify with the characters' feelings and views in order for any of the text to make sense. Children who function within their intrapersonal intelligence will involve themselves thoroughly in this experience. And for those children whose level of interest is less, all the more reason to introduce and offer these kinds of experiences in a consistent and safe atmosphere.

▶ Activity 1
Sound Sculptures

Materials

Cereal boxes, wire.

Directions

This first activity is a visual way for kids to begin to see what sounds might look like even if they can't hear them. The entire point of Byrd Baylor's book is to look at things

differently and to slow down so that we can. For most children, putting those lofty requests in visual terms is a way of getting those ideas across.

Using a collection of cereal boxes of all sizes and wire, students will construct pieces of sculpture that represents what certain sounds might look like. To demonstrate this idea, the teacher will take an idea from the book, perhaps "hearing a whole sky of stars," and create, on the spot, a sculpture that defines that sound. Be sure to explain your procedures and rationales for making the sculpture a certain way. Children will be asked to do the same.

Give your boys and girls a choice of selecting a sound that can be heard, like wind or fire, or let them choose more difficult sounds such as silence, rocks expanding, etc.

This should be an individual activity.

Personal Learning Capacities

Give the students the gift of time with this activity and let them get in touch with their intrapersonal capabilities. Once they figure out their own sense of certain sounds, then their other intelligences, such as visual/spatial and logical/mathematical, can function in an integrated way to assist in accomplishing the activity.

Evaluation

Completion, clear explanation.

Activity 2 ◀ · · · · · · · · ·
Pantomime/Freeze

Materials

None.

Directions

This is a drama activity that requires students, through pantomime, to look at and demonstrate different observations, viewpoints or understandings than what is normally expected.

Review Baylor's text of listening differently and explain that this activity will go beyond sound. For instance, ask six volunteers to go to the front of the class and, as a group, pantomime school then freeze. Now ask six different volunteers to go to the other end of the room and pantomime,

as a group, how school might look or sound differently.

The first volunteers might create a classroom scene; the second set of volunteers might create a prison scene or a school of fish.

Divide the class into three groups. Each group will make a list of five situations, objects, attitudes, etc., that can be seen differently. One group will rotate and demonstrate, through pantomime/freeze, the typical definition or description of the situation, while the other two groups demonstrate, through pantomime/freeze, different ways of seeing the situation. Here are some situations, objects and attitudes:

- Silence
- Family
- Rocks
- Clouds
- Freedom
- War
- Other

Personal Learning Capacities

If you wish to see the personal intelligences at work, nonverbal experiences such as this one are strong areas for that to happen. Because it is a thinking activity that requires kids to express their view of inanimate situations clearly, communication skills are very important. This is where both the interpersonal and intrapersonal capabilities are allowed to function.

We know, through observation and reading, that one of the identifying markers for intrapersonal students is their ability to take risks and offer original solutions to problems. This particular pantomime experience will allow that to happen. We know too that interpersonal students use their interpersonal capacities to set the tone for appropriate focus, social outcomes and follow-through within a group. This pantomime activity will allow for that to occur as well.

So sit back and watch how your students initiate, work through and complete this drama situation. And by all means, when the event is completed, spend time discussing specific roles taken, problem-solving techniques, intelligences used and the overall sense and opinion of the exercise.

Evaluation

Participation, teamwork, completion, follow-through, clear demonstration.

· · · · · · · · · ▶ Activity 3
Conversations with a Rainbow

Materials

Paper, pen or pencil, cassette recorder.

Directions

Pick a glorious day when the shade of the sky is exactly the right hue, when the temperature is precisely perfect, when

going outside is really the only reasonable thing to do if it's your day to breathe. Take your covey of kids, pencils, paper and a tape recorder, and go outside.

With your boys and girls, find an ideal spot to sit and simply observe all that is outdoors. Follow a cloud, stare at a rock, find a blade of grass and get to know it. Look for and spend some time selecting one thing each of you would like to have a conversation with. Maybe it is that blade of grass or the cloud. Perhaps it is a leaf on the ground or a grain of sand. Whatever it is, talk to it. Ask it questions.

In many of her children's books, Byrd Baylor has these kinds of conversations. With dust devils and green clouds and, oh yes, hawks. Peter Parnall has a few conversations too, using words that could only be spoken with pen and ink.

When you and your students have found something to have a conversation with, begin the conversation. Think of at least ten things to talk about or ten questions to ask the something. How would your something answer those questions? Create a written record of your conversation, or better yet, record it. Simply talk about the something you have chosen to have a conversation with, ask the questions you have always wanted to ask that something and write down the answers you think that something would say. When time is up, everyone returns to the classroom and shares the conversations. You may wish to model your own conversation experience first just to help children with the rhythm of the exercise.

Of course, if I could have gone with you on your outdoor excursion I would have wished for a rainy kind of day because maybe then I could have talked to a rainbow. And if that had happened, here are some questions I might have asked.

- Why are you made up of different colors instead of, say, all green?
- If there is no pot of gold at the end of you, what is?
- Why are you curved?
- Do you ever appear at night?
- What kind of sound do you make when you are in the sky?
- Where do you come from?
- What keeps you from falling down to the ground?
- Do you have a first name?
- If I could touch you, what would it feel like?
- Have you ever been on a horse?

When the conversations have been shared, conclude by asking these rainbow questions to your students and see what kind of answers you get. They might even match mine.

Because I'm multicultural.
A pot of beans.
I was born that way.
No. My mother won't let me stay up that late.

I say YOW ! a lot. I'm afraid of heights.
I was born in Philadelphia but I've lived all over.
Suspenders.
Eugene, but don't tell anybody.
A Hershey candy bar on a warm day.
Why do you think I'm curved?

Oh, I almost forgot. The children's conversations would be wonderful to act out.

Personal Learning Capacities

Students who don't get in touch with their intrapersonal intelligence on a regular basis will sometimes try to sabotage activities like this, ones that require them to remain on task. Be patient and give those students every opportunity to stay focused. Guiding them through the exercise may be an option.

Evaluation

Communication skills, thoughtful questions, participation, completion.

Community Activity

Read *The Other Way to Listen* one more time. As you read, students will use sheets of newspaper to create sounds appropriate to different sections of the book where sounds are mentioned. Students can tear, wiggle, crumple, blow on or snap the pieces of newspaper as they try to create original sounds to embellish the reading of the story.

Reflective Question or Journal Entry

"What does a whole sky full of stars sound like?"

Wrap-Up

Spend some time during the day sharing more of Byrd Baylor and Peter Parnall's books, the titles of which are listed below. Find the commonalties of the books. Compare the way Parnall chooses to describe like characters or creatures in the different books. Also compare the setting of their books to the natural setting of your own community. Then lead the children into a different way of listening to things. Ask them to pretend they cannot hear or speak. Hold up several objects or pictures of objects such as feathers, marbles, a sun, a rainbow, rain, trees, etc. As you hold each object up, children will use their facial and body expressions to show what those objects "sound" like.

Related Books

Asch, Frank. *The Earth and I.* New York: Harcourt, Brace and Co., 1994.
Baylor, Byrd. Pictures by Peter Parnall. *I'm in Charge of Celebrations.* New York: Charles Scribner's Sons, 1986.

————. Pictures by Peter Parnall. *The Desert Is Theirs*. New York: Charles Scribner's Sons, 1975.

————. Pictures by Peter Parnall. *Everybody Needs a Rock*. New York: Scribner's Sons, 1974.

————. Pictures by Peter Parnall. *Hawk, I'm Your Brother*. New York: Charles Scribner's Sons, 1976.

Berends, Polly Berrien. Illustrated by Brad Sneed. *"I Heard" Said the Bird*. Dial Books, 1992.

Bouchard, David. Illustrated by Henry Ripplinger. *If You're Not from the Prairie*. New York: Atheneum, 1995.

Guiberson, Brenda Z. Illustrated by Megan Lloyd. *Cactus Hotel*. New York: Henry Holt, 1991.

Related Music

Evenson, Dean. *Desert Moon Song*. Soundings of the Planet, 1992.

Kater, Peter, and Carlos Nakai. *Migrations*. Silver Wave Records, 1992.

Kater, Peter, and Carlos Nakai. *Honorable Sky*. Silver Wave Records, 1994.

Nakai, Carlos. *Canyon Trilogy*. Canyon Records, n.d. 443 N. 16th Street, Suite 6, Phoenix, AZ 85016.

Oldman, Coyote. *Landscape*. Perfect Pitch Records, 1988. 1450 6th Street, Berkeley, CA 94710.

Winter, Paul. *Canyon*. Living Music, 1985.

13
Roxaboxen

by Alice McLerran
Illustrated by Barbara Cooney
(NEW YORK: PUFFIN, 1991)

Background

My childhood was spent in a small town in Texas. Lots of trees, lots of friends, lots of time. My dad owned the grocery store and my mom taught fifth grade. And during the summers when Daddy was busy selling flour and lard and Mom was preoccupied with snapping beans, I played. And played. And played. My favorite thing to do was go to Lydia Johnson's and build "houses."

We would go out in her backyard and make the outline of a large house out of empty Coke or Grapette bottles that I got from Daddy's store. Oh, the houses we would make. Giant living rooms, long halls, front porches and enough bedrooms to put all our sleeping babies down for a nap. The kitchen was the best. We would double line that area with Coke or Grapette bottles and make the stove out of flat rocks. Then we would get dirt and water and cook the best mud pies you ever tasted.

When I read *Roxaboxen* by Alice McLerran and illustrated by Barbara Cooney, I felt a real kinship with the author and the experiences her mother had on that small plot of ground in Yuma, Arizona. Her round stones, boxes and forts represented the same as my soft drink bottles, mud pies and "babies." That of childhood. Safe and wondrous and unending.

For the girls and boys in your classroom the activities that accompany this marvelous book bring to mind the adventure of childhood through the concept of simple play. All your kids need are a lot of boxes, a few rocks, adequate space and time to laugh and use their imaginations.

Hook

Materials

Rocks, wooden dowels.

Directions

The introduction to *Roxaboxen* begins with a short field trip outside. Take your crew out on the playground or somewhere around the school and ask each of them to find a perfect small rock about the size of the bottom of a coffee cup. Bring everybody back in and sit on the floor in a circle with all of the rocks in a pile in front of you.

If rocks are hard to come by, however, short wooden dowels work just as well. These dowels can be purchased at lumber and hardware stores and usually come in 3-foot lengths and in different diameters. I prefer 1/2-inch diameter dowels that are about 9 inches long. Ask to have them cut when you buy them.

As you sit with your boys and girls, share memories like the one above with your class. Let them share some memories of their own too. Urge them to talk, to listen, to remember.

Demonstrate a patting rhythm on the floor that will be used for this introductory activity. With your hand, "pat, pat, right" on the floor. Again, "pat, pat, right" on the floor. Do that over and over and ask the kids to follow your rhythm and duplicate it. Watch to make sure all kids are in sync.

Then as you make the "pat, pat, right" rhythm with your hand, sing the following rhyme over and over as you pat:

Rock fell on my head, Ma, rock fell on my head.
Rock fell on my head, Ma, rock fell on my head.

Continue singing and patting until you sense that the entire class has attained a common rhythm and pattern. Some students will have a bit of trouble initially, but be patient. They will get it.

The music looks like this:

Rock Fell on My Head, Ma

Once the students get that common pattern going, begin passing one rock at a time around the circle, starting with the person on your right. Each child will pass the rocks along, in rhythm as they sing the ditty above. When the rocks have made their way around the circle, let them pile up, once again, in front of you.

Discussion

After an activity such as this, the conversation will take care of itself. Kids will want to talk about how difficult it was or how easy it was. They'll probably discuss how the constant rhythm helped them concentrate on passing the rocks. Some might even want to do it again. Others will simply want their rocks back. Most will want to know why you did this activity in the first place

Whatever the discussion, when it has finished, settle your students down and take a little time talking about play. Generate a conversation about their own style of play. What do your students like to do most? What are their favorite games? How do they pass the time?

Share some of your childhood play adventures with them too, then read *Roxaboxen*.

Personal Learning Capacities

Students must get in touch with their musical/rhythmic intelligence for this one, and you will be able to tell fairly quickly which children have a strong sense of rhythm and tone and which don't. All the more reason to include activities such as this in your lesson planning.

▶ Activity 1
Pet Rock Poetry and Creative Writing

Materials

None.

Directions

Place the following poem on chart paper or an overhead transparency. Children will become familiar with it and use it as a resource for a creative writing activity.

I Found a Rock This Morning

BY MARTHA BRADY

I found a rock this morning. It was white and speckled green
My teacher said it was the prettiest rock she'd ever seen
Its shape was just like Florida. We studied states this week
I put the rock right on my desk so all the class could peek
Throughout the day I held it, 'cause it felt good in my hand
I even smelled it once. You know, it's my rock and I can
I took the rock to Music. Who knows, maybe it could sing
It went with me to PE. Perhaps basketball's its thing
When it was time for Writing Lab, I wrote about the rock
I wrote so much the teacher had to point up to the clock
The rock went in my pocket as I finished all my work
I heard the bell and felt my rock and patted it for luck

The clouds began to gather as I hurried quickly home
And then the rains came pouring down and soaked me to the
bone
When Mother saw my squishy clothes she pointed down the
hall
"Take all your clothes and put them in the washer. I mean all."
I did as I was told and fast. You should have seen her eyes
I gave her all that I had on and got a towel to dry
I grabbed an apple from the fridge and sat close to the fire
As Mother took my wet clothes out and put them in the dryer
I ate the fruit while Mother cooked, when suddenly, Ker-plok
My eyes got big as UFOs. "Oh no," I said, "my rock"
I found a rock this morning. It was white and speckled green
My teacher said it was the prettiest rock she'd ever seen
Of course my mom has other thoughts. She fears when I am
older
That I'll find something speckled brown and come home with a
boulder

When the students have been introduced to the above poem and get a feeling of one person's experience with a rock, they will take the rock they used for "Rock Fell on My Head, Ma" and decorate the rock any way they choose, either by drawing a face on it, painting flowers on it or using its shape to help define how they decorate it.

Once the rock is decorated they will take it with them everywhere they go for a week. When the week is up ask them to write an account of that experience either through journaling, short story, poetry or any other creative writing endeavor.

Personal Learning Capacities

Here is a verbal/linguistic experience that requires students to stay in tune with their intrapersonal intelligence for a long stretch of time. Each day as they carry the rocks around, students must be mindful of that experience and gauge how that experience is affecting them. It will be interesting to see how they choose to share that information.

Some kids will need teacher-generated stop gaps along to way to keep them on track. You may wish to touch base with their progress as the days go on by asking for an example of their feelings on a daily basis. Sometimes merely asking to see the rock will be enough to direct them back to the task at hand.

Evaluation

Observation skills, completion of task, good writing, following directions, length of writing assignment.

Activity 2
Boxes Alive

Materials

- Assorted boxes
- Duct tape
- Exacto knife (for teacher use only)
- Scissors
- Tempera paints
- Markers
- Glue guns
- Glue sticks

Directions

Have the girls and boys look at Barbara Cooney's illustrations in *Roxaboxen* and acknowledge all of the different ways boxes were used to enhance the houses and games in the book. During a course of a few days ask your class to begin bringing in boxes of all kinds and sizes. Set aside one whole day in which the children create whatever and they wish out of the boxes. If you look hard enough you will find that most of your subjects will be integrated into this experience.

Here are some suggestions of what the children might work on:

♡ Arrange boxes randomly. Students will create skits using the boxes as props and sets.

♡ Use boxes as sets and scenes for acting out children's stories or social studies scenarios.

♡ Use boxes to create a city.

♡ Use boxes to create a newscast set to review aspects of weather.

♡ Use boxes to create a train to "ride in" as you study states and regions.

♡ Classify boxes according to size, length, volume, weight.

♡ Use boxes to build a space station.

♡ Use boxes to create an antipollution machine or a new mode of transportation.

♡ Use boxes to create a "state-of-the-art" home.

♡ Use boxes to create a class totem pole.

Personal Learning Capacities

I have tried throughout this book to include many single activities that incorporate most of the learning styles. This is another one. Simply let the students choose which box creation they want to be a part of, and

they will select the areas that work best for them. When it is all over, most of your boys and girls will have awakened all of the intelligences that help make up who they are. Your job is to watch, watch, watch, keep them on task and provide a safe environment in which they can work.

Evaluation

Appropriate task, teamwork, consistent involvement, attitude, evidence of effort.

Activity 3 ◄ • • • • • • • •
Roxaboxen Treasure Map

Materials

Paper sacks (optional), drawing paper (optional), markers, containers, special object.

Directions

Ask each child to bring a small container to school, such as a small variety pak cereal box, a film canister or a cough lozenge tin. Inside these containers the students should place something special, like a perfect small stone or a marble. Several students or just one student will go outside and hide the "buried treasure." The student or students who hide the treasure will create a treasure map, which the rest of the students will follow in trying to find the treasure.

This activity can be accomplished in two days. The first day can be a scouting day, when all the students involved go outside and find the locations in which they wish to bury the treasure. The first day also can be spent creating the specific treasure map and making enough copies of the map for the rest of the students to have when the time comes to look for the buried treasure. The second day can be spent in the actual treasure hunt.

(Remind students to use legends with their maps if they intend to use symbols as clues.)

Personal Learning Capacities

This activity combines solid logical/mathematical intelligence with visual/spatial intelligence in a very kinesthetic arena. Students can hone in on their active imaginations while they create the maps yet still methodically use their patterning and sequential sense to set up the logistics of this experience. The big plus, of course, is that kids can go outside to do most of this. And fresh air never hurt anyone's learning.

Community Activity

Go around the room quickly and ask students to name interesting things that come in boxes according to the letters of the alphabet.

Reflective Question or Journal Entry

"Some people use boxes for homes. How would it feel if a box was your shelter at night?"

Wrap-Up

Spend a few moments with Barbara Cooney's illustrations. These, in my opinion, are what flavor the book and bring the bygone days so close to us, the readers. Discuss the illustrations and why they work. What did the class learn from them? How did the illustrations show children playing together in a successful way?

Write letters to the author and the illustrator (in care of the publisher) and let them know what your favorite parts of the book were. Pick one perfect stone from the class collection and include it with your letter.

Related Books

Baylor, Byrd. Illustrated by Peter Parnall. *Everybody Needs a Rock*. New York: Aladdin Paperbooks, 1974.

Blizzard, Gladys S. *Come Look with Me*. Charlottesville: Thomasson Grant, 1993.

Cooney, Barbara. *Hattie and the Wild Waves*. New York: Viking, 1990.

Isaacson, Philip M. *Round Buildings, Square Buildings and Buildings That Wiggle Like a Fish*. New York: Knopf, 1988.

Lionni, Leo. *On My Beach There Are Many Pebbles*. New York: Mulberry Books, 1961.

Related Music

Lanz, David. "Dream Field." *Heartsounds*. Narada Productions, 1983.

Puzzle Place. *Rock Dreams*. Sony Wonder Music, 1995.

Various Artists. " I Won't Grow Up." *Celebrate Broadway*, Vol. 7. RCA, 1995.

Wee Sing. *Big Rock Candy Mountain*, Video. MCA/Universal Home Video, 1995.

14
Switch on the Night

by Ray Bradbury
Illustrated by Leo and Diane Dillon
(NEW YORK: KNOPF, 1983)
(NEW YORK: SIMON AND SCHUSTER BOOKS FOR YOUNG READERS, 1995)

Background

Night ... what a scary, scary thing when you are five. Remember all those noises? Noises under the bed, noises in the closet, noises outside the window, noises under the pillow. When I was young and noises were bigger than the house I lived in, I spent most of my time staring up into the gaping hole in my bedroom ceiling where the attic fan sat grinning mischievously at me. I stared at that hole until I fell asleep. Each night that is how I fell asleep. No counting sheep for me. Just staring upward into the dark, black hole. Waiting for daytime.

Yes, night was a scary, scary thing back then, and for most children it is still scary today, but do they love to talk about it. This thing called "night." They love the mystery and the unknown of it. Stories of the night seem bigger and better. Accounts of bravery seem larger than life.

Curriculum in most elementary schools touches on the subject of night through the study of the solar system, units on weather, night animals, night occupations, etc. The following activities will take us on a slightly different path. They will focus mainly on *children's* perceptions of night. And, as with other activities in this book, they will allow students to use their senses and all of their intelligences to experience a common subject such as night. So, using Ray Bradbury's *Switch on the Night*, a strange, but fascinating children's book about all the scary and magical things that happen at night, as a beginning ... let's begin.

Hook

Gather your girls and boys near you on the floor and discuss night. Talk about words that describe night. Discuss with the children personal experiences, theirs and yours, that occurred at night. Give the kids a bit of leeway with these conversations and include make-believe night stories as well. These true or pretend stories can be funny or scary. In fact, if scary stories are the topic, and they usually are, you might want to read the following story to your kids and let them create an ending. As you begin to read it, why not change the character's name (William) to the name of a child who is sitting in the circle with you?

Materials

None.

The Noise

BY MARTHA BRADY

"William, will you go out on the deck and water the plants that are in the pots?" yelled William's mother as she drove down the driveway on her way to the grocery store. Watering the plants was not William's favorite chore, nor was taking out the garbage, or making his bed or anything else for that matter. "Okay," he murmured in a voice so soft that even he had trouble hearing it. "What did you say?" his mothered yelled a bit louder, as she nudged the car out into the street, "I didn't hear you." "I said, okay," whispered William loud enough to know that his mother had heard his response.

Watching his mom turn the corner, William waved good-bye to the tail lights of her car and slowly meandered down the side of the house and to the backyard where the deck was. "Now where is that watering can?" he muttered to himself. "I can't water the plants if I can't find the can." William poked around inside the shrub that was next to the house until he found the green plastic container. "Maybe if I kick the can underneath this part of the shrub, I won't be able to see it, and then I can tell Mom that I couldn't find the can and I couldn't water the plants." He stared at the can for a second or two. "Nope. She would take the skin off my ears," he said, as he grabbed the can and began to fill it with water.

The last rays of the afternoon sun began to sink behind the hill that was close to William's house, and it became a bit harder for him to locate the pots that his mom had told him to water. With a bit of effort, however, William finally located the first pot closest to him, and as he raised the plastic container to begin watering, he noticed that all of the plants in that pot had been eaten down to the dirt. "Something was hungry. I wonder what bit these off?" he said, looking around to see if anyone had heard him. Walking to the next pot, he noticed that all of the flowers had been eaten from there as well. "Well this should make my job easier," William said, as he walked slowly to the next pot.

By now, the sun was completely gone and darkness was quickly covering the entire backyard as well as the deck. "Mom should be back from the store by now," he thought, "I'll just go in the house and wait. It's too dark to finish watering." He headed for the sliding door that went into the den but found it was locked. William yanked and tugged with all his might, but could not get it to budge. A small sense of panic swept over him as he stepped back from the door. "Maybe I'll go around the side of the house and wait for Mom on the front step," he figured, as an uneasy feeling began to tingle the backs of his ears.

Suddenly the darkness seemed to wash all over William and everything else. He could barely see his hand that was carrying the water bucket. Then, from the other edge of the deck he heard a sound. Something was chomping on the hedge growing along the side of the deck. Whatever it was was tearing the long hedge to pieces. "Yow!" yelled William as he jumped off the deck and ran toward the side of the house. The tearing, gulping, thrashing noise was now closer. William sped around the corner of the house and has he did, tripped over the garden hose that was lying on the ground. The noise got louder and louder. Something was coming closer and closer. William gasped for air as he tried to untangle his legs from the knotted green hose. The noise was so loud now that he wanted to cover his face.

William struggled to free himself from the water hose. With a great kick, he finally loosened the hose from around his legs. He jumped up and continued to run as fast as he could. Something, some noisy thing was getting closer and closer. William was terrified but he kept running toward the front yard.

Just as he made it to the front of the house, William's mother's car turned into the driveway. "William, look out!" she screamed, seeing something in the glare of the headlights. Huffing and puffing, William ran to the side of the car and leaned against the door to catch his breath. Slowly, he turned toward the side of the house, which was illuminated from the lights of the car. There, thrashing and gnawing and coming closer and closer and closer was a____(?)____. William and his mother looked at each other. And in the next second they____(?)____

Discussion

At the conclusion of the story allow the kids to make up their own ending. Perhaps William and his mother jumped into the car and locked the doors. Perhaps they ran down the street, screaming. Perhaps William's mother threw the grocery bags at the something that was running toward them. Who knows? Your kids will.

Once everyone has had a chance to participate, end the dialogue by saying, "Oh, and by the way, the thing that was making all that noise was just … a very hungry bunny. And William and his mother looked at each other and … laughed." That will soothe those little beating hearts just a bit. And, when the hearts have slowed somewhat, read the beautifully illustrated story *Switch on the Night* by Ray Bradbury, illustrated by Leo and Diane Dillon.

Personal Learning Capacities

Even though 80 percent of what we do in the classroom is linguistic by nature, some of your boys and girls do not have a strong verbal intelligence. Storytelling is an excellent way of strengthening that intelligence—not just so children can interact with the telling and the teller, but so they can listen to all the words being said as well.

▶ Activity 1
Vocabulary Puzzle

Materials
Index cards, graph paper.

Directions
During the course of your unit on night, keep a list of all appropriate night vocabulary words that begin to accumulate. In fact, you may wish to have the students list particular words about night that they heard as you were reading the children's book *Switch on the Night*. Put those words on the board, on chart paper or on index cards. Then give your girls and boys an opportunity to create their own crossword puzzles using those words. You may wish to create a sample crossword puzzle first, using just a few of the vocabulary words. Showing the sample on an overhead gives the class a chance to practice before they create their own.

The following is a sample puzzle using night vocabulary words that were found in the book.

Across
1. They twinkle at night. (stars)
2. A round thing in the night sky. (moon)
3. When there is no light, it is_____. (dark)
4. Tiny insects that "sing." (crickets)
5. Opposite of day. (night)

Down
1. They use batteries to help you see at night. (flashlights)
2. They hop and jump. (frogs)
3. They light up the dark in smaller ways. (candles)

Personal Learning Capacities

The verbal/linguistic student will excel in this activity because, once again, there is an interaction with words. Also experiences that relate to puzzles, problems, formulas, etc., affect the logical/mathematical students in as meaningful a way as words do to the verbal students. These logical thinkers will engage in these types of activities because of the order and preciseness of the activity. And hopefully, the simplicity and safety of this particular activity will also be a safe ground for the student who does not have a strong logical or verbal/linguistic intelligence.

Evaluation

Correct answers to puzzle, effort, completion of task.

Activity 2
Crêpe-Paper Sculpture

Material

Crêpe paper, toilet paper (inexpensive option).

Directions

Children must get into small groups for this activity. Give them time to brainstorm about creatures or objects that can be found at night. The vocabulary list will certainly help. One person in the group will stand frozen as the other group members wrap crêpe paper all over that student in an effort

to create a night object or creature. Most children think of creating stars first, so you may want to create a star as your model and tell the girls and boys to think of something else

Personal Learning Capacities

Getting kids up out of their seats is always a good thing. This kinesthetic activity allows boys and girls to move around a bit and still problem-solve at the same time. The interpersonal students will enjoy the group interaction, and your logical/mathematical children will once again get a chance to work something out.

Evaluation

Teamwork, participation, appropriate behavior.

Activity 3
Sheets and Words

Materials

Twin-size sheets. (Look for sales at discount stores or ask parents to donate them.)

Directions

Four students will hold the corners of one sheet and move, wiggle, billow or roll the sheet in appropriate ways to define vocabulary words that pertain to night. Adding quiet

instrumental music will assist in keeping the kids focused on the object at hand. Here are suggested words:

rain	night	moon rising	avalanche
wind	snow	clouds	waterfall
crickets	sleep	hurricane	silence
thunder	dawn	dew	tornado
stars	ghosts	black	cats

Personal Learning Capacities

This activity is good in so many ways. The intrapersonal children will need to use their interpersonal skills to accomplish this experience, and the interpersonal students will need to internalize to get in touch with their intrapersonal selves. All children will use their kinesthetic abilities to solve the problem of defining the words in appropriate ways. The visual/spatial girls and boys will also get a sense of accomplishment as they put their imaginations to work.

Evaluation

Teamwork, appropriate movements, following directions, completion of task.

Activity 4
Music and Movement

Materials

Sheets (one per child), "Night" by Martha Brady.

Directions

Teach your boys and girls the simple rolling song "Night" found on page 95. When the kids have learned it, use sheets again, but this time each child should have access to one. There should be no problem in asking the kids to bring one from home. If sheets are unavailable, pieces of cloth or scarves will do just as well. (Towels are too heavy for this activity.)

With the sheets, cloth pieces or scarves in hand and as the children sing the song, they will interact appropriately to what the lyrics say. Give kids an option to sit on the floor as they experience this.

Personal Learning Capabilities

We know that all curriculum can be related to music in some way, and this is one example. Not only will your musical learners enjoy this activity as they sing the notes, memorize the words and simply enjoy the melody, they will also succeed in keeping the beat to the song and perhaps create their own rhythms to go along with the song.

Musical activities such as this also continue to strengthen the linguistic learner. Remember, there are many ways to open up this particular intelligence in your children. Song lyrics are one such way.

Of course, combining music with movement is still another way of broadening the curriculum to reach those nonkinesthetic students. This activity is safe enough to allow a little risk-taking for those students who have trouble getting in tune with their bodies.

Evaluation

Participation, effort, learning lyrics, appropriate movement.

Activity 5
Dot to Dot

Materials

Drawing paper, markers or crayons.

Directions

Give students a piece of paper and have them place one small dot and one large dot on the page. They are to draw something that relates to night by using those two dots as integral parts of their drawing. For some children this will be a difficult activity to begin. You may wish to show the class an example. Here are two dots. Create an appropriate drawing to share with your students.

When the assignment has been completed, give the class a chance to share pictures and stories that come from the pictures. A creative writing activity could easily follow.

Personal Learning Capacities

Quite often in the classroom we give kids a chance to draw, and this activity is no exception. It gives those visual/spatial learners a chance to do just that: draw and design. But it also offers the logical/mathematical girls and boys an arena in which to work. These kids get to figure, calculate and solve the problem of how to use those dots to create something.

Evaluation

Appropriate drawing, completion of task.

Community Activity

Each child in the class will be responsible for assisting in the creation of a large bulletin board whose central theme is night. Give children choices of working in groups or alone and allow them to work in areas that best suit them. Those areas could be drawing murals, characters or letters, or researching and collecting data that relate to night. Some students may wish to select appropriate music to be played while everyone is working. There may be a child who wishes to document the process, through journal-writing or photography. Some students may wish to explain what's on the bulletin board to students from other classrooms. Some may

NIGHT

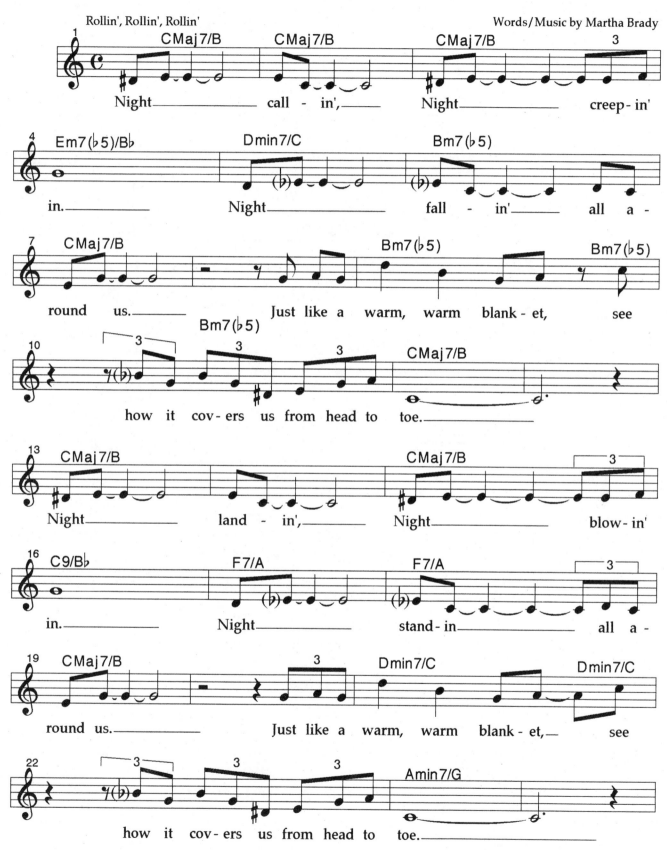

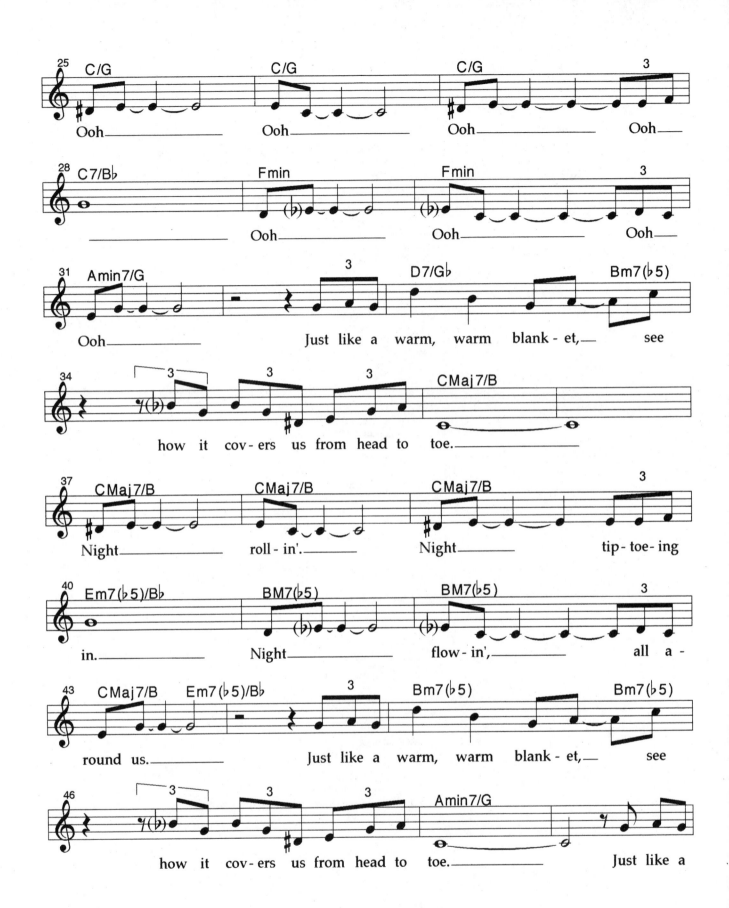

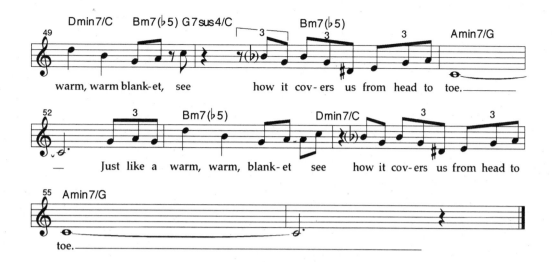

warm, warm blank-et, see how it cov-ers us from head to toe.

Just like a warm, warm, blank-et see how it cov-ers us from head to

toe.

simply want to assist. Each task is important. Each task should be acknowledged.

Reflective Question or Journal Entry

"When you think of night, what kind of music comes to your mind?"

"In your mind, walk from the front door of your house to your bedroom in the dark."

"Night is scary/comforting because_____."

"How would you draw night?"

"If you could be a night animal, what would you be? How would you stay safe?"

"Why is night dark?"

Wrap-Up

Take your kids on a campout. During class. Outside. On the playground. Kids should come to school dressed as they would be if they were actually going on a campout. Build a pretend fire. Sit around the campfire with your boys and girls and discuss how things look and are different during the day than at night. To make it even more authentic, have the class observe things around them and discuss how those things change when night comes.

Related Books

Asch, Robert. *Happy Birthday, Moon.* New York: Simon and Schuster, 1982.

Bierhorst, John, Selected by. Illustrated by Judy Pedersen. *On the Road of Stars.* New York: Macmillan, 1994.

Brown, Margaret Wise. *Goodnight, Moon.* New York: HarperTrophy, 1947.

Dickinson, Terence. Illustrated by John Bianchi. *Exploring the Night Sky.* Ontario: Camden House, 1987.

Edens, Cooper. *If You're Afraid of the Dark, Remember the Night Rainbow.* San Diego: Green Tiger Press, 1979.

Hansen, Ron. Illustrated by Margot Tomes. *The Shadowmaker.* New York: HarperTrophy, 1987

Heine, Helme. Translated by Ralph Manheim. *The Marvelous Journey Through the Night.* Germany: Sunburst Books, 1970.

Laskey, Kathryn. Illustrated by Trina Hyman. *The Night Journey.* New York: Puffin Books, 1981.

Leuck, Laura. Illustrated by Ora Titan. *Sun Is Falling, Night Is Calling.* New York: Simon and Schuster, 1994.

Schwartz, Alvin. Illustrated by Stephen Gammell. *Scary Stories to Tell in the Dark: Collected from American Folklore.* New York: HarperCollins, 1981.

Sendak, Maurice. *In the Night Kitchen.* New York: Harper and Row, 1970.

Smucker, Anna. Illustrated by Steve Johnson. *No Star Nights.* New York: Knopf, 1989.

Waber, Bernard. *Ira Sleeps Over.* Boston: Houghton Mifflin, 1972.

Walter, Mildred Pitts. Illustrated by Marcia Jameson. *Darkness.* New York: Simon and Schuster Books for Young Readers, 1995.

Related Music

Evensen, Dean, and Tom Barabas. *Wild Dancer.* Soundings of the Planet, 1992.

Herdman, Priscilla. *Star Dreamer: Night Songs and Lullabies.* Alacazam Records, 1994.

Kahn, Si. "What's That Noise." *Good Things and Bedtimes.* Rounder Records, 1993.

Karen and the Musical Medicine Show. *Skating on the Moon.* Zoom Express. 1992.

Kidsongs. *Good Night, Sleep Tight.* Video. Warner Reprise, n.d.

Wasinger, Tom. *The World Sings Goodnight—2.* Save the Children Records, 1995.

15
Time Flies

by Eric Rohmann
(NEW YORK: CROWN PUBLISHERS, 1994)

Background

This wordless picture book takes us on a journey through time. A time when things were large, thick and deep. A time when creatures were wide winged. When teeth were long and sharp. A time when the earth was lush and overgrown. A time long ago. A time of dinosaurs.

The author takes us ever so close to these creatures, into their mouths, perched on their pointed teeth, flitting on their noses. And with the help of a little bird who guides us on our journey, throughout the journey we always feel safe and convinced that no harm will come to us.

Children will love this book because of the strength of the illustrations, the broad scope of these drawings and the limitless possibilities of making this book their own, through words, music and art activities.

Hook

Materials

None.

Ask your girls and boys to sit at their desks and just watch what you are about to do. They are not to ask questions or comment on the event that is about to take place. Stand in one corner of the room and hold a stuffed animal in your hand as if it were a bird. "Fly" the stuffed animal slowly around the room, zooming over your desk, past the book cases, near a bulletin board. Continue maneuvering the stuffed animal around the room until you come to the door that leads out of the room. Open the door and let the stuffed animal "fly" out.

Discussion

Lead a discussion in what the children saw. What things did the animal pass over as it made its journey around the classroom? Make a transition from the actual things that the animal flew over to the history of those objects. An example might be your desk. What things have happened at your desk? When? Why? Make your last transition from events surrounding your desk or other classroom objects to history and events in time. Now you may introduce *Time Flies* by Eric Rohmann.

Personal Learning Capacities

The experiences just mentioned, the flight and the discussion of the flight, open up possibilities for many of the learners in your classroom. The visual/spatial child will be able to see the entire flight and make some sense of it. The linguistic learner will appreciate and be involved in the what, when, where, why and who of the questions you asked. And your children who need the experience of thinking things through and putting some order to that process can use their logical/mathematical intelligence to track that entire flight and sequence it in some way that benefits them.

> ▶ **Activity 1**
> **Soundtracking the Story**

Materials

Two cassette players with built-in microphones, hand-held microphones (optional), ear phones, blank cassette tape, student-selected music.

Directions

This activity works well in a "center" format and requires little supervision. Children will select several cassette tapes of various classical music selections. They will read *Time Flies* once again. The students will then select appropriate music to play through earphones as they read the book. This might mean reading several pages and using one type of music to describe the action of those pages, then changing mood and selecting another piece of music to use for the next few pages.

Once the music has been selected, students will have the opportunity to tape those pieces onto a blank tape. When the music is completed, students will play their newly created "soundtrack" and read the children's book once again.

This activity is very fulfilling for students, and they will want to do it many times. I would urge that you begin with classical music then give them a chance to branch out to other music genres, such as rock, country, blues, etc. The older kids may wish to use music with lyrics to assist them in the telling of the story.

Personal Learning Capacities

This activity is very good for those students who need to work on their musical intelligence. It allows them a chance to listen to sounds and notes and then figure out how they enhance the mood of the story. The intrapersonal intelligence can kick into gear when the kiddies deal with how the music makes them feel, personally, and how it affects the mood of the story.

Again, activities such as the one above require some thought processes, some logical ways of putting something together so that there can be a functional end result. Logical/mathematical students will easily be stimulated with this very good activity.

Evaluation

Completion of project, use of appropriate music, staying on task.

Activity 2
Emotion Drawings

Materials

Cassette player
Soundtrack tape (jazz, classical western, showtunes, rock and roll, sound effects)
Art paper
Markers or crayons

Directions

Children will read the book and play the "soundtrack" as well. While this is happening they will also take a crayon, marker or pencil and draw an unbroken line on paper that describes different emotions that come to mind and body as they look at the pages and hear the music that goes with the pages.

The drawing might have circles, squiggly lines and slashes. It might have bumps, curves and zig-zag lines. Each paper will be different because students will hear something different and respond in their own way. Just remind them to keep the pencil ON the paper at all times and concentrate on the different moods of music that are being played.

Depending upon the music played, a child's paper could look something like this:

Personal Learning Capacities

This is another way for intrapersonal students to reflect on what they see and feel. The use of crayons or markers will offer visual/spatial

stimulation, and those students who are not musical by nature will be able to call up their musical intelligence to help define their own emotions as they complete this activity.

Evaluation

None.

Activity 3
Adding Words

Materials

2 cassette players
Blank cassette tape
3 x 5 blank card
Markers
Tempera paints
Crayons

Directions

Play the soundtrack again on one of the cassette players. Put a blank tape into the other cassette player and activate the microphone. Look at the book and tell the story in your own words. Now you have an original rendition complete with background music and narration that other girls and boys in the classroom can listen to at their leisure.

Use a 3 x 5 blank card cut down to size and design a personal cassette tape cover, or "J" card that will fit into the plastic case that holds the cassette tape.

Personal Learning Capacities

The visual/spatial intelligence is acknowledged with the creation of the original cassette-case design. Kids can be very creative with this aspect of the activity above, and it also can be used as a kid-watching event for the teacher.

In addition, because speaking skills are used as well as listening skills, linguistic students and those who are not as strong linguistically will have an opportunity to practice speaking, thinking of appropriate words that fit the story or looking in the dictionary for words that better describe how they wish to "tell" the story.

Evaluation

Creative expression, following directions, completed piece, clarity of voice, quality of work.

Activity 4
Timeline Comics

Materials

Art paper, pencils, acetate sheets (optional).

Directions

Students will discuss their own classroom "time in history." For example, what event happened on the first day of school? When did the gerbil come to class? What date was the first snow? Who was the first substitute? Using the first day of school until the present as this timeline, they will define their own important events from that timeline. To depict that personal timeline, students will draw wordless comic "cells" that sequence those personal events. These cells can be drawn on art paper or acetate sheets.

Personal Learning Capacities

Here we go with the intrapersonal student thinking about the doing, the visual/spatial student creating and designing and drawing and the logical student using math skills to draw and design.

Evaluation

Accuracy in timeline, clarity of drawing, following directions, teamwork, creative expression, appropriateness of task.

Activity 5 ◄ • • • • • • • • •
What's Next?

Materials

Pipe cleaners.

Have students look at the last picture in the children's book *Time Flies*. Ask the question "Where is the bird going now?" The boys and girls will think about this for a moment, discuss it with each other then get into groups and use pipe cleaners to shape three things the bird might see on its next flight into history. Students might create the shape of the Great Pyramid, an old-looking car or even Mickey Mouse ears. Each shape should represent some time in history. Be sure to give time to discuss the eras of history described by different pipe-cleaner structures.

Personal Learning Capacities

The interpersonal and visual intelligences go hand and hand with this activity. It is a nice, easy and very successful way for kids to use these two intelligences to assist them in learning about other historical events and the sequences those events followed.

Evaluation

Teamwork, appropriate behavior, completion of task, quality of history figures, accuracy of facts.

Community Activity

Students will create a class timeline of events from the first day of school to the present. Each student will select an important event during that time. They will describe that event on a sheet of paper and clip the paper to a piece of yarn or thin rope that has been strung across the room. They can then celebrate their own personal event or someone else's through movement, drama, clay, drawing, oral history, poetry, etc.

Reflective Question or Journal Entry

"Why did the author use the bird as our journey guide?"

Wrap-Up

Sit with your children on the floor and look at the illustrations in the book one more time. Ask children to look at each page and look at things in the drawings that can be found in present-day life, such as rocks, sky, water, etc. Talk about how some things change and some things stay the same. This could lead into comparisons of different times in history.

Related Books

Aliki. *Dinosaurs Are Different*. New York: HarperCollins, 1985.

———. *Digging Up Dinosaurs*. New York: HarperTrophy, 1981.

Anno, Mitsumasa. *Anno's Flea Market*. New York: Philomel 1984.

Barton, Byron. *Bones, Bones, Dinosaur Bones*. New York: HarperCollins, 1990.

Dodson, Peter. Illustrated by Wayne D. Barlowe. *An Alphabet of Dinosaurs*. New York: Scholastic, 1995.

Hoff, Syd. *Danny and the Dinosaur*. New York: I Can Read HarperCollins, 1958.

Joyce, William. *Dinosaur Bob*. New York: HarperCollins, 1995.

L'Engle, Madeleine. *A Wrinkle in Time*. New York: Dell Yearling, 1962.

Laskey, Kathryn. Illustrated by Trina Schart Hyman. *The Night Journey*. New York: Viking, 1981.

Odell Scott. *Sing Down the Moon*. Boston: Houghton Mifflin, 1970.

Wood, A. J. Illustrated by Wayne Andersen. *A Night in the Dinosaur Graveyard*. New York: HarperFestival, 1994.

Related Music

Harley, Bill. *Dinosaurs Never Say Please*. Round River Records, 1987.

Various Artists. "If Dinosaurs Were Here Today." *The Dinosaur Album*. Kid Rhino Records, n.d.

16
The Tub People

by Pam Conrad
Illustrated by Richard Egielski
(NEW YORK: HARPER AND ROW, 1989)

Background

When I was a child, my bathtub toy was an old white shower hose. It had a spray nozzle on one end and a rubber faucet connector on the other end that looked a lot like a mouthpiece. I spent hours in the tub, it seemed, playing with that old rubber thing. I held the hose up like a trumpet and blew into it so hard that my face turned red from the effort. Every so often I'd make a sound come out of the hose, and that small accomplishment usually kept me in the tub a bit longer trying to duplicate what I thought was the vicious growl of a wild animal.

Sometimes I'd pretend the hose was a monster from the deep, gliding ever so slowly under the water until the precise moment when it rose up to attack the floating bar of Ivory soap, which was, of course, a raft. Or I imagined a dangerous storm at sea, so I stuck the spray nozzle into the water and once again blew into the other end. This time hard enough to create giant waves. The bar of Ivory soap bobbled and spun around, and all my imaginary friends who were on the raft at the time of the storm hung on for dear life. What adventures I had in that tub, and to my mother's delight, I occasionally got clean in the process.

The Tub People by Pam Conrad, illustrated by Richard Egielski, brought back some excellent bathtub memories for me. This children's book offers a great little story which could do the same for the kids in your class.

Hook

Materials

None.

The day before you read this imaginative story to your girls and boys, ask them to bring their favorite bathtub toy to school. If you have a rubber duck hidden somewhere back behind the towels in your own bathroom, bring it along as well.

When the time comes to read *The Tub People*, start off the event with a bathtub toy parade. Yes, that's right! A bathtub toy parade. Give the boys and girls a chance to line up and walk to the classroom next door to show off their prize bathtub toys. Have a question-and-answer period while you are there. The students in the other class must have burning questions about the bathtub toys. Questions like "Are you kidding?" or "How long have you had a rubber submarine?" Or maybe "You spent your own money on that?" When the fun is over, bring the kids back, toys in hand, and have a rousing conversation about all of the bathtub toys in attendance. That will make the reading of *The Tub People* so much more enjoyable.

Discussion

For this particular book, suggest that the kids discuss the book from the point of view of one of the tub people. Lead off the discussion with a simple question such as "How did you come to be a tub person?" Students will answer as either the mother, father, grandmother, doctor, police officer, child or dog. Other questions that might follow are "What things did you do in the tub to have fun?" or "How did you feel when the child was lost?" Now let the students ask questions pertaining to the book. End the conversation with "Who do you think took the Tub People upstairs to the bedroom?"

Personal Learning Capacities

I appreciate activities that allow students to use their intrapersonal intelligence. Point-of-view situations do just that. They create mindful atmospheres for children and set up situations where children can think about how they and others simply "are." Activities like this also offer an arena for the linguistic child too, with opportunities for discussion, description and dialogue.

Activity 1
Tub People Board Game

Materials

Empty film canisters
Graph paper
Tempera paints
Cardboard
Posterboard
Markers
Scissors

Directions

Pair students up for this activity and give them free rein to express and accomplish this board-game project in any way they choose. Basically, the students are to devise a board game that follows, in some way, the gist of the story—that is, family together, family member(s) in jeopardy, family resolving a conflict. The students then would have to create ways in which to show peril and obstacles, and ways in which to show success in overcoming the perilous events and obstacles. You may wish to create a model for the kids to see, but in most cases the students will want only to get started.

Empty film canisters work well for small Tub People. They are easy to grasp, can be painted and are small enough to fit on most boards. Have on hand also enough different mate-

rials so kids can choose how they wish to make the board. Each board game should include clearly defined rules for play.

When the board games are completed, here are a few things that the kids can do with them.

♡ Set up board game centers.

♡ Take the board games to a lower grade and teach those children about Tub People.

♡ Assign a creative writing episode for the board games.

♡ Bring to life one of the board games through an informal drama activity.

♡ Go to the library and research classic board games and their origins.

♡ Laminate the board games and give them to young patients in children's hospitals.

The girls and boys may need access to *The Tub People* as they create their board games, so it is advisable to have several copies of the book available. Remember, too, that projects such as these take time. Working short periods of time for several days allows kids the advantage of not feeling rushed and also gives them think time in between time spent actually working on the project. Below is a sample board game that students can use as a stimulus to get them started on their own.

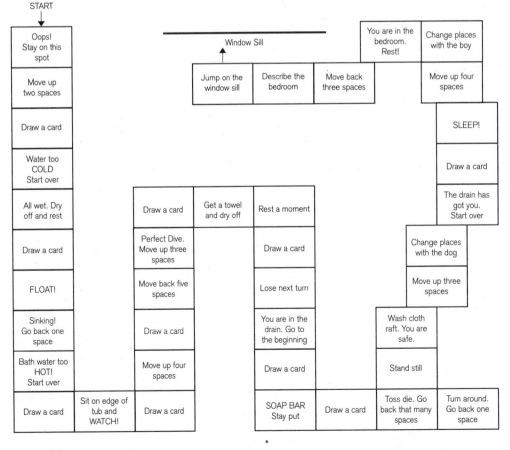

1. 7 players
2. Line up Tub People at START
3. Player 1 tosses die and moves the number of spaces that corresponds to the number on the die.
4. Each player takes turns.
5. Players follow directions on each space.
6. If player lands on DRAW A CARD, player will draw a card, read the card and follow directions on the card.
7. Player who makes it to the WINDOW SILL wins.

Write the following questions and instructions on small cards and place in area of board game marked PLACE CARDS HERE:

WHO IS THE AUTHOR?
WHO IS THE ILLUSTRATOR?
WHAT IS THE COPYRIGHT DATE?
WHAT ARE THE TUB PEOPLE MADE OF?
WHO LIKED TO PLAY SEA CAPTAIN?
WHEN DID THE TUB PEOPLE WINK?
IF YOU WERE SWEPT DOWN THE DRAIN, HOW WOULD YOU
 HAVE SURVIVED?
MAKE GURGLE SOUNDS OF WATER IN A DRAIN.
WHO SAVED THE LITTLE BOY?
SHOW HOW TUB PEOPLE SWIM.
BOB UP AND DOWN LIKE YOU ARE FLOATING IN A TUB OF
 WATER.
WHO IS THE PUBLISHER?
DESCRIBE GRANDMOTHER IN THE BOOK.
WHAT DO YOU THINK THE BEDROOM LOOKS LIKE?
DESCRIBE THE SHOWER CURTAIN NEXT TO THE TUB.
WHY DIDN'T ALL OF THE TUB PEOPLE SINK TO THE
 BOTTOM OF THE TUB?

Personal Learning Capacities

This one activity integrates so many different learning possibilities that it will be interesting for you to once again stand back and watch what transpires as your students engage in this experience.

You will see some students' mathematical capabilities emerge as they physically create the board and systematically devise rules for the game. Visual/spatial capabilities may awaken when certain boys and girls have the chance to convey their ideas for the board games with drawings, diagrams and paints. For some, working together in a reliable sort of way will be very tricky, so to ensure successful completion of the project, partners must tune in to their interpersonal intelligences. And finally, the board game itself, how it is played, how a winner is selected, how it makes sense, all require good solid verbal/linguistic skills.

Evaluation

Completion of board game, relationship of board game to book, participation, teamwork, clarity of rules, correct spelling, legible writing.

· · · · · · · · · ▶ Activity 2
Bathtub Toy Songs

Materials

Bathtub toys, cassette tapes of various children's melodies.

Directions

If you use an old bathtub in your room for a reading sanctuary, clean the pillows or books out of it and ask your girls and boys to place their bathtub toys into the tub. Give students a list of well-known children's songs or have a selection of those songs (instrumentals preferred) available for them to listen to. Workable tunes for kids include "Old McDonald"; "Three Blind Mice"; "Row, Row, Row Your Boat"; "BINGO"; "Oh, Susannah"; "Jingle Bells" and "Twinkle, Twinkle Little Star," to name a few. Each student will randomly select a toy from the tub and write a song about that toy to the tune of the available melodies you have or any melody they wish to use.

Here are two sample songs you may want to share with the children in your class:

Rubber Duck

(To the tune of "Mary Had a Little Lamb")

1. *Do you see this rubber duck, rubber duck, rubber duck*
 Do you see this rubber duck, wonder if it floats
2. *Place it in a tub, we'll see, tub we'll see, tub we'll see*
 Place it in a tub, we'll see, wonder if it floats
3. *Oops, it's sinking out of sight, out of sight, out of sight*
 Oops, it's sinking out of sight, don't think it will float
4. *Now it's lying on the bottom, on the bottom, on the bottom*
 Now it's lying on the bottom, I guess it didn't float.
5. *Now I'll put my hand in the water, hand in the water, hand in the water*
 Now I'll put my hand in the water, to try to find that duck
6. *I can't find it anywhere, anywhere, anywhere*
 I can't find it anywhere, I guess I'm out of luck
7. *Maybe if I get in the water, get in the water, get in the water*
 May if I get in the water, I will that find duck
8. *Now I'm sitting in the tub, in the tub, in the tub*
 Now I'm sitting in the tub, looking for that duck
9. *If I stick my head in the water, head in the water, head in the water*
 If I stick my head in the water, I might see that duck
10. *Blub blub blub blub blub blub blub, blub blub blub, blub blub blub*
 Blub blub blub blub, blub blub blub, Whew! I found the SOAP?

Turn The Water On
(To the tune of "Row, Row, Row Your Boat")

Turn the water on, jump into the tub
Grab your ducks and plastic trucks
And toss them in, kerflub!
Find some bouncy balls and a rubber frog

Make a wish with Smerfy fish
And toss 'em in, kersplog!
Find a yellow boat, and a shark that's gray
Get them wet and don't forget
To bathe some as you play!

When all the songs are completed, let the kids share them and possibly create motions that go with the lyrics. Then have them record their original endeavors so they can listen to them over and over.

Personal Learning Capacities

This activity is considered a musical intelligence activity because it is more than just enjoying singing a song. It offers students a chance to awaken their abilities to produce and appreciate rhythm, to hear a melody and relate it to something else, to create tonal patterns that are personal and to perform a musical piece. And if we allow some kids to use existing melodies, then their primary focus can be on the original lyrics and they won't get bogged down with the impossibility of original melodies, which can turn off some nonmusical learners.

Evaluation

Completion of task, presentation, teamwork, appropriate lyric that makes sense.

Activity 3
Pin Ball People

Materials

Old bowling pins
Colored cotton balls
Pipe cleaners
Cloth pieces
Glue markers
Glue gun
Ribbon

Call around to the bowling alleys in your area. Ask for discarded bowling pins. They are sometimes hard to find and often require patience in gathering enough for an entire class, but if you are persistent, you'll have thirty pins in no time.

The ideas are limitless in what to use the pins for. I suggest having the kids write their own puppet skits, create appropriate puppets out of the bowling pins to go with the skits and present those skits for other grades, at PTA meetings, during holiday functions and as a means of in-class discipline dialogues.

Personal Learning Capacities

Intrapersonal capabilities will be honed when the children use their focusing skills to work on this project. "Knee deep in thought" should ring true throughout the creation of these bowling pin characters.

This too is one of those activities that should see investment from all of the students in your class. The logical/mathematical kids can figure out designs and calculate proportions, the visual kids can work with color and patterns, the kinesthetic kids can use their hands and manipulate the finished puppet during the skit, the linguistic children can write the script and read the lines, the musical kids can include raps or songs in the puppet skit, all the kids can be interpersonal when they present the puppet play and the intrapersonal children can sit back and wonder what all of it means.

Evaluation

Completion of task, teamwork, good work, participation, script-writing skills, voice projection, creative expression.

Activity 4
Bathtub Toys and Puppetry

Materials

Puppet stage
Bathtub toys
Puppets (Mr. Webster, Doll Carriage)
Sign
Backdrop, toy shelf (optional)
Backdrop, bathtub (optional)

Directions

The girls and boys will use their own personal bathtub toys as characters in the following generic puppet story. Read the script first, then let the kids add their own bathtub toys in appropriate places to fill out the context of the play. The core of the play should be general enough to plug in any bathtub toy. This should be an interesting assignment for the students and one that requires a bit of logic, perseverance and imagination. As always, be sure to video the performance.

Write in particular bathtub toys and their names (if applicable) in the blank lines.

The Missing Bath Water

BY MARTHA BRADY

Characters

NARRATOR 1	BATHTUB TOY
NARRATOR 2	WHITE
BATHTUB TOY 1	BATHTUB TOY
BATHTUB TOY 2	BLUE
BATHTUB TOY 3	BATHTUB TOY
BATHTUB TOY 4	GREEN
BATHTUB TOY 5	BATHTUB TOY
BOAT	PURPLE
DOLL CARRIAGE	BATHTUB TOY
BATHTUB TOY A	ORANGE
BATHTUB TOY B	NEW TOY 1
BATHTUB TOY C	NEW TOY 2
BATHTUB TOY X	BATHTUB TOY D
BATHTUB TOY Y	BATHTUB TOY E
BATHTUB TOY Z	BATHTUB TOY F
BATHTUB TOY RED	MR. WEBSTER

[enter _____, the _____, as NARRA-
TOR 1 and _____, the _____, as
NARRATOR 2.

NARRATOR 1: The Big World Toy Store was the largest
toy store in town. It had 5 big rooms filled with toys of
all kinds. There were big toys, little toys, plastic toys,
metal toys, paper toys. There were red trucks, blue balls,
yellow tea sets, black train sets, brown bears and green
army men. Toys, toys, toys ...

NARRATOR 2: The first room was filled with dolls. There
were Barbie dolls and Chatty Cathy dolls and dolls you
feed and dolls that cry. There were miniature dolls and
life-size dolls and antique dolls and dolls from around
the world. There were so many dolls that there was no
room on any of the shelves to place one more doll.

NARRATOR 1: The second room was full of games. There
were board games and checker games and games with
dice and games with cards and spin the spinner and an-
swer the questions and find the hidden battleship games.
There were so many games that there was no room on
any of the shelves to place one more game.

NARRATOR 2: The third room was full of trucks and cars.
There were black racing cars and army trucks, and Mon-
ster trucks and remote control 4x4s and miniature cars
and dump trucks and fire engines. There were so many
trucks and cars that there was no room on any of the
shelves to place one more truck or car.

NARRATOR 1: The fourth room was full of stuffed animals.
There were teddy bears and colored dragons and rabbits
and pigs. There were large lions and tiny mice and kit-
tens and puppies. There were so many stuffed animals
that there was no room on any of the shelves to place
one more stuffed animal.

NARRATOR 2: The fifth room was full of shelves. Empty
shelves. There were tall shelves and thin shelves and wide
shelves and narrow shelves. There were white shelves
and striped shelves and wood shelves and plastic shelves.
And way in the back, in the corner, on one of the very
top shelves [pauses] were the [pauses] bathtub toys.

[exit NARRATORS. Enter 5 BATHTUB TOYS and one toy
that is a bathtub toy BOAT]

BATHTUB TOY 1: Boy is it dark up here.

BATHTUB TOY 2: [yelling] Yoo-hoo! Anybody out there?

BATHTUB TOY 3: Don't waste your breath. Nobody ever
comes back to this room.

BATHTUB TOY 2: Well, if nobody ever comes back to this
room how is anybody ever going to buy us and take us to
a bathtub where we can finally play in the water.

BATHTUB TOY 4: That's a good question.

BATHTUB TOY 3: Nobody's going to buy us and we'll
never, ever see bathtub water. So you'd better get used to
it.

BATHTUB TOY 5: But that's what we're made for. To play
in bathtub water.

BATHTUB TOY 2: You're right. And that's exactly what I
want to do. Play in bathtub water.

BATHTUB TOY 1: Any suggestion on how to go about
doing this?

BATHTUB TOY 5: You bet I have a suggestion. If no one
wants to buy us, then we'll just leave this room and find
our own bathtub to play in.

BATHTUB TOY 3: I hate to break some bad news to you
_____, but last time I looked, you didn't own a
pair of legs. How do we get out of here?

BATHTUB TOY 5: I've been thinking about that too. I fig-
ure if _____ (bathtub toy boat) toots the whistle
on the side of his boat, it'll get the attention of one of the
doll carriages in the other room and the carriage will roll
in here and we'll all jump into the carriage and it can take
us to the nearest bathtub.

BATHTUB TOY 2: That's a great idea.

BATHTUB TOY 3: I have to admit, I agree. It beats sitting
around watching my paint crack. I say let's do it too.

NARRATOR 1: The bathtub toys turned to _____,
the boat, and urged him to toot his whistle as loud as he
could to get the doll carriage's attention. They pleaded
and begged and bribed and praised and it finally worked.

BOAT: Okay, I'll do it. But when we find bath water, I get to
go in first.

NARRATOR 2: They all agreed and the boat began to toot
his whistle

BOAT: TOOT! TOOT! TOOT! TOOT!

BATHTUB TOY 1: I don't hear anything or see anything.
That doll carriage is not going to roll all the way back
here to pick us up.

[ALL agree]

NARRATOR 1: But as soon as the bathtub toys agreed that
the doll carriage was not coming, suddenly, and to their

delight, in rolled the most beautiful doll carriage they had ever seen.

DOLL CARRIAGE: You called?

BATHTUB TOY 2: Oh, carriage. Thank you for coming. We have a big favor to ask you.

DOLL CARRIAGE: Well, ask it quick, I'm on a break right now. All of the dolls are having a tea party in another room and I have a little bit of free time before I have to go pick them up.

BATHTUB TOY 3: Okay. Here it is. Nice and quick. We're all bathtub toys, right?

DOLL CARRIAGE: Well, I didn't think you were parts of a Monopoly game.

BATHTUB TOY 3: Funny. Anyway, we're all bathtub toys who have never been in bathtub water before in our lives and since—

BATHTUB TUB 4: And since it looks like nobody is ever going to buy us, we were wondering if we could get you to drive us to some bath water so we can get wet. You know like float around in a tub. Like we are supposed to.

DOLL CARRIAGE: Sounds reasonable enough to me. Hop in.

BATHTUB TOY 1: You mean it? We don't have to convince you? You'll take us?

DOLL CARRIAGE: I'm feeling a bit hospitable right now, so like I said, hop in.

BATHTUB TUB 2: Hospitable? What does that mean?

DOLL CARRIAGE: Hold on. [looks out in audience and asks] Does anyone know what the word hospitable means? [gets a dictionary from side of puppet stage] Here you! [points to someone in audience] Look it up. [someone looks up "hospitable" and reads definition out loud] Like I was saying, I'm feeling a bit hospitable right now, so [pauses] hop in.

NARRATOR 2: So the_____, the_____, the_____, the_____, the _____ and the boat jumped in the doll carriage and off they went in search of a tub full of water.

[DOLL CARRIAGE and BATHTUB TOYS go across puppet stage and off]

NARRATOR 1: They went up one street ...

[DOLL CARRIAGE and BATHTUB TOYS go across puppet stage and off]

NARRATOR 2: And down another ...

[DOLL CARRIAGE and BATHTUB TOYS go across puppet stage and off]

NARRATOR 1: Up one alley ...

[DOLL CARRIAGE and BATHTUB TOYS go across puppet stage and off]

NARRATOR 2: And down another ...

[DOLL CARRIAGE and BATHTUB TOYS go across puppet stage and off]

NARRATOR 1: And finally came to a small house at the end of the block.

DOLL CARRIAGE: This house must have a bathroom with a tub. We're going in to find out.

[DOLL CARRIAGE and BATHTUB TOYS exit]

NARRATOR 2: The crew of water adventurers knocked on the door [knock, knock, knock] and went into the house, but when they walked into the bathroom all they found were three bathtub toys, standing on the edge of the tub crying.

[enter_____(A),_____(B) and_____(C), all sobbing]

BATHTUB TOY 3: Pardon me, do you mind if we jump in your bathtub and play a bit in the wa— Hey, what's the matter? Why are all of you crying?

BATHTUB TOY A: It's the water.

BATHTUB TOY 1: We won't take up much space. You see we have never been in bath water before and we really would like to get wet and—

BATHTUB TOY A: There is so water.

BATHTUB TOY B: It's gone. The water is all gone.

BATHTUB TOY C: It disappeared last week and we have not seen any since.

BATHTUB TOY 2: But where did it go?

BATHTUB TOYS A, B and C: [wailing] We don't know. All we know is that Billy, the kid who lives here, was drinking the bath water every time he bathed. And his mom told him if he didn't stop, he would have no more baths— only showers. Have you ever tried to float in a shower? [ALL begin sobbing again]

DOLL CARRIAGE: I'm real sorry to hear it, but we've got to keep moving. I don't have much time and my passengers must find a tub full of water to play in. Good luck. Hasta la vista.

NARRATOR 2: And off the merry band of tub floaters went.

[DOLL CARRIAGE and PASSENGERS go across puppet stage and off]

NARRATOR 1: They soon came to an apartment building where they rang the first doorbell they came to. The door opened and standing there were 3 very unhappy bathtub toys, a _____(X), a_____(Y) and a _____(Z). The doll carriage asked if his troupe of water babies could come in and frolic in the tub.

BATHTUB TOY X: You could—

BATHTUB TOY Y: If we had water—

BATHTUB TOY Z: But we don't. It's gone. Disappeared ... kaput ... vanished.

BATHTUB TOY 1: But where did it go? Water just doesn't vanish?

BATHTUB TOY Z: The twins who live here kept drinking the bath water and well ... We haven't seen the tub filled in a week. It's depressing.

BATHTUB TOY 4: This doesn't look good. I'll never see the inside of a tub, ever, in my whole life. What are we going to do? [begins to cry]

BATHTUB TOY 3: We're going to another house, that's what we're going to do.

NARRATOR 1: And the small group of rubber toys and their driver continued searching for a bathtub with honest to goodness real water.

[DOLL CARRIAGE and BATHTUB TOYS go across puppet stage and exit]

They went up the street ...

[enter 3 more BATHTUB TOYS, RED, WHITE and BLUE on stage, speaking to audience]

BATHTUB TOY RED: I don't know what happened. We woke up this morning as usual, stood on the edge of the tub to jump in and VOILA! No water.

BATHTUB TOYS WHITE and BLUE: It was the darndest thing. [ALL look at each other and then at audience and exit] If that scrawny kid would quit drinking the bath water—

NARRATOR 2: And down another.

[DOLL CARRIAGE and BATHTUB TOYS go across puppet stage and off]

[enter 3 new BATHTUB TOYS, GREEN, PURPLE and ORANGE on stage, speaking to audience]

GREEN, PURPLE and ORANGE BATHTUB TOYS: [singing to the tune of "Oh Where, Oh Where Has My Little Dog Gone?"]

Oh where, oh where has the water gone

Oh where, oh where can it be

Look inside the tub, it is dry as a bone

There is no water, you see

[ALL gulp and exit]

NARRATOR 1: Up one alley ...

[DOLL CARRIAGE and BATHTUB TOYS go across puppet stage and off]

[enter 2 NEW BATHTUB TOYS, talking to audience]

NEW TOY 1: I just don't know. One minute the water was here. The next minute it was gone. Something about too much bath water being drunk ...

NEW TOY 2: Yeah! One minute we're in here with a 3-year-old, the next gone ... fer sure.

NARRATOR 2: ... and down another ...

[DOLL CARRIAGE and BATHTUB TOYS go across puppet stage and off]

[enter 3 more BATHTUB TOYS, D, E and F, talking to audience]

BATHTUB TOY D: It's a mystery to me, yes sirree. It's a real mystery to me.

BATHTUB TOY E: I remember we were all standing on the edge of the tub sort of staring out in space—you know how that goes—and I was just thinking to myself, "Should I do a double somersault or just dive in natural like" ... when I looked down into the tub and ... you guessed it. No water.

BATHTUB TOY F: Nada. How much bath water can a kid drink?

[DOLL CARRIAGE and BATHTUB TOYS go across puppet stage and stop]

BATHTUB TOY 1: This is ridiculous. We have been up and down all the streets and alleys in this town and we can't find any house with a tub full of water. What are we going to do?

BATHTUB TOY 2: I wonder how far the Pacific Ocean is from here?

BATHTUB TOY 3: The Pacific Ocean is too deep and the waves are too high. We would float away and never be heard from again.

BATHTUB TOY 4: Then I guess the only thing we can do is go back to the toy store.

BATHTUB TOY 5: And crawl back on the shelf.

NARRATOR 1: So the doll carriage and its unhappy passengers slowly made the trip back to the Big World Toy Store. The bathtub toys waved good-bye to the doll carriage and went to the back room where they quietly crawled back up to the top shelf in the corner.

NARRATOR 2: Suddenly the toys heard noise coming from outside the room. The door to the room opened and in walked Mr. Webster, the owner of the Big World Toys Store.

MR. WEBSTER: I believe we do have a few ... somewhere around here. Hmm, let me think. [pauses in thought] Where did I put them? A-ha! Here they are way back here on the top shelf.

NARRATOR 1: And with a rush, the bathtub toys were scooped up and placed in side a box.

MR. WEBSTER: What a great idea, Fred. That should bring in the customers. Good luck on your first day.

NARRATOR 2: With that the bathtub toys found themselves being carried past all the rooms of The Big World Toy Store, out the front door, down the street and through another door.

NARRATOR 1: And one by one they were gently placed in a gleaming white tub filled with clear, clean, beautiful *water*.

BATHTUB TOY 2: Water! We're in water. Look everybody, we're in water.

NARRATOR 2: The bathtub toys frolicked and swam and did somersaults in the water. They raced and dived and floated on their backs. The toys played so much and had such a wonderful time that never once did they notice the sign that hung over the bathtub: [hold up sign]

GRAND OPENING
THE ACME BOTTLED WATER COMPANY
"So Delicious That You'll Want to Bathe in It"

NARRATOR 2: The toys had so much fun that customers came in just to see the toys in the tub. And as they left, they bought gallon after gallon of that delicious water to take to their own homes.

NARRATOR 1: From that day on, the bathtub toys had a permanent home right in that tub of water, down the street from The Big World Toy Store. And rumor has it that no matter where you go in that town, up the street, down the street, up the alley, down the alley, hundreds of little girls and boys are sitting in their tubs, playing with their toys and drinking the bath water. And you mom's out there, don't worry. Remember, the water's delicious.

Personal Learning Capacities

Drama, in whatever form it takes, whether it be informal impromptu classroom skits, formal plays, puppetry or even pantomime, offers a wide range of avenues in which students can successfully engage in learning contributions. For this particular puppet experience, most, if not all, the girls and boys in the classroom will have opportunities to find niches in which to use their personal ways of knowing. Through memorization or reading of the scripts to creating the puppets to figuring out how to make a puppet stage to concentrative efforts, the class can tune in to all of the intelligences and have fun in the process.

Evaluation

Appropriate behavior, characterization, teamwork, creative expression, participation, performance.

Community Activity

The book *The Tub People* and all of the activities in this chapter have revolved around inanimate objects having the power of speech. As a community activity, students will look around the room and select several inanimate objects, such as an eraser, a globe, a book, a pencil, someone's coat, a chair, quarter, etc. One at a time, the students will take the selected inanimate objects, go into the puppet stage and tell, from the viewpoint of the inanimate object in hand, what they thought of the puppet play or how they might have assisted in helping the bathtub toys find water.

Reflective Question or Journal Entry

"Look toward the end of The Tub People at the illustration with the moon in the window and the Tub People standing on the window sill. Describe, tell or draw a picture that shows what is on the other side of the window. Be specific."

Wrap-Up

After the class has seen a video of the puppet play, box up all of the bathtub toys and send a copy of the video and the toys to a local shelter for homeless children or to needy children in your own particular school.

Related Books

Arnold, Tedd. *No More Water in the Tub.* New York: Dial Books for Young Readers, 1995

Burmingham, John. *Time to Get Out of the Bath, Shirley.* New York: Thomas Y. Crowell Co., 1978.

Conrad, Pam. Illustrated by Richard Egielski. *The Tub Grandfather.* New York: HarperCollins, 1993.

Cowley, Joy. *Mrs. Wishy Washy.* San Diego: The Wright Group, 1980.

Joyce, William. *George Shrinks.* New York: Harper and Row, 1985.

Schwartz, Alvin. Illustrated by Syd Hoff. *I Saw You in the Bathtub.* New York: HarperTrophy, 1989.

Wood, Audrey, and Don Wood. *King Bidgood's in the Bathtub.* New York: Harcourt Brace Jovanovich, 1985.

Related Music

Bartels, Joanie. "There's a Hippo in My Tub." *Beep, Beep and Splash, Splash.* Discovery Music, n.d.

Raffi. "Bathtime." *Raffi in Concert.* Troubador Records, 1987.

Sesame Street. *Splish Splash. Bathtime Fun.* Sony Wonder Records, 1995.

Various Artists. "Splish, Splash." *A Child's Celebration of Rock 'n Roll.* Music for Little People, 1996.

17
The Whales' Song

by Dyan Sheldon
Paintings by Gary Blythe
(NEW YORK: DIAL BOOKS FOR YOUNG READERS, 1990)

Background

Children's books do strange things to me. I think, more than anything else, they point my emotion spinner to GO. They trigger events and memories, tactile moments and even smells from my past. Like a bookmark, they quickly take me to an appropriate page of my life. They often clarify fragments of time to such a startling degree that entire chapters of my own experiences reappear for me to embrace once again. Reading *The Whales' Song* was no different an experience. It gave me a chance to take a trip to my childhood yet another time.

When I first read this marvelous picture book in the aisle of an exhibit hall at a national reading conference, I immediately felt a small safety blanket of words drape gently around my shoulders. I stopped, read the entire book again and was comforted.

Perhaps the soft linenlike illustrations did the trick. Or maybe the face of the grandmother. Possibly it was the way the rooms were arranged in the pictures. Warm and filled with important things. No matter, the deed was done. I belonged to that book, in that large cavernous hall of vendors and noise, and everything from front page to last made sense. It all made sense. Even though I have never seen a whale or heard its song.

Hook

Materials

None.

Directions

Find a good piece of floor and sit down with your brood. Give them a chance to talk about their grandparents. Ask if they can remember any stories their grandparents told them. Stories about themselves as children or perhaps just a simple story of something that happened. Share a personal story that one of your grandparents told you as a child. If one doesn't come to mind, you may wish to tell or read the following story. Personal stories are wonderful gathering devices. Perhaps this one can be used as a net to catch the children's five senses. Those sensory awakenings will come in handy later on.

Makin' Fried Pies
BY MARTHA BRADY

My grandmother made the best fried pies in all of Texas. On those wonderful occasions when I spent the day or night with her, she began my visit by walking up and down the wide hallway of the boarding house where she lived, yelling to the other grandmothers who lived there too, that "today was Fried Pie Day." They all smiled. They knew what that meant: Martha was here for a visit.

Making the pies was always a ritual for the two of us. My grandmother and I went through the procedures of creating the pies, time after time, in the same way and in the same order. Mamaw (what do you call your grandmother?), dragged out an old white chair, placed a Sears catalog on the seat and up I'd plop, level with the top of the counter. Then she brought out THE BOWL. The bowl was the biggest, smoothest, most beautiful wooden bowl I had ever seen. It had little nicks and scratches on its insides where she or I had gouged it with a fork while making other fried pies. Those scratches and nicks somehow made delightful designs that I tried to rename each time we used the bowl.

In this bowl we dumped flour and salt and a big scoop of smooth snow-white lard. The lard looked like vanilla ice cream and was as soft as the lotion my grandmother often rubbed into her hands. I loved the lard. I loved the feel, the look and sometimes even the taste of it. Here is some lard for you to look at while I continue telling this story. Don't taste it until I tell you what lard really is.

My grandma let me use my fingers to mix everything up. I squished the flour and lard together and great big blobs of goo clung to my hands like white paste. As I mixed, Mamaw poured in a little bit of water. Just enough, not too much. She poured and I squished. Pour. Squish. Pour. Squish. I think this might have been the best part of making fried pies. She then rolled and pulled and rounded off that big wad of goo and dusted the bowl with flour and rolled and pulled and rolled that goo again. And at the precise moment that only she knew, she said, "it's time," and I took

that big mound of white stuff and threw it on the counter top with all my might. I then took my fist and punched a big dent right in the middle of the mound. It looked like a volcano that had blown off its top. Mamaw then grabbed a long, round wooden roller out of the drawer and flattened that round mound so flat that you could hold it up and see the shadow of your hand on the other side. The whole thing looked like a large, delicate china plate to me.

Next, my grandmother took a big coffee can with both ends cut out and she pressed one end of that coffee can onto that flat piece of white stuff. A perfect circle. Every time she pressed she always created a perfect circle. I picked up that circle of white stuff, which she now called a pie shell, and I gently placed it down on another part of the counter top. My grandmother then took a spoonful of peaches or nectarines that had been cooking in sugar for a long time on the stove, and she placed that spoonful of sweet-smelling fruit right in the middle of that pie shell circle. And then came the second best part of making fried pies. She let me fold one side of the pie shell over to the other side until it looked like a half moon. After I folded she always said, "Take your thumb and make a wish on the moon," and I pressed my thumb all around the edges of that half moon, making a wish with each little thumb print that looked like lace.

Mamaw then plopped that moon into hot grease and lifted the dripping moon out only when it had turned a golden brown. Next, she put it on a plate to cool so it wouldn't burn my mouth when I ate it.

Most of the time I couldn't wait for the scrumptious looking food to cool, so I usually took one of the fried pies and sat out on the back steps and took little tiny bites and wriggled them around in my mouth to cool them off a bit faster. Mamaw eventually came outside, and we'd sit side by side on the back steps just eatin' our fried pies.

Fried Pie Day was a very important part of my childhood and so was my grandmother. I can still feel the dough in my hand and the flour between my fingers. And every once in a while, when I look up at the night sky and there is a half moon gliding across that star sea, I smell peaches. I really do.

Discussion

When you have finished telling the story, ask your girls and boys to share the following experiences: What did they *hear* as you were telling the story? If they could have *touched* something in the story, what would it have been? Did the story make their brain *smell* a particular odor? Did they *see* something in their imagination as you told the story? What *tastes* did their tongues savor? After a good discussion of what the senses do to enhance a story, it is time to ask your students to use their senses one more time as you read *The Whales' Song* by Dyan Sheldon, paintings by Gary Blythe.

Personal Learning Capacities

The verbal/linguistic children in your classroom, those kids who have that genuine love for language and words, will explore oral history or personal stories with relish and real eagerness. Activities that include personal sharing of authentic stories do more than just allow kids to hear words. They offer a chance for those children to relate things important to them by putting words together that are important to them. That is what authenticity is all about. Adding sensory awareness simply heightens the experience and gives children a place to focus.

Giving children permission to feel, touch, see, taste and smell the story awakens their visual/spatial intelligence as well. What a superb way for some children to "hear" this particular story.

> ### ▶ Activity 1
> ### Illustrating with Clay

Materials
Pipe cleaners (choices of colors), modeling clay.

Directions
Prepare to read the story once again, and this time concentrate on the illustrations. Set up your room so that the students are sitting on the floor, each with a lump of clay or several pipe cleaners on the floor in front of them. Show each illustration and ask the boys and girls to form, with the clay and/or pipe cleaners, an additional object that could belong in the illustration. For example, on the double page with pictures of two large whales, students may choose to create a shark. They would tell where the new object appears in the illustration and how the addition of that object might change what is happening in the illustration. Example: The addition of a shark might answer why some of the small red fish look startled and somewhat afraid.

Continue adding one new entry onto each illustration, discussing the changes that could occur because of the addition of that new object, and conclude by discussing how the entire story might have ended differently because of all the new objects.

Personal Learning Capacities

To think at all about the doing and the consequences of that doing is an intrapersonal experience. Through this activity, students will have an opportunity to look at the whole illustration, think about the importance of the whole illustration as well as the different parts that make up the whole illustration. They can then contemplate the interactions among all of the parts and how an addition to that whole piece will change things. An additional intrapersonal experience might be to have the kids reflect on the entire book and create one object that they think would change everything.

For example, if someone chose to create an oil slick out of clay, the change of dialogue would be very interesting. How they feel about that change is the valuable part of the activity.

Because children are working hands-on, or manipulating something, inventing as it were, the kinesthetic intelligence is used. The sculpting of the objects with clay or pipe cleaners strengthens the visual/spatial capabilities of all learners as well.

Evaluation

Completion of task, appropriate objects, verbal participation, nonverbal participation, staying on task, understanding the connection of picture to the object.

Activity 2
Acting Out Verbs

Materials

Scarves, balloons, strips of cloth, feathers, rubber balls.

Directions

Make an open space in your classroom. Give students hand props such as balloons, scarves, feathers, streamers or swatches of cloth. Talk about action words. Open to any page of the book and ask the children to find a word that "moves." Explain that as you read the story again, the girls and boys will listen for all of the action words in the story. When they hear them one at a time, they will demonstrate the action word by moving their bodies and utilizing their hand props. Some nice calm ocean music would be delightful here.

Personal Learning Capacities

Move those bodies around. Give them props to focus on, and let your kinesthetic learners tell this wonderful story the way they do best, through movement. Those types of learners will be able to define action words better than any sentence they could write on the board.

Evaluation

Appropriate behavior, appropriate responses, direct observation, listening skills.

Activity 3
How Did It Get There?

Ask students to select one object, creature or human in any of the illustrations and write or discuss where the object, creature or human came from, how it got in the story and what is ultimately going to happen to it.

Personal Learning Capacities

Students have the opportunity to think intrapersonally for a while about the object they choose to talk or write about. The internal system goes into gear when children define to themselves why they have chosen a particular object and what they would like to happen to the object.

By explaining those thoughts through writing and/or discussion, students are also offered another chance for the linguistic intelligence to come to the front.

Activity 4
Sequence Scene

Materials

Butcher paper, markers.

Put a large piece of butcher paper on the floor. Play a selection of ocean music again. Go to the middle of the butcher paper and draw one thing that you learned in reading the book. Each child will do the same, one at a time. When all the students have finished, sit back and ask the boys and girls to try to sequence the pictorial events the way they happened in the book.

Personal Learning Capacities

This activity is basically an intra- and interpersonal activity that allows your students to work together and at the same time do some internal recall of things they find important about the story. Putting the pictures in sequence allows the logical/mathematical and visual intelligences to come to the front, while verbalizing that sequence helps awaken the linguistic capabilities of all the students. (And you thought it was just an art project.)

Evaluation

Participation, verbal communication, correct sequencing, detail.

Community Activity

Students will create a mural that depicts the migration patterns of whales.

Reflective Question or Journal Entry

*"If you could give someone
you know a gift, who would you give it to
and what would the gift be?"*

Wrap-Up

Go to the library and research how other animals communicate with each other. Which animals sing? Which animals make physical movements? Which animals "talk"?

Related Books

Coleridge, Ann. Illustrated by Marg Towt. *Longneck's Billabong*. Cleveland: Modern Curriculum Press, 1987.

Kipling, Rudyard. Illustrated by Pauline Bayner. *How the Whale Got His Throat*. New York: Peter Bedrick Books, 1987.

Lewis, Paul Owen. *Davy's Dream*. Hillsboro, OR: Beyond Words Publishing, 1988.

Metaxas, Eric. Illustrated by Paul Lopez. *The Boy and the Whale*. Bridgeport, CT: Storybooks, 1994.

Rylant, Cynthia. *The Whales*. New York: Scholastic, 1996.

Serventy, Vicent. *Whale and Dolphin*. New York: Scholastic, 1984.

Related Music

Classic Disney, Volume 1. *Whale of a Tail*. Walt Disney Co., 1993.

Echoes of Nature. *Beluga Whales*. Delta Music, 1995.

Gentle Persuasion. *Bach by the Sea*. Philips, n.d.

Jenkins, Ella. *Come Dance by the Ocean*. Folkways Music, 1991.

Langstaff, John. "Blow, Ye Winds in the Morning." *Traditonal Sea Songs, Dances and Chanteys*. Revels Records, 1992.

McCutcheon, John. *Water from Another Time*. Rounder Records, n.d.

Original Motion Picture Sound Track. "Whale Swim." *Free Willy*. MJJ, 1993.

Peacock, Christopher. *Island Life*. Pure and Simple Music Co., 1994. P.O. Box 563. Eastsound, WA 98245.

Raphael. *Angels of the Deep*. Heart of Space, 1996

Sampler. "Humpback Whales." *The Sounds of Nature*. Special Music Co., 1990.

Wee Sing. *Under the Sea*. Video. MCA/Universal, 1995.

Winter, Paul, and Paul Halley. *Whales Alive*. Living Music, 1987.

18
Wilfrid Gordon McDonald Partridge

by Mem Fox
Illustrated by Julie Vivas
(BROOKLYN, NY: KANE/MILLER BOOK PUBLISHERS, 1984)

Background

My first memory at around three years of age was standing among tall blossoms in the front yard flower bed, hiding from my mother. If I had had some sense of awareness at that tender time, I would have recognized very quickly the fear in my mother's voice as she frantically yelled my name over and over. (Only later did it occur to me that the scores of loud neighbors who came to my house on that sunny day did not do so because of my birthday.) Though a terrible memory for my mother, I'm sure, it was a colorful clear snapshot of one moment in my life.

That snapshot was the first one written in my own memory bank and was subsequently followed by flashes of Mother wringing a chicken's neck and then frying that unfortunate fowl for dinner, standing in my parent's closet smelling the permanence of moth balls and warming my toes on those cold Texas nights with a heavy black iron heated to glowing then wrapped in towels and placed gently under the covers at the foot of my bed.

I must say, with the hustle and bustle of daily survival, I hadn't conjured up those memories of my childhood in a long time, until I read Mem Fox's *Wilfrid Gordon McDonald Partridge*. With the help of Julie Vivas's blustery illustrations, Fox's descriptions of memories were just the perfect catalyst for bringing my own early childhood visual recollections to the present. What a gift these two talented women gave me, and what a gift this book will be for you and your children.

Reading *Wilfrid Gordon McDonald Partridge* was like eating a favorite stew—warm, palatable and oh, so delicious. And when you think about it, that is exactly what memories are, little spoonsful of ourselves, oftentimes too salty, sometimes too thick, but full of nourishment just the same.

Here's to a wonderful memory meal with your boys and girls. *Bon appétit.*

Hook

Materials

None.

Directions

Memories are the most personal of things, and so it should be that you begin your introduction of *Wilfrid Gordon McDonald Partridge* by sharing with your class small glimpses of yourself and your own memories. Bring several objects to class that are very important to you, objects that trigger a certain memory, a certain story, a certain situation that has been marked indelibly in your mind for all time to come.

Play some soothing music that will settle the children and focus them to the event at hand, and simply share the objects and the memories that go with them.

Discussion

This is a time for attention to be directed at you, the teacher. In other words, all students will have an opportunity to ask you questions regarding the memories you shared and the objects that prompted those memories to come to the surface. So that every girl and boy in your class gets the chance to engage in dialogue (and you want them to), give each of the youngsters in your class two Hershey's Kisses. Each child must ask two questions. Each time they ask their allotted question they get to eat one of the candies.

When the questions have been asked and the candy has been eaten, read *Wilfrid Gordon McDonald Partridge*. The activities below can then be used to help boys and girls reclaim some of their own memories, foster the magic of those memories and reinforce the part those memories play in their own, and others, lives.

Personal Learning Capabilities

Watch your children to see who really showed an interest in your memories and the stories that unfolded. Were some intent on your every word? Did some students ask good questions? Did they understand which emotions you used to better define and describe your memories? Did some girls and boys assist others who were having difficulty wording their questions? These observations are clear indications of students who function well within the interpersonal intelligence.

And because the intelligences inter-relate so well with and in each other, the same indicators above can almost be said of the boys and

girls in your class who function well within the linguistic intelligence. You may wish to look for these clues as well: Do some students enjoy asking questions about your memories and also hearing other children give their answers as well? Is it easy for some of your youngsters to speak up voluntarily and ask questions of you? Do some of your kids have a distinct "voice" when asking their questions?

Even if the focus of the lesson is primarily you, observation time can still occur and is still critical as you continue to construct that complete snapshot of each of the boys and girls in your classroom.

Activity 1 ◄ · · · · · · · · · · ·
Memory Charades

Materials

Chairs, hats, scarves.

Directions

Here is a great little informal drama activity that is nonverbal in nature but still requires students to use several skills in order to be successful. All that is needed is some open space and chairs that can be stacked, rearranged or otherwise used by the youngsters as props to enhance the clarity of the "Memory Charades" episodes.

Very simply, each child will think of one memory that can be pantomimed alone or with one other person. Using the chairs in any configuration to help describe the memory, the students will pantomime the memory with the help of two friends who will know the memory in advance. The class tries to guess the memory after each episode is completed.

Having a collection of hats and scarves on hand adds to this activity tremendously.

Personal Learning Capabilities

This one is kinesthetic for all the right reasons. It is a movement activity, it has all the characteristics of being a play, it requires a sense of space and where to belong in that space and it smacks of drama, in a nonverbal situation. This is one of those activities that also shows how intelli-

gences relate so well to each other. In this instance, children can function within the kinesthetic and interpersonal intelligence as well.

Evaluation

Clarity of pantomime, attention to detail, teamwork, sequencing events, observation skills, completion of task.

· · · · · · · · · · ▶ Activity 2
Memory Rebus

Materials

None.

Directions

You may want to set this activity up a bit by suggesting to the students that they all think of one funny memory. Be sure to give them an example of one of your own funny memories. The youngsters will then create a rebus which, when answered, will describe the memory. Because this can be a fairly difficult activity, offer a generic phrase, which all students will begin with. This will assist them in finding a starting place, which is sometimes hard for primary and/or some intermediate students to accomplish. Here are two examples that will help children focus. One rebus is simple and very short. The other is a bit more complicated although still possible to create. "The funniest thing that ever happened to me was when ..." An example might be "The funniest thing that ever happened to me was when I snored." Or "The funniest thing that ever happened to me was when I fell into a hole full of mud as I was walking to school." The rebus for this sentence looks like this:

Personal Learning Capacities

This is a demonstration of problem-solving within a given situation and is a perfect arena for the logical/mathematical intelligence to function. Creating rebuses, or rebii, also puts the visual/spatial intelligence to good use because those kids who learn visually can demonstrate skills in drawing, creating patterns, using color, etc.

Evaluation

Completion of assignment, correct sequence of words and symbols, appropriate behavior.

Activity 3 ◀ • • • • • • • • •
Watercolored Memories

Materials

Art paper, watercolors, brushes, newspapers, small paper cups.

Directions

Read *Wilfrid Gordon* once again with your class. This time dwell on the illustrations as you read. When the author uses special words to describe memories such as warm, "something from long ago" and others, ask students to show how the illustrator captures those words or feelings. The words and phrases used in the book were

> "... something you remember..."
> "... something warm..."
> "... something from long ago ..."
> "... something that makes you laugh ..."
> "... something as precious as gold ..."

Upon completion of the book, make a list of those descriptive words and/or phrases on the board. Students will use art paper and watercolors to create their own definitions of those phrases. When they have finished painting, sit in a circle on the floor with the artwork and talk about the differences in describing things through words and describing things through drawings. Use the book as an example. Most importantly, spend a lot of time letting the children share their own pictures. Then ask them what it feels like to be an illustrator.

Personal Learning Capacities

This is such a lovely intrapersonal activity that relies heavily on the visual/spatial intelligence to make it work. This watercolor experience does work because children, when there is structure of some kind, really are capable of doing the most marvelous things with this particular medium. The double benefit of this exercise is that students will see the importance illustrators play in the telling of a story in a children's book.

Evaluation

Following directions, describing memories appropriately, staying on task, completion of task, verbal participation, positive attitude.

• • • • • • • • • ▶ Activity 4
Inanimate Memories

Materials

Objects.

Directions

Students will bring one inanimate object to class: a comb, pencil, empty potato chip bag, baseball glove, etc. All of the objects will be placed on the floor with everybody sitting in a circle around the objects.

Volunteers will select one object each, not necessarily their own, and act out, verbally or nonverbally, one memory that particular object might have had if it was, in fact, capable of having memories. In other words, giving inanimate objects the power to be animate.

Once the short dramatization has occurred, other students will try to guess what was acted out and how it related to the object. Then all of that information must be put into a sentence that the inanimate object might say if it had the power of speech.

Here are a couple of samples you may wish to model for your children to make things more understandable:

Object	Acting	Connection	Object Speaking
comb	slicking back hair and shaking leg	Elvis's hair	"I remember combing Elvis's hair when he was a little boy."
potato chip bag	lying in a ball on the floor with hands over head	potato growing in the ground	"I remember when things were simpler back then. All I ever had to worry about was getting dirt in my 'eyes.'"

Personal Learning Capacities

Words and movement. What better way to reach most of your kids than with a good, worthwhile and difficult activity that combines linguistic capabilities with kinesthetic endeavors. Everybody stretches with this one. Including you.

Evaluation

Correct answers, participation, teamwork, making sense with answers.

Activity 5 ◀ · · · · · · · ·
Memory Construction

Materials

Cotton	Ribbon
Bendable wire	Packing "peanuts"
Tongue depressors	Yarn
Paper plates	Paper clips
Balloons	Rubber bands
Cups	Other

Directions

We, as teachers, are always trying to think of ways for children to see things differently, for them to get a different perspective, a different viewpoint. Here is a wacky idea that will bring memories from an internal place to an external one.

Using a combination of interesting materials such as cotton, cloth, wire, etc., students will construct a physical object that represents what a memory might look like if it could be touched or seen. Add one more part of the assignment by asking students to think of one particular memory and somehow include in the construction a clue as to what that particular memory is.

As always, have a model of your own constructed memory and something attached to that creation that gives clues to a particular memory that is included in the constructive piece.

A suggested memory structure might be a big mound of fluffy cotton in which are inserted wire coils, a few straws and several pieces of ribbon dangling down. Inside this original sculpture is a cut-out picture of a bicycle, which will be the clue that this particular memory has something to do with a bicycle.

Students will share their newly built memories and try to guess what the different clues mean.

Personal Learning Capacities

Many intelligences can be applied here. Memory construction is first and foremost a very strong intrapersonal activity. Kids also will use their visual intelligence with the selection, texture and design of the creation, their kinesthetic intelligence with the actual construction of the memory and their logical intelligence in planning and demonstrating how the gizmo works.

Evaluation

Completion of project, clear explanation of project, staying on task, knowledge of sequence of events in explanation of project.

Community Activity

Children in your class will write a collective book about memories and send the book along with a copy of *Wilfrid Gordon* to a retirement home in their local community.

A possible title of the book might be *The Best Memory I Ever Had: My Grandma and Grandpa Too.* The students will interview their grandparents about their memories. Students will select one grandparent memory. On one side of a page, they will write about their own best memory; on the other side of the page they will write about their grandparent's best memory. Cover page and illustrations added, the book should be bound nicely and sent to some lucky elder citizens. Don't forget to send along Mem Fox's book too, signed by all the children.

Reflective Question or Journal Entry

"Explain 'old.'"

Wrap-Up

Now it's time for the youngsters in your class to bring an object that helps define a moment in their lives. Sit comfortably on the floor and take turns sharing the objects and what they represent.

Related Books

Jones, Rebecca C. Illustrated by Shelly Jackson. *Great Aunt Martha.* New York, Dutton, 1995.

Kroll, Virginia. Illustrated by Nancy Cote. *Fireflies, Peach Pies and Lullabies.* New York: Simon and Schuster, 1995.

MacLachlan, Patricia. Engravings by Barry Moses. *What You Know First.* New York: HarperCollins, 1995.

Martinet, Jeanne. Illustrated by Judy Lanfredi. *The Year You Were Born.* Tambourine Books, 1995.

Schachner, Judith Byron. *Willy and May.* New York: Dutton, 1995.

Related Music

Chapin, Tom. *Family Tree.* Sony Kids, 1988

Fink, Cathy. *Grandma Slid Down the Mountain.* Rounder Records, 1989.

Kater, Peter, and Carlos Nakai. *Migrations.* Silver Wave Records, 1992.

Various Artists. "Grandma's Feather Bed." *Big Country for One and All.* Music for Little People, 1995.

19
Yonder

by Tony Johnston
Illustrated by Lloyd Bloom
(NEW YORK: SCHOLASTIC, 1988)

Background

I love stories that take me from one moment in time to another. Stories that vividly describe the sequences of life and all the events that surround those sequences. I love the orderliness of family, the clarity of decisions, the ritual of aging, the celebration of circles.

Yonder embraces all of those attributes and does so with such illustrative richness that I can smell the dirt of the land, feel the sweat of hard manual labor, see the quilted fields, touch the skin of grandbabies and dream of tomorrow and the safe sameness that it brings.

Children and heritage don't necessarily go together in this day and age—at least in the simplistic definition of times gone by. But in *Yonder,* Tony Johnston and Lloyd Bloom recount and demonstrate the passing on of values, of memories, of things sacred in such melodic and visual terms that all children should come away with a deeper understanding of how and why human cogs fit into all those differently shaped pegs.

Hook

Materials

None.

Directions

A perfect hook for this book is music. Select a piece of instrumental music that really captures the time in history that this story portrays. My favorite, of course, is any rendition of "Shenandoah." There are many choices that define this time period, however, and some of those choices can be found in TV theme music cassettes or CDs.

Whatever the choice, play the music and ask your youngsters to think of a scene in a movie that might work with that kind of music in the background. Discuss the different answers and finally lead them to the late 1800s and the way of life in that era. Talk about clothes, transportation, inventions, education, population and cities. Spend a moment discussing things that we have access to now that didn't exist back then, such as jets, TVs, computers, etc. When you have finished setting the mood with pertinent information,

continue playing the music and begin reading *Yonder* by Tony Johnston, illustrated by Lloyd Bloom.

Discussion

Let's combine discussion with the following first activity.

Personal Learning Capacities

Students simply listen to music and then discuss. And in so doing, the musical intelligence will enhance and strengthen the linguistic intelligence. This simple hook is yet another example of how closely related the intelligences are and how they work to strengthen one another.

Activity 1
Sponge Art

Materials

Tempera paints, sponge pieces, containers, newspapers, paper towels.

Directions

Before you begin discussing the book and the illustrations with your girls and boys, give each child a piece of art paper and some cut-up pieces of sponges. Arrange several containers filled with primary tempera colors in front of the children. Now give each child a number, 1 through 19. If there are more than nineteen students in your class, and I know that there must be, give two children the same number. Explain that as you read *Yonder* one more time, students will be responsible for creating a sponge art illustration of what they think a certain scene might look like. They will only be responsible for one scene, and you will call out the

number that is responsible for each illustration. Here's an example: "Number 1, listen very carefully. You are in charge of this illustration."

> *Yonder is the farmer on a jet black horse.*
> *Yonder are the hills that roll forever.*
> *Yonder is the river that runs to sea.*
> *Yonder. Way over yonder.*

Student #1 will quietly work on that illustration while you continue with the book. At the conclusion, students will sequence the illustrations. Then in their own words and with the help of their illustrations, they will translate the story.

Personal Learning Capacities

Sponge painting is a messy, wonderful, formless kind of visual art activity that keeps the nonvisual kid engaged. Why? The nature of the beast. The colors ooze, and that's expected. The paper smudges, and that's okay. There are no hard edges, and that's really exciting to know. And sponge dabs can cover other sponge dabs, which can cover other sponge dabs, which can ... you get the picture. So, if the creative environment is safe, the art form at least doable and the meaning of the text is made clearer because of the sponge art activity, then I'd say some kids are functioning at a pretty good level. Now if they can tell you why they sponged what they did and how it related to the words in the story and to their own visions, you earned your pay for the day.

Evaluation

Participation, staying on task, effort.

Activity 2 ◄ • • • • • • •
Yesterday, Today, Tomorrow

Materials

None.

Directions

Here is a drama activity that requires kids to think on the spot once again. Three groups of children will go to different areas of the room. One area will be designated YESTERDAY, one area TODAY, one area TOMORROW. Kids have no choice of areas. The teacher will decide.

Read one page of *Yonder* at a time. After each page has been read, the group of children who are in the YESTERDAY corner will act out, talk about or pantomime the events of the page as they were written or as they might have been before the 1800s. The children in the TODAY corner will act out, talk about or pantomime the events of the page as they might occur in current times. The children in the TOMORROW corner will act out, talk about or pantomime the events of the passage as they might occur in futuristic times.

For props, have a bunch of plastic mixing bowls of various sizes for kids to use. They'll figure out appropriate ways to use them.

Personal Learning Capacities

Children express their emotions almost constantly when they are in a school setting. We see them laugh, lose control, ignore, wonder, agree, disagree, fight, cry, get scared, find bravery, succeed. We see them create with almost every breath. And some of the kids in the classroom use their bodies in the most magnificent ways to express those emotions. Activities such as YESTERDAY, TODAY, TOMORROW give those kids a structured format in which to express those emotions. Drama and the kinesthetic intelligence are simply made for each other.

Evaluation

Teamwork, staying on task, verbal skills, appropriate behavior, participation.

• • • • • • • ► Activity 3
Silent Movie

Materials

Hats
Scarves
Fake mustaches
Costumes
Strobe lights (optional)
Slide projector (optional)
8- or 16-millimeter projector (optional)
Cassette player
Video camera and tape

Directions

Before you break the news to your kids that they are going to create a silent movie rendition of *Yonder*, go to a video store, rent a silent movie and show it to your girls and boys. Give them a chance to really dissect the film. Write down all that was learned from viewing the video. Give the youngsters a chance, too, to talk about the kind of music that was used to enhance the picture and make the action and the tender moments of the movie more realistic.

When the students have a clear understanding of what a silent motion picture is and looks like, they will choose to be either actors, lighting technicians, sound technicians or film crew.

1. The actors will translate the text of *Yonder* into a nonverbal, overacted, very dramatic, bigger than life, hammy three-act play.
2. The lighting technicians will locate, set up and run either strobe lights, slide projector sans slides or an old

8- or 16-millimeter sound projector, which will be used to simulate the fast jerky motions that are so indicative of silent movies.

3. The sound technicians will gather appropriate selections of music that can be used during the play to define action, chaos, danger, love, etc. These students must work closely with the actors so that they know the acting sequence of events.

4. The film crew will not only video tape the event but will be responsible for physically setting up each scene.

Personal Learning Capacities

In doing this silent movie, ask yourself what you want the boys and girls to come away with. Is it teamwork? Is it follow-through? Do you want them to show responsibility? Is it problem-solving? Could it be that you want them to experience taking someone's vision and making it their own? Could it be simply for fun?

Multilevel activities such as this one, activities that require all kids in the classroom to make interest and ability choices, cover the seven intelligences in independent ways and in inter-related ways. And if we believe that all kids are different and that they learn through many, many scripts, then we have offered those youngsters seven or more scripts to choose from. What a gift to give kids.

There is no doubt that if you see students immersed in the excitement and energy of activities like this, learning is a possibility.

Evaluation

Follow-through, responsibility, timing, appropriate behavior, participation, listening skills, following directions.

Activity 4
Dear Diary

Materials

Sheet, slide projector (for back lighting), rope, clothes pins.

Directions

Students select characters from the book and write several diary entries from the point of view of the characters. Before they begin their entries, however, ask the kids to write a thumbnail physical description of their characters. Often when kids can "see" something in their thoughts, words come easier.

To add a little zest and mystery to this activity, students will then stand behind a large sheet that has been backlit in such a way as to allow shadows to occur. The students, one at a time, will pantomime appropriate movements as they read their entries while other classmates observe. Discussions will follow.

Personal Learning Capacities

Creative writing episodes come in all different flavors. (This little linguistic tidbit is strawberry, I think.)

Evaluation

Teamwork, appropriate entries, participation, patience.

Community Activity

Bring to school several *National Geographic* magazines that feature stories that show wooded landscapes, rolling hills, etc. As you read *Yonder* slowly, students will find pictures they think best describe the different parts of Tony Johnston's book. Be sure to have your youngsters discuss why certain pictures seem appropriate.

Reflective Question or Journal Entry

"Describe how the farm in the book looks now."

Wrap-Up

Sit on the floor and ask for volunteers to talk about what they think their lives will be like as they get older.

Related Books

Bates, Katherine Lee. Illustrated by Neil Walkman. *America the Beautiful.* New York: Atheneum, 1985.

Rylant, Cynthia. Illustrated by Diane Goode. *When I Was Young in the Mountains.* New York: E.P. Dutton, 1982.

Say, Allen. *Grandfather's Journey.* Boston: Houghton Mifflin Co., 1993.

Wells, Rosemary. Illustrated by Susan Jeffers. *Waiting for the Evening Star.* New York: Dial Books for Young Readers, 1993.

Related Music

Berkey, Jackson. *The Mountains.* N.p., n.d.

Fleck, Bela. *In Roads.* N.p., n.d.

Guthrie, Woodie. "Cumberland Gap." *Worried Man Blues.* Special Music Co., 1991.

Juggernaut String Band. *Square Dance.* N.p., n.d.

Nashville Symphony. "Shenandoah." *Nashville Platinum.*

Rhines, Marie. "Cumberland Gap." *The Reconciliation.* Sedona Music Records, 1995.

St. Olaf's Choir. "Shenandoah." *Voices.* N.p., n.d.

20
Yo! Yes?

by Chris Raschka

(NEW YORK: ORCHARD BOOKS, 1993)

Background

Golly. What? Nothing. Sure? Kinda. Talk. Okay. Well? Book. Where? Here. Here? Yes. So? Good. Huh? Read. Read? Now. Here? Yes. Okay. Well? Good. Good? Good. Good.

Hook

Choose a student to read the above sentences with you. You say one word, the student says the following word. That's all the hook you need for Chris Raschka's brilliant book *Yo! Yes?*

Materials

None.

Discussion

Read the book slowly as you show the illustrations. Students will tell what the book means and how the illustrations create clarity for the book. Once the book has been introduced and read, read it again. This time after each page has been read, ask the girls and boys to think up additional words or phrases that could have been included in each page to help with the telling of the story.

For example, page one says, "Yo!" A student's interpretation of that one word may be, "Hey you! With the green jacket on. I walk down this street every day and you're always standing right there at that same spot. Do you hear me talking to you?"

The illustrations are the key that enable students to build a sensible dialogue for each page. When the new interpretations are completed, ask someone to read the newly created rendition. Discuss the differences and if, in fact, one word per page was really sufficient to understand the author's point of view.

Personal Learning Capacities

Students who easily make connections between words and meaning function within their linguistic intelligence. With Raschka's book this particular type of connection is all the more stimulating for these boys and girls because there is an interesting challenge there.

There is a challenge of sorts too, for students who find the meaning of the text through visual clues. Instead of building upon the word meanings, some of your youngsters will study the illustrations to a greater degree and be able to grasp and embellish the author's intent.

As I have said so often in this book, observation is such a critical aspect of your teaching. This examination of text, so to speak, is another meaningful opportunity for you to pay attention to the efforts and ways each of your children make sense of *Yo! Yes?*

> ▶ **Activity 1**
> **Two-Word Book**

Materials

None.

Directions

In this simple, vivid children's book, Chris Raschka has succeeded in defining communication on a level that we all can understand. Therefore, using communication as a focus and *Yo! Yes?* as a central catalyst, creative arts activities of various forms that support the important theme of understanding and getting along with one another can emerge.

The following activity is a great way to begin. Students in the classroom will think of two words. Each word should be either a verb, an adjective or an adverb. If verbs, adjectives or adverbs are a bit constricting, then any two words will do. Both words, however, should be able to stand alone and make sense when they are said alone. Independently, they should also be able to make a statement and ask a question. An example for the first word might be "Okay." An example of the second word might be "What?"

When two words, one used as a statement, the other a question, have been decided upon, those two words are given

to another student in the class. That student will use these two words as starter words for creating a story, with illustrations, making sure each page of the story is limited to only one word, as in Chris Raschka's endeavor. Children can use Raschka's format as a model or the story at the beginning of this chapter.

Students should also have the option of working in pairs. When the project is completed, girls and boys can share their stories and then give those stories to the students whose words they used.

Personal Learning Capacities

Activities that combine writing and drawing give students opportunities to utilize more than one intelligence. For this partnering activity, ask students to choose the area that is the most difficult for them, either drawing or writing, and have them be responsible for completing that part of the book project.

Evaluation

Sequencing skills, teamwork, completion, drawing skills, attitude, staying on task, ability to explain booklet.

Activity 2 ◀ · · · · · · · ·
Communication Drama

Materials

None.

Directions

On 5 X 7 cards, write down classroom responsibilities and directions such as these:

1. Erase the blackboard.
2. Line up for lunch.
3. Take this to the office.
4. Please get out your math book.
5. Work quietly.

Students, in groups of four or six, will be shown one of the cards. They will act out that responsibility or direction in a verbal way. However, they can only say one word at a time as they act it out. "Erase the blackboard" might look and sound like this:

Students will pretend to be cleaning up the room. One student will pretend to empty trash. One student will pretend to be putting books in a back pack. One student says, "There." Another student might say, "What?" The dialogue, one word at a time, would continue thus: "There." "Where?" "See?" "Oh." "Well?" "Okay." "Thanks." "Clean?" "Yes." "No." "What?" "Wipe." "Did." "Sure?" "Yes." "Okay." "Done."

After sharing this example, retell it in a normal way to see if the students can figure out what the specific direction was.

The kids in the group select a direction and act it out in one-word segments. When the scene is finished, other students will retell what they saw and heard.

Personal Learning Capacities

Some heavy-duty thinking caps need to be worn with this activity. Children must stay focused, tune in their observation skills and integrate several intelligences. Discuss with your students how their kinesthetic side will lead them to success. Talk about the clues that will be given when students move and act in certain ways. Also discuss the importance of the words used in the exercise. How will certain words benefit the students' understanding of the event? Finally, include the visual/spatial aspect of this activity. How will what they see assist them in figuring out the sentence that is being acted out?

Evaluation

Following directions, observation skills, participation, appropriate behavior, connecting words and movement.

· · · · · · · · · ▶ Activity 3
... And Finally

Materials

None.

Directions

Students will study the sequence of events that occurred in *Yo! Yes?* and predict what happens to the two new found friends once they jump up into the air with joy. They will write that conclusion in a one-word-per-page format and read to the class.

Personal Learning Capacities

Predicting is a logical/mathematical event. Combining that with the problem-solving aspect of this activity, children have a strong arena in which to use their logical/mathematical intelligence to successfully create an original ending to Raschka's story.

Evaluation

Completion, teamwork, following directions, correct responses.

Materials

None.

Directions

Share with your class a retelling of *Yo! Yes?* in limerick form, or read the following example:

A kid on the street walking slow	A
Had nothing to do but yell, "Yo."	A
Another kid heard	B
Said, "Yes," that's his word	B
And they became friends. There they go.	A

Review the correct limerick form (AABBA), then ask the students to pair up and write their own limericks either about this book, or original limericks about any two people, creatures, animals, etc., that have found each other and formed a friendship.

Personal Learning Capacities

Limerick writing requires some interest and knowledge in rhythm patterns. Children who perform that skill do so by using their logical/mathematical intelligence. This particular linguistic exercise is a good example, also, of how intelligences relate to each other, in this case, the playing with words that limerick writing provides and a correct understanding of the rhythm and pattern of the words.

Evaluation

Completion of limerick, teamwork, creative thinking.

Community Activity

Students will write and illustrate their own *Yo! Yes?* book in a language other than English. This means doing a bit of research such as going to the library, calling travel agents or writing foreign embassies. It may mean interviewing people they know who speak another language.

When the projects are completed, wrap them up and send them off to Chris Raschka, in care of his publisher, Orchard Books. Include a nice note thanking Mr. Raschka for writing such a wonderful piece of children's literature.

Reflective Question or Journal Entry

"Name five friends you would like to take to Disneyland. Think about your choices and ask yourself why you chose each of those five special people."

Wrap-Up

Ask children to go to the library and select one book that has to do with friendships. Students will share those books with each other.

Related Books

Aliki. *Best Friends Together Again.* New York: Greenwillow Books, 1995.

Allen, Jonathan. *Two-by-Two-by-Two.* New York: Dial Books for Young Readers, 1995.

Begaye, Lisa Shook. Illustrated by Libba Tracy. *Building a Bridge.* Flagstaff: Northland Publishing, 1993.

Deedy, Carmen Agra. Illustrated by Deborah Santiki. *The Last Dance.* Atlanta: Peachtree Publishers, 1995.

Kellogg, Steven. *Best Friends.* New York: Dial, 1985.

Paterson, Katherine. Illustrated by Donna Diamond. *Bridge to Terabithia.* New York: HarperTrophy, 1977.

Smith, Doris Buchanan. Illustrated by Charles Robinson. *A Taste of Blackberries.* New York: HarperTrophy, 1973.

Steig, William. *Amos and Boros.* New York: Penguin, 1971.

Viorst, Judith. Illustrated by Lorna Tomei. *Rosie and Michael.* New York: Atheneum, 1975.

Related Music

"Bert" and "Ernie." "But I Like You." *Greatest Hits.* Children's Television Workshop, 1996.

Disney Classics. "Best of Friends." *Disney Classics Volume VII.* Walt Disney Records, 1995.

Jenkins, Ella. *Multicultural Children's Songs.* Folkways Music, 1995.

Silverstein, Shel. "Friends." *A Light in the Attic.* Columbia Records, 1985.

Taylor, James. "You've Got a Friend." *James Taylor.* Warner Bros., 1976.

Various Artists. *Hand in Hand.* Music for Little People, 1995.

Various Artists. "Friends Around the World." *Take My Hand.* Walt Disney Records, 1995.

Index

About the Author

Martha Brady, a national consultant in arts integration, has been an educator for thirty years. Currently on the faculty at Northern Arizona University, she is the author of two other creative arts books and an audiocassette of songs for children.